THE
SEARCH
FOR
ALEXANDER

AN
EXHIBITION

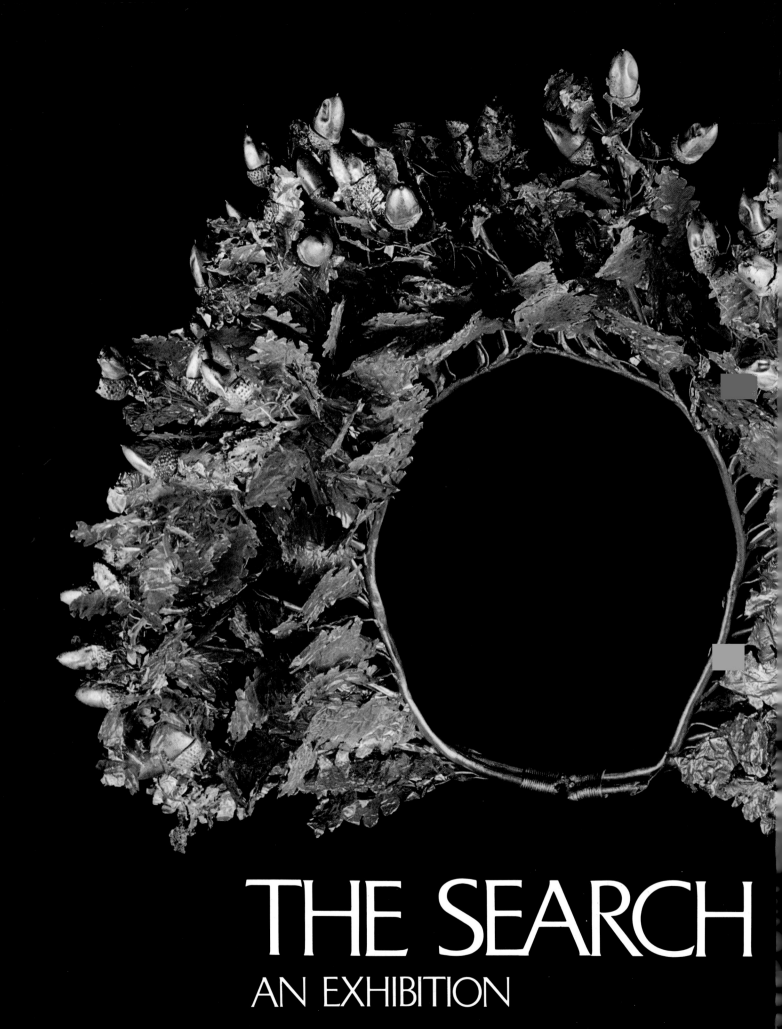

THE SEARCH
AN EXHIBITION

NATIONAL GALLERY OF ART, WASHINGTON

ART INSTITUTE OF CHICAGO

MUSEUM OF FINE ARTS, BOSTON

THE FINE ARTS MUSEUMS OF SAN FRANCISCO

WITH CONTRIBUTIONS BY

NICHOLAS YALOURIS
INSPECTOR GENERAL OF ANTIQUITIES OF GREECE

MANOLIS ANDRONIKOS
PROFESSOR OF ARCHAEOLOGY
UNIVERSITY OF THESSALONIKE

KATERINA RHOMIOPOULOU
EPHOR OF ANTIQUITIES AND DIRECTOR
ARCHAEOLOGICAL MUSEUM OF THESSALONIKE

ARIEL HERRMANN
FELLOW FOR RESEARCH
AND
CORNELIUS VERMEULE
CURATOR
DEPARTMENT OF CLASSICAL ART
MUSEUM OF FINE ARTS, BOSTON

PUBLISHED WITH THE COOPERATION OF
THE GREEK MINISTRY
OF CULTURE AND SCIENCES

NEW YORK GRAPHIC SOCIETY
BOSTON

FOR ALEXANDER

This publication was produced for the exhibition at the National Gallery of Art, Washington, D.C., November 16, 1980–April 5, 1981; the Art Institute of Chicago, May 14, 1981–September 7, 1981; the Museum of Fine Arts, Boston, October 23, 1981–January 10, 1982; and The Fine Arts Museums of San Francisco: M. H. de Young Memorial Museum, February 19, 1982–May 16, 1982.

The exhibition *The Search for Alexander* has been made possible by the National Bank of Greece and Time Incorporated, and with the cooperation of the Greek Ministry of Culture and Sciences.

Translations from the Greek: Essay by Manolis Andronikos and catalogue entries for loans from Greece translated by Judith Binder. Essays by Nicholas Yalouris and Katerina Rhomiopoulou translated by David Hardy.

Cover illustrations: Front, *Alexander the Great,* cat. no. 155 (Pella Museum)
 Back, *Gold chest* (larnax), cat. no. 172 (Archaeological
 Museum of Thessalonike)

New York Graphic Society books are published by Little, Brown and Company. Published simultaneously in Canada by Little, Brown and Company (Canada) Limited.

Printed in the United States of America

CONTENTS

FOREWORD

The search for our heritage is the essential aspect of what an art museum in our day is all about. As the National Gallery has been fortunate in mounting exhibition after exhibition representing our search into various aspects of that heritage, it has always been of particular poignance to me personally that we were not reaching the one aspect of Western civilization's roots to which many of us feel the deepest kind of affinity, namely that of ancient Greece.

I had talked about this with the Greek authorities on frequent occasions, starting in the summer of 1974. A call from Thomas Hoving, then director of the Metropolitan Museum, in September 1976, reinforced my conviction that it would someday be possible to borrow an exhibition of Greek antiquities to show in the United States, and our Trustees approved such an exhibition in principle. Only months after further discussions in Athens in the spring of 1977 came the great discovery, at three o'clock on the afternoon of November 8, 1977, of the tomb at Vergina, whose contents form the centerpiece of this exhibition.

I first saw photographs of those contents after a board meeting at the National Geographic Society, when pictures were being made ready for publication, several months later, by the *National Geographic* in its July issue of 1978.

Subsequently, in a meeting that summer with Zachary Morfogen, David Finn, and Caroline Goldsmith, I learned of the long-standing project initiated many years before by Zachary Morfogen at Time Incorporated, which had begun in discussions with a Greek editor with the idea of publishing a book on Alexander the Great. As their ideas had subsequently evolved in Greece and here, they came to include a television series, and even the possibility of an art exhibition.

It seemed to me a kind of divine happenstance, for which the ancient Greeks would have had an appropriate god to thank, that all of these strands seemed susceptible of being conjoined in what has become the exhibition shared by a consortium of American museums and described in this catalogue.

From our earliest conceptualization of the show, it had struck me that the way to pursue it in its American tour was as a search in reverse chronology, starting with the present, where we all live biologically, and searching backward into the cultural heritage on which we live culturally and intellectually.

No theme could serve better to dramatize this essential human quest, to discover where we have come from, than that of Alexander, whose fame over the ages equals that of any temporal leader in history. That fame has affected the world's art, and through our audiovisual search, supplemented by a presentation of selected works of art of later periods, we can penetrate backward into the world of antiquity, where the exhibition itself begins.

The show serves as a progress report, as our quest becomes more and more specific in its eagerness for data about the ethos of Alexander and the material culture of his own time and place. It is fitting that the climax of this search should be a royal tomb in Macedonia, which might even be that of Alexander's own father, Philip II.

A similar, but essentially different, exhibition preceded this one in the summer of 1980 in Salonica, the capital of modern Macedonia, in conjunction with the opening of a new wing in the archaeological

museum there. This, in turn, had been preceded in the summer of 1978 by a quite different but very splendid show, incorporating some of the same pieces, entitled *Treasures of Ancient Macedonia*.

The present exhibition shares aspects of both these illustrious predecessors. In emphasis, it is more akin to the earlier Salonica exhibition, presenting the achievement of ancient Macedonia which modern archaeology has revealed to us. We are particularly pleased that so many of these ancient treasures have been allowed out of Greece for the first time. At the same time it shares with the more recent exhibition an interest in exploring the impact of Macedonia on subsequent world civilization. The American show does this, in contrast to Salonica, by means of a new audiovisual presentation drawing on the total treasury of world art, and supplemented by varying groups of iconographically related works of art to be found in the region of each participating museum, together with a small nucleus of objects generously lent from Greece seen at each location and listed on page 190.

An exhibition of this kind does not come about without the generosity and earnest efforts of an enormous number of people. The key to any art exhibition is the lenders who make it all possible. Together with my fellow directors of the other museums in the American consortium, James Wood at Chicago, Jan Fontein at Boston, and Ian White at San Francisco, I wish to express our deepest gratitude to the individuals and institutions who have generously put these priceless and irreplaceable objects in our care for the benefit of our viewers. Paramount among these are the government and people of Greece. President Karamanlis was prime minister during the formative period of this exhibition, and his personal interest in the show's success has been a crucial factor. His able assistant, Ambassador Molyviatis; Prime Minister Rallis; former Minister of Culture and Sciences, Dimitrios Nianias, and his successor Andreas Andrianopoulos; the Minister to the Prime Minister Mr. Tsaldaris; and General Secretary of Tourism Lambrias have all shown a keen interest in this project. The close cooperation of Alexander Kotzias and, before that, Katerina Koumarianou has been indispensible. Mr. Harry Haralambopoulos of the Greek National Tourist Organization and Mr. Alexis Ladas of the Hellenic Heritage Foundation have also been of the greatest help. The Greek ambassador to the United States, John Tzounis, his predecessor, Menelas Alexandrakis, and his able press counselor, Alexis Phylactopoulos, have been tremendously supportive.

We are immensely grateful also to the Greek Council of Archaeological Advisors, chaired by the general secretary of the Ministry of Culture, Mr. Sophokles Sophoulis, which supported the loan of these objects for exhibition here. Needless to say, the directors of the lending Greek museums are also especially to be thanked.

For their financial support on behalf of the exhibition, we wish to express our deepest gratitude to a great variety of supporters. On the Greek side, the National Bank of Greece, under the governorship first of Angelos Angelopoulos and subsequently Euthymios Christodoulou, has been most helpful, as have other agencies of the Greek Government, particularly the Ministry of Culture and Sciences. The financial support of Time Incorporated is also warmly appreciated, and its chairman, Andrew Heiskell, has lent his personal support for this project over a long

period. And I would like to make special mention of Zachary P. Morfogen, Managing Director of Time Incorporated's Books and Arts Associates, whose personal vision and dedication have been essential to the success of this undertaking. His diplomacy and enthusiasm have carried the project through irresistibly.

I would also like to express our great appreciation to the Director of the International Communications Agency, Ambassador John Reinhardt, for help in securing federal immunity for the loans.

The support by Mobil of the audiovisual section of the exhibition is also deeply appreciated. In addition, each museum has had to find important additional resources, and to all these generous donors, credited in each location, we offer our collective thanks. At the Gallery, we should like to thank the Congress of the United States for its support of our exhibition program.

The scholarly underpinnings of an exhibition of this kind are also quite complex in the realization. Professor Nicholas Yalouris has from the beginning taken the keenest interest in every detail of the exhibition, and in addition to all his other onerous duties has found time to guide the selection of the objects and provide the very significant essay on the iconography of Alexander the Great from ancient times to the present that is such an important part of this catalogue. Working closely with him and specifically on the exhibition in the form it took at Salonica has been the very able director of the Archaeological Museum of Thessalonike, Katerina Rhomiopoulou, whose deep knowledge of the archaeology of this period has been very helpful, and to whom we are also grateful for her precious contribution as the head of the team that prepared the learned catalogue essay. We are also particularly fortunate in having the discoverer of the Vergina finds, Professor Manolis Andronikos, help the exhibition in countless ways, and provide an essay of his own with an eyewitness account of the discovery.

On the American side, we are grateful to Professor Phyllis Lehman for her early help, and for the curatorial department of the Boston Museum of Fine Arts, headed by Cornelius Vermeule. Ariel Herrmann of that department has been particularly helpful, and the catalogue entries for the loans from outside Greece have been furnished in great part by our Boston colleagues. We would also like to thank Professor Eugene Borza of The Pennsylvania State University for his helpful counsel.

Those involved in mounting the exhibition at the Gallery and the other participating museums are too numerous to mention. I would be remiss, however, if I did not signalize the important work done by Gaillard Ravenel of the Gallery's Design and Installation Department in shaping the show, together with William Williams, Kent Lydecker, and Christopher With of the National Gallery's Education Department.

Ancient Macedonia in the period of Alexander the Great produced some of the most beautiful gold objects ever crafted. It also produced an extraordinary historical figure. We at the National Gallery are immensely pleased by the opportunity to bring these threads together, and to participate in a search that is part of the larger, ongoing search for our common heritage.

J. Carter Brown
Director
National Gallery of Art

LENDERS TO THE EXHIBITION

GREECE

Athens, National Museum: 4, 50A, 72A, 110
Athens, Benaki Museum: 79A
Dion, Museum: 50
Ioannina, Museum: 103
Kavalla, Museum: 47, 88, 89, 90, 118, 120, 121, 122
Komotini, Archaeological Museum: 51, 52, 59, 105, 106, 107, 108, 119
Kozani, Museum: 67, 112
Larissa, Museum: 109, 113
Olympia, Archaeological Museum: 7
Pella, Museum: 146, 147, 148, 149, 150, 151, 152, 153, 154, 155
Thessalonike, Archaeological Museum: 49, 60, 100, 101, 102, 104, 111, 114,
 115, 116, 117, 123, 124, 125, 126, 127, 128, 129, 130, 131, 132, 133,
 134, 135, 136, 137, 138, 139, 145, 156, 157, 158, 159, 160, 161, 162,
 163, 164, 165, 166, 167, 168, 169, 170, 171, 172, 173
Veroia, Museum: 55, 68, 140, 141, 142, 143, 144
Volos, Museum: 48

EUROPE AND UNITED STATES

Baltimore, Walters Art Gallery: 10, 11, 33
Berlin, Staatliche Museen Preussischer Kulturbesitz, Antikenmuseum: 54, 64, 81
Bloomington, Indiana University Art Museum: 56
Boston, Museum of Fine Arts: 5, 8, 14, 15, 16, 17, 18, 19, 20, 22, 23, 24, 27,
 28, 29, 30, 31, 32, 36, 37, 45, 58, 69, 74, 75, 77, 79, 91, 92, 93, 94, 95,
 96, 97, 98, 99
Brooklyn, The Brooklyn Museum: 39, 70
Brussels, Musée de la Cinquantenaire: 42
Cambridge, Fogg Museum of Art, Harvard University: 38
Chicago, Alsdorf Foundation: 40
Copenhagen, NY Carlsberg Glyptotek: 1
Geneva, George Ortiz Collection: 43, 53
Houston, Museum of Fine Arts: 71, 72, 76
London, British Museum: 25, 34, 35
Madrid, The Prado: 12
Malibu, The J. Paul Getty Museum: 6, 13
Munich, Staatliche Antikensammlungen: 80
New York, The Metropolitan Museum of Art: 46, 83
New York, Norbert Schimmel Collection: 57, 61, 62, 65
Pforzheim, Schmuckmuseum: 66
Paris, Musée du Louvre: 3, 41, 44
Princeton, The Art Museum, Princeton University: 78
Richmond, Virginia Museum: 63, 73, 84, 85, 86, 87
St. Louis, The St. Louis Art Museum: 82
Switzerland, Private Collection: 9
Vienna, Erkinger Schwarzenberg Collection: 2

ALEXANDER AND HIS HERITAGE

By NICHOLAS YALOURIS

From the beginning of the fifth century B.C., and particularly after the Persian Wars, the Macedonians felt the need to reaffirm their ancient ties with their compatriots in southern Greece. The new horizons then opening up and the new political, economic, and intellectual conditions being created instigated their emergence from the isolation in which they had hitherto lived.

This need for rapprochement and cooperation prevailed generally among all the Greek city-states; it was encouraged and fortified by the recent experience with the Persians, when the Greeks, for once united, had carried the day against a foe many times stronger than themselves. This favorable atmosphere was cultivated by enlightened fifth-century politicians and sages who used the gatherings at the sacred sanctuaries as occasions for promoting a policy of concord and unity among all Greeks.

Thus the appearance of Alexander I, forebear of Alexander the Great, at Olympia after the Persian Wars assumes the significance of a landmark. His participation in the Olympic Games, after he had personally argued the case that the Macedonians shared a common ancestry with the other Greeks, was an event with decisive implications, not only for the fate of Greece but of the whole of the ancient world.

From this time on, communication between southern and northern Greece increased: the intellectual and artistic world of the culturally more advanced south was not indifferent to this opening toward Macedonia. Community of race, language, religion, and ideals formed an adequate basis for attracting even the most preeminent writers and artists to the court of the Macedonian kings.

Pindar, Bacchylides, and Simonides, and at a later date Euripides, Zeuxis, Apelles, and Lysippos, together with a host of other artists and intellectuals, all met with a favorable response from the educated Macedonian public. Even the towering figure of philosophy, Aristotle, accepted Philip's invitation and devoted a significant part of his life to the education of the young Alexander, who at an early age had given ample evidence of his outstanding intelligence and thirst for knowledge. The achievements of the southern Greeks in every sphere of art and letters were thus carried to Macedonia where they were gradually assimilated. The leading role in this process was played by Athens, "the school of Hellas." According to Plutarch (*Alexander,* IV, 6) competitions were frequently organized in Macedonia "not only for tragedians and flautists or players of the kithara, but also for rhapsodes."

In this way the Macedonians became familiar with the achievements of the other Greeks, which had been completely assimilated in the land of the descendants of Herakles (as the Greeks believed the Macedonians to be) by the fourth century. During this period, the Macedonian state was ruled by a series of competent monarchs and enjoyed great economic prosperity, particularly in the reign of Alexander the Great, which in turn opened up unlimited opportunities for further development of the various ideas that had been adopted from the south.

Macedonia was by that time the main meeting ground for all the great scholars as well as for the intellectual pioneers of the period, from southern Greece, the Aegean islands, and Asia Minor. Macedonia was the "New World"; its rulers extended an unconditional welcome and liberal patronage that

the Middle Ages, and is duly recognized as one of the four great kings of the ancient world (the other three being Nebuchadnezzar (or Darius), Caesar, and Charlemagne (or Constantine the Great). The Christians of the Greek mainland also numbered him among the saints. Alexander is honored as the pious knight, the defender of Christendom and as yet another Byzantine hero, Diogenes Akritas, the protector of the Byzantine Empire.

Alexander's popularity surpassed that of any of the other heroes of the ancient world. His achievements, whether real or imaginary, in all their endless variety, adorned both secular and religious monuments. Countless are the paintings and works of plastic or miniature art that flooded the medieval world. Further, many of the numerous illuminated manuscripts dating from the eleventh to the seventeenth centuries depict Alexander's achievements; some of them are of exquisite craftsmanship, while others have a charming simplicity in their execution.

Alexander penetrated the most distant, inaccessible, and strange lands and encountered the most curious, most savage, and wisest of men. He went to the Valley of the Diamonds and carried off the diamonds guarded by poisonous snakes; he did not enter the Valley himself, but tricked the birds of the region into bringing them to him.

He ventured as far as the earthly paradise near the Pillars of Hercules, where a number of wise descendants of Herakles had taken refuge to escape the "debauchery and lawlessness" of mankind and where they had lived since "on vegetables and scholarly wisdom." Thence he came to the Island of the Blessed, beyond the Ocean, where he gazed upon Paradise. He passed through the land of the Nereids (a variation, this, on Odysseus' encounter with the Sirens) who bewitched passers by with their sweet singing. He stood at the Fountain of Immortality and bathed in its waters, together with his retinue and their horses, who thus renewed their strength to continue their wearisome journey.

During the course of his wanderings he entered the cave in which the gods of the Greeks and their arrogant rulers were imprisoned, where he met with Kronos and Hermes, both bound in chains. After this dangerous adventure, which recalls the visits of both Odysseus and Herakles to the underworld, he was aided in his return to the light of the sun by "Almighty God."

In other versions he encountered fierce, wild pygmies, hairy giants dressed in sheepskins, fish-eating people, and anthropomorphic monsters like the dog-headed race, the one-eyed Cyclops, and the tribe of headless men. He came to the land of the Amazons, who submitted to him without resistance. He also came into contact with other female tribes, such as the tailed and tusked giantesses, the bearded and horned women, the Lamiai with their horses' legs; he killed dragons and other monsters by the freshwater

Figure 2 Alexander with the Philosophers of India, illumination from an Islamic manuscript. (The Pierpont Morgan Library, New York. M.471, f. 330)

Note: Illustrations of works of art designated by figure numbers are for reference; these objects are not in the exhibition, but most are in the audiovisual introduction.

Two representations of The Ascent of Alexander: Figure 3, a Romanesque capital from the cathedral of Basel; Figure 4, a woodcut by Hans Schäufelein (ca. 1480–1539) (Royal Library, Windsor Castle).

lake; finally, he met the prophetic trees of the Sun and the Moon, which foretold his death.

When he had crossed the earth from end to end, the indefatigable hero was driven by his unquenchable thirst for knowledge to explore the heavens and the depths of the ocean.

His ascent to the heavens is inspired by the attempt of Bellerephon to fly up to Olympos on the winged horse Pegasus. He harnessed two giant carnivorous birds (described in some manuscripts as griffins) to a chariot, having kept them without food for three days. Standing in the chariot he held a long pole with a ''horse's liver'' fixed to the end just above the birds' heads. The hungry winged beasts strove to reach the food (in some versions the bait was one or two whole animals) and flew ever higher into the air, eventually carrying Alexander up to heaven. The hero did not stay long there, however, for an anthropomorphic bird (in some versions it is an angel) appeared before him and pointed out to him the likely consequences of his pride; good Christian that he was, he obediently returned safely to earth — in contrast with Bellerephon who ultimately paid dearly for his insolence. This was one of the most popular episodes in the entire Alexander legend and it is portrayed in countless surviving works of Byzantine and east and west European art: in sculptures, mosaics, engravings, wall-paintings, miniature paintings, and embroideries.

Alexander's return to earth was typical of his adventures: he landed at a spot far removed from his point of departure and had a journey of many months before he found his camp, where he is portrayed as arriving in tattered clothes, exhausted from his tribulations.

The other major undertaking — his exploration of the depths of the ocean — was equally well known in the Middle Ages and is illustrated in numerous manuscripts.

According to one popular tradition, Alexander's exploration of the depths of the sea took place not in the ocean, but in the waters off Santorini. He had a bathyscope constructed of glass in the shape of a bell or a barrel, and took three living creatures with him on his journey: a cock, a cat, and a dog. The crowing of the cock would be an indication, in the murky depths of the sea, whether it was day or night; it was believed that the breathing of the cat would purify the air within the craft, and the dog was taken against the contingency that he would be unable to resurface for some reason: in which case he would kill it and since the sea refuses to retain bodies in its depths he would be washed up on the shore along with the dead dog and the other occupants of the bathyscope.

Alexander's precautions were justified, for worse came to worst. The cause of the accident is sometimes attributed to the clumsiness of the man responsible for paying out the chain and allowing the vessel to descend, sometimes to the infidelity of a woman who accompanied him and who became infatuated with another lover and abandoned the chain, thus leaving Alexander at the bottom of the sea.

The Renaissance was marked by a sudden renewal of interest in classical antiquity and the influence of ancient Greece was all-pervasive. Interest in the figure of Alexander was renewed, but the attraction was no longer the legendary life and fantastic achievements attributed to the hero as he was variously clothed by different peoples at different times. The historical figure of the hero now returned from the ancient sources: Arrian, Plutarch, and other historians. Even the dress and weaponry of Alexander and his army, as depicted in countless works of art throughout Italy and the West, are genuinely those of the ancient world.

The figure thus regained its authenticity, but without losing its legendary nature. Alexander again became what he had been for the men of his own time: a heroic descendant of Herakles, sprung from divine seed, and a dazzling meteor that flared and extinguished itself, changing the entire shape of the ancient world within a brief period of time. The general returns to the fore — the general who, according to Plutarch, always slept with his dagger and his text of Homer under his pillow; the admirer and emulator of Achilles, with whom he shared not only bravery, but the fate of a premature death when he was at the pinnacle of his career.

The whole of Alexander's life and work, including even the most recondite events narrated in the ancient sources, became a source of inspiration for sculptors, painters, engravers, and producers of min-

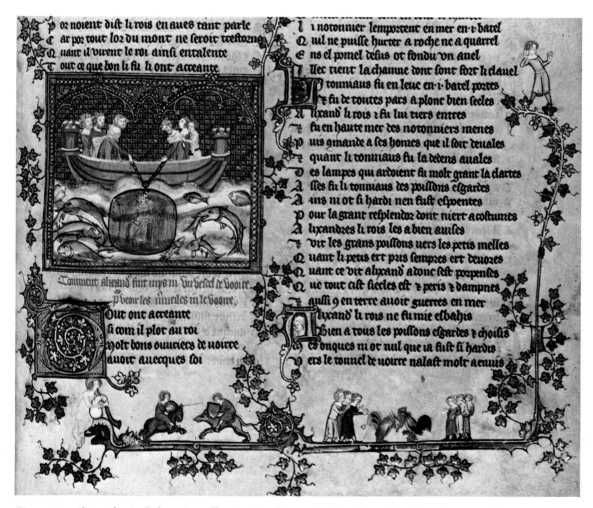

Figure 5 Alexander in Submarine, illumination from a fourteenth-century French manuscript of The Romance of Alexander. (*Bodleian Library, Oxford University, Ms. no. 264, folio 50a*)

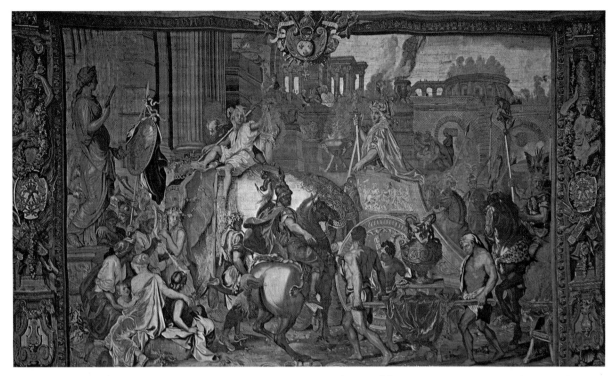

*Figure 6 Alexander's Entry into Babylon, Gobelins tapestry designed by
Charles LeBrun and Louis Testelin, 1664. (Mobilier National, Paris)*

*Figure 7 Alexander's Entry into Babylon, painting by Francesco Fontebasso,
1761–1762. (Bourg-en-Bresse, Musée de l'Ain)*

iature art. Their works offer a kaleidoscope of scenes ranging from his birth and childhood to the taming of Bucephalus and from his adult life up to the point of his death: they include his quarrel with his father Philip about the latter's marriage to Cleopatra; his meeting with the ascetic philosopher Diogenes; his friendship with Hephaistion and his lamentation on his companion's death; his practical demonstration of his trust in his doctor, Philip, when the latter was falsely accused of intending to poison him; the incident of the Gordian knot; countless battles fought against overwhelming odds; his triumphant entry into Babylon; his generous behavior toward his enemies, particularly to Darius and his family; his marriage to Roxane; and many other scenes.

We thus have an endless gallery of works of art dating from the Renaissance and succeeding periods, which includes masterpieces from the hands of Verrocchio, Raphael, Parmagianino, Altdorfer, Jan Bruegel, Pietro da Cortona, Ludovico Carracci, Veronese, Tiepolo, Poussin, Rembrandt, Rubens, Watteau, Thorwaldsen, Ingres, David, Delacroix, and Daumier.

The world's rulers basked in Alexander's glory, drawing parallels between episodes in his life and in their own: a painting by Lebrun depicts the successes of Louis XIV alongside Alexander's triumphal entry into Babylon, and Bernini gave his portrait of the French monarch the features of Alexander.

Pope Paul III, whose secular name was Alexander and who was renowned for his knowledge of the ancient world, adorned the Sala Paolina of Castel Sant' Angelo in Rome with a lavish series of murals inspired by Alexander's life and based on ancient descriptions and works of art. This series of paintings, in which the Pope compared himself to his namesake, the ruler of the ancient world, was a decisive retort to the Roman aristocracy who were vying with each other in decorating their palaces with scenes from the lives of their mythical Roman ancestors. The same motives impelled the Pope to issue a medallion that had a scene of Alexander worshipping the high priest Jaddus at the gates of Jerusalem on one side and a portrait of himself on the other.

Alexander was also a rich source of inspiration for Western poets and writers.

In contrast with the West, it was the legendary figure of Alexander that continued to predominate in Greek lands, which at this period were subject to Turkish rule. He shared in the fortunes and national

Figure 8 Gold medallion of Pope Paul III (1534–1549), showing on the reverse Alexander worshipping the high priest Jaddus at the gates of Jerusalem. (British Museum, no. P513.37)

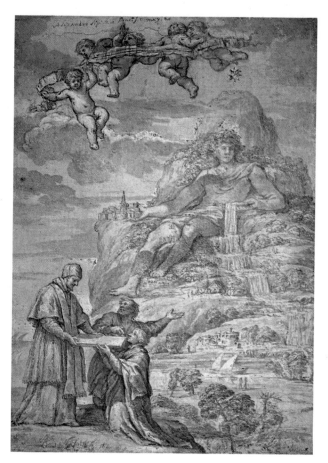

Figure 9 Drawing by Pietro da Cortona (1596–1669): The artist Deinokrates and Pietro da Cortona deliver to Pope Alexander VII (1655–1667) Deinokrates' plan to transform Mt. Athos into the image of Alexander the Great. (British Museum)

dreams of the enslaved Greek race and became a rajah, taking part in the struggles of the other Greek freedom-fighters to dispel the centuries-old tyranny.

On the eve of the Greek War of Independence he became the symbol that embodied the desire for a national uprising. His bust was a prominent feature of the proclamation circulated in 1797 by Rhigas Pheraios, the passionate believer in the Megali Idea and inspired writer who was one of the most outstanding martyrs to the Greek cause.

At the same time the "Rimada" and the "Phyllada" of Alexander the Great continued to be the most widely read popular romances, since they reminded the enslaved Greeks of the former glories of the nation. The popular imagination drew upon these stories and wove new versions of them in the form of fairy tales, in which the basic features of the originals were clearly discernible.

One of these fairy tales concerns Alexander's sister, who is depicted in folk art as a Gorgon, with a fish's tail and holding a club, a rudder, a trident, or an oar in her hand. According to the tale, Alexander's sister spilled the "immortal" water her brother had given to her to guard and in her despair threw herself into the sea and was transformed into a Gorgon. Ever since she searches the seas, asking the boats she meets if Alexander, her brother, is alive. If the captain, wisely, replies, "He is alive, and rules, and is master of the world" the boat continues on its way in calm weather and the Gorgon departs happy. But if the captain, without thinking, answers that her brother died long ago, the Gorgon becomes frenzied and raises a great storm to sink the boat.

Representations of the Gorgon reflecting this story can be found in embroideries, relief-carvings, murals and ship's figureheads; there are a number of different versions of the narrative, deriving from the story of the Sirens and of other sea spirits. The Gorgon is an enigmatic figure, at once beneficent and destructive; her legend is deeply rooted in the Greek world, particularly that large section of it having close ties to the sea.

Alexander reached the height of his popular appeal when he became an established hero of the folk shadow-theater, Karagiozis, in which he makes his appearance in the nineteenth century. In many of the pieces performed in this theater, Alexander is the leading figure. In the most widely known, the legendary hero overcomes the "Accursed Serpent," recalling both pagan and Christian themes, such as St. George's slaying of the dragon, or Herakles' destruction of the Lernaean Hydra. Alexander is consistently depicted as an ancient warrior, with shield, breastplate, and helmet, though the end of his spear bears the cross. He is at once hero of the ancient world, Christian in arms, and Greek freedom-fighter.

The themes connected with Alexander deriving from folklore and myth retained their popularity even after the achievement of Greek independence. They were a source of inspiration not only for artists but also for men of letters and writers.

Popular and literary tradition, troubadors and scholars united to serve the common goals and aspirations of the Greeks. Similarly in modern times, scholars, poets, and writers turned their attention to the figure of Alexander, among them some of the great pioneers and founders of the modern literary tradition such as Palamas, Kazantzakis, Seferis, and Ritsos.

Within the realm of modern Greek literature, the significance of Alexander, and of other figures of antiquity, centers mainly on the continuity between ancient and modern Greek culture — a subject that dominates and shapes the intellectual life of modern Greece. Halepas, for instance, made a herm with a bust of Alexander, the rear of which is carved with a full-length portrait of Saint Barbara, a symbol of the Greek Orthodox Church. And a painting by Engonopoulos shows Alexander the Great and Pavlos Melas, a modern hero of the struggle for Macedonian independence, with their arms around each other; the activities of the two heroes are thus identified, and both the general of the ancient world and the modern freedom-fighter are seen as representatives of the same Greek ideal of noble bravery.

The shattering of a number of national dreams, of which Alexander had come to be the symbol in modern times, left a deep scar on the Greeks, and particularly on Greek intellectuals. Seferis was to lament it, and most recently Ritsos bitterly imagines "the wax image of Alexander the Great, without his spear and helmet, lying supine. . . ."

Despite all this, Alexander, whether as legend or as historical figure, continues to affect Greek lives and to enrich literature and art; and, above all, he continues to captivate the hearts of people throughout the entire world, as he did in the past and as he always will. This is confirmed by the works in this exhibition and the popular interest aroused by the ceaseless harvest of finds from excavations, which shed ever-increasing light on his achievements, his personality, and his age.

AN OUTLINE OF MACEDONIAN HISTORY AND ART

By KATERINA RHOMIOPOULOU

According to ancient tradition, the Macedonians and the Dorians of southern Greece had a common ancestry. That the Makednoi and the Magnetes tribes sprang from a common ancestry is clear from the fact that both names have the root *Mak-*. They are first mentioned by Hesiod, who asserts that they were the descendants of Makednos and Magnes, sons of Zeus and Thyia, and that they inhabited the land of Pieria. The two tribes had migrated to this area toward the end of the Bronze Age from the region of the Pindus mountains, where they had settled when, together with other tribes, they moved down from the plains of central Europe at the beginning of the second millennium B.C. Herodotus, speaking of what he calls the "far-traveled" Greek race, claims that in the time of Deukalion it inhabited Phthiotis and subsequently, in the time of Doros, settled in the area around Ossa and Olympos; driven from there by the Kadmeioi, he says, "it dwelt in Pindus, being called the tribe of Makednos." From Pindus it migrated to Dryopis and thence down to the Peloponnesos where "it was called Dorian." The tradition of the common ancestry of the Macedonians and the Dorians of southern Greece remained alive until the end of the period of the migrations of the tribes, when Macedonia entered the historical period with the ascent to the throne about 700 B.C. of Perdiccas I, founder of the Argead-Temenid dynasty.

Herodotus and Thucydides both claim that Perdiccas was a descendant of Temenos, son of Herakles, who captured Argos after the fall of the Mycenaean kingdoms. Perdiccas and his brothers, Aeropos and Gauanes, "fled from Argos" to Illyria and upper Macedonia, whence they came down to the region of Pieria and found the tribe of the "Argeadai Makednoi" settled there, the Magnetes having already moved farther south to settle in Magnesia in Thessaly. The "Macedonian land" stretches from the northern fringes of Olympos to the point where the rivers Haliakmon and Loudias "mingle their waters in the same bed." Here the descendants of Temenos, who "in ancient times came from Argos," joined with their kin the Macedonians and created the kernel of what was to become the Macedonian state.

The Macedonians drove another Greek tribe, the Pierian Thracians, out of this area and made themselves masters of the fertile plain that was essential to the survival of a people whose economy was based on agriculture and stock-raising. They expanded initially in the direction of the modern village of Vergina, where Perdiccas founded the capital of the kingdom, Aigai, and thereafter toward the northwest fringes of the plain — the region, that is, between Veroia and Edessa. The Macedonian language was an early dialect of Greek, while the royal house spoke the Doric Greek of that period. The early territorial expansion of Macedonia thus meant that a Greek-speaking population was established as early as the eighth century B.C. in Pieria, Eordaia, Elimeia, Almopia, and Bottiaia (that is, in what is now central and western Macedonia) — the area that thenceforth constituted the heart of the Macedonian state.

One of the most striking features of the history of Macedonia was the fact that the monarchy was never abolished, thanks to the conservatism that marked every aspect of Macedonian life. This conservatism derived from the conditions under which the Macedonians had to struggle for survival, isolated

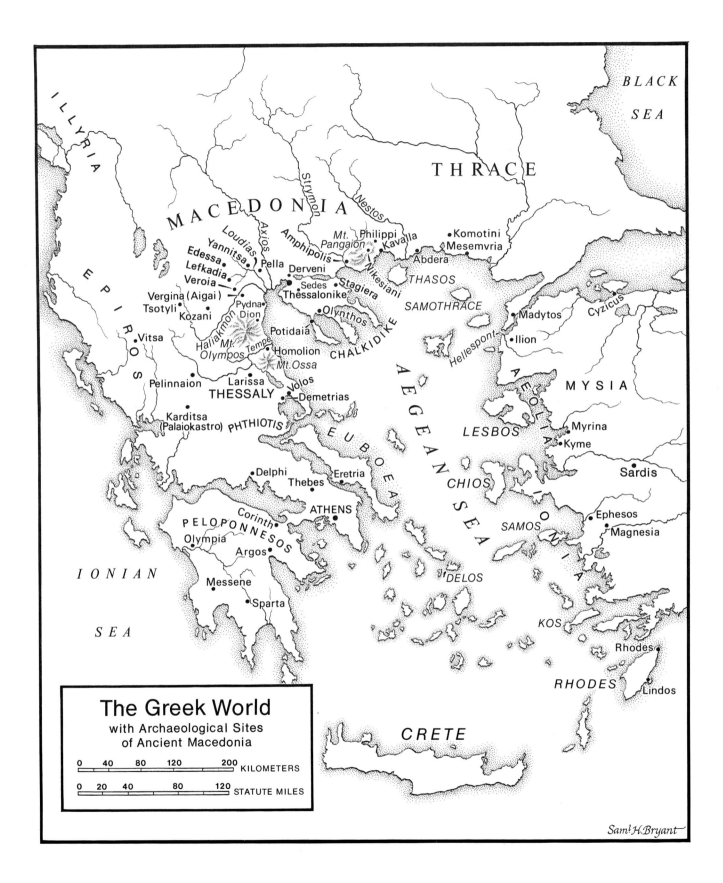

The Greek World
with Archaeological Sites of Ancient Macedonia

```
0    40    80    120      200   KILOMETERS
0  20   40      80      120   STATUTE MILES
```

BLACK SEA

THRACE

ILLYRIA

MACEDONIA

Strymon

Nestos

EPIROS

Loudias
Axios
Amphipolis
Yannitsa
Edessa • Pella
Lefkadia
Veroia
Derveni
Vergina (Aigai)
Pydna • Sedes
Tsotyli • Dion
Kozani
Thessalonike
Haliakmon *Mt. Olympos* *Tempe*
Potidaia
Homolion
Mt. Ossa
Vitsa

• Mt. Pangaion • Philippi
Kavalla
Abdera
Nikesiani
• Komotini
Mesemvria
Stagiera
THASOS
SAMOTHRACE
Olynthos
CHALKIDIKE

Madytos
Cyzicus
Ilion
Hellespont

MYSIA

Pelinnaion
Larissa
THESSALY
Volos
Demetrias

Karditsa
(Palaiokastro)
PHTHIOTIS

EUBOEA

AEGEAN SEA

AEOLIA

LESBOS

Myrina
Kyme

Sardis

Delphi
Thebes
Eretria
Corinth
PELOPONNESOS
Olympia
Argos
ATHENS

CHIOS

IONIA

SAMOS

DELOS

Ephesos
Magnesia

KOS

IONIAN SEA

Messene
Sparta

Rhodes
RHODES
Lindos

CRETE

Saml. H. Bryant

22

to all intents and purposes from the political and cultural developments taking place in southern Greece. The population, consisting largely of peasants and shepherds, clustered around the large land-owning families who formed the immediate social circle of the royal house, clung to its ancient customs and to its adherence to the principle of obedience to its leader. The institution of the monarchy thus survived until the end, with a ruler-monarch who exercised real power, who was at the same time commander-in-chief of the army, religious leader, and chief justice, and who was never, as far as we can tell, challenged by the people. Arrian's comment on the Macedonian kings is to the point: "They ruled the Macedonians not by force but by the law."

The king was surrounded by the council of elders and by the *"hetairoi"* or "Companions," a select army unit drawn from the sons of leading Macedonian families. The relationship of the monarch to the *hetairoi* was unusual and involved a nexus of mutual rights and obligations. The assembly of the *hetairoi* elected the king and gave approval to his actions. From the end of the fifth century this body lost its exclusively aristocratic nature when youths from a broader spectrum of the population began to be drafted into it.

Macedonia was ruled by a succession of competent kings, among them *Alexander I* (498–454 B.C.), whose reign covered the period of the Persian Wars and who was the first Macedonian ruler to take part in the Olympic games; *Perdiccas II* (454–412 B.C.) whose tactical maneuverings amid the fluctuating fortunes of the Peloponnesian War enabled him to strengthen the Macedonian state; and *Archelaos* (412–359 B.C.), who was "exceeding wise and sought the company of many wise men," and whose attempts to organize the state and ensure its smooth functioning made him the most outstanding of Philip II's predecessors. The series culminates in the reigns of Philip (359–336 B.C.) and Alexander (336–323 B.C.), the two greatest figures in Macedonian history. Philip was the first to attempt to implement the ideal of a united Greece, based on the idea of a fatherland. During his reign the Macedonian state doubled its territory and its population, its income was increased, and the foundations were laid for a foreign policy based on far-sighted aspirations. It was precisely these factors that made it possible for his son, Alexander the Great, to set in motion his ambitious designs and to realize the achievements that have caused him to be regarded as one of the most outstanding figures in the history of the world.

The history of the Macedonian state after Alexander's death was turbulent. A succession of competent and ambitious monarchs strove to preserve intact the heritage bequeathed to them by Alexander, but ultimately, a series of misfortunes and misjudgments led to the battle of Pydna, in 168 B.C., in which the Macedonians were defeated at the hands of the Romans. With the treaty signed at Amphipolis, Macedonia became a Roman province — an event that marked the beginning of the end for the rest of Greece too, which followed the fate of Macedonia twenty years later.

II

The political strength of the Macedonian kingdom began to be apparent as early as the fifth century B.C., but it was in the fourth that it exercised a significant influence on the course of events in Greece when it began to make itself felt among Greece's neighbors (especially in the north); and from the end of the fourth century it started to affect the eastern Mediterranean and Asia Minor. The economic prosperity that derived from the political activities of the kings ensured a standard of living favorable to the development of art.

The archaeological evidence available at the present does not permit us to speak of a distinct "Macedonian style" in the various branches of art represented. We can say with certainty, however, that the Macedonian workshops were initially influenced (until the fourth century B.C.) by the major artistic centers of the south (Athens and Corinth) and of the Aegean and Ionia. The influences were both direct, in the form of imported objects, and indirect, exercised through the Greek colonies on the coasts of Chalkidike and Macedonia itself. These influences continued to be felt after the middle of the fourth century, and went very deep, since the Macedonian rulers invited outstanding artists to their courts; it can be argued that the art of Macedonia now has the same general features as that of the rest of Greece. Art throughout the entire Greek world (that is, Greece, and the Hellenistic kingdoms of the East and in Africa) was now characterized by a homogeneity and eclecticism stemming from the fertile mutual interaction of the regions, each with its local religious and artistic traditions. These contacts in the sphere of art were unaffected by the political history or the wars of the period (fourth to second centuries B.C.). Despite all this, local preferences in the choice of motifs, whether purely decorative or taken from the realm of legend, can be detected in Macedonia and

other parts of Greece, together with innovations both in the manner in which the motifs are combined and in the choice of materials used.

The existence of gold and silver mines in the mountains of Macedonia, particularly in the east (Pangaion and the mountain behind Philippi), and of the copper of Chalkidike favored the development of artistic activity, especially metalworking and jewelry.

It is now clear, however, that the gold and silver from the mines of eastern Macedonia were insufficient to account for the enormous output of works of art and other objects from the fourth to the middle of the second centuries. Alexander's campaigns in the East, the conquest of the Persian Empire, and the acquisition of the royal treasury of Darius, king of Persia, led to an unprecedented quantity of precious metals and works of art in gold and other materials flooding into Greece and particularly Macedonia.

Persian art and the luxurious way of life of the East were, of course, known to the Greeks much earlier than this. Both during and after Alexander's campaigns, however, it is clear that first the Macedonians and then the other Greeks were captivated by the elaborate Persian jewelry and precious vases, which they copied and transformed, giving to them a completely new spirit — a combination of Eastern features with the morphological elements that give Greek art its particular identity. The result was a felicitous combination of Eastern motifs and forms with the decorative and functional devices familiar to the Greeks.

A number of innovations in the decoration, the techniques, and the forms deployed in Greek art reflect the changed life-style of the Greeks in this period resulting from Eastern influences and the new demands and tastes of the customer. They also demonstrate the skill, imagination, and inventiveness of the Greek artists and craftsmen, who succeeded in combining the traditional features of Greek art — its dynamism and balance, grace and restraint — with the elaborate and sophisticated features of the East.

Within the field of the minor arts the output of jewelry and metalworking more generally was impressive both for its quantity and for its quality. Ceramic objects (pottery and terra-cottas) continued to be produced in the traditional manner, the only change being new variations of shape and motif.

The local pottery production of Macedonia from the fourth century onward cannot be said to be distinguished either for its originality or for the quality of its clay. The interests of the local potters centered on conservative shapes and clumsy imitations of Attic models. This pottery has not yet been classified, and it can be dated only with reference to Attic pottery,

whenever the two are found in the same context. Fortunately, Attic imports have been found together with local wares among the grave offerings uncovered in many of the burials in the cemeteries at Kozani, Pella, Lefkadia and Vergina. Later, toward the middle of the Hellenistic period, Macedonian pottery becomes part of the Hellenistic "koine."

Local terra-cotta workshops have been identified at Pella, Veroia, and Thessalonike. The objects are interesting for their quantity, their size, and the range of their motifs, which were derived both from daily life and from the realm of religious belief. They were clearly influenced by the leading workshops of the period in Ionia and Rhodes.

The sculpture discovered in Macedonia also reflects its Attic and Ionian-island models. Local workshops have already been identified at Pella and Veroia, and there may have been others. The surviving examples exhibit the familiar characteristics of fourth-century Attic art, though modified according to the competence of the local sculptors and the demands of the customers.

In metalworking (to which most of the exhibition is devoted), the innovations referred to above were aimed at making the details stand out so that the visual effect would be more complete. The traditional techniques of filigree and granulation are found in combination on the same object, with attached decorative motifs or figures, often executed in a different metal (gold and silver, gilded silver, gilded bronze). Precious or semiprecious stones were also used. Down to the middle of the fourth century reliance was placed on the modeling of the metal itself in order to achieve the desired aesthetic and decorative effect. From 330 B.C. onward, there was a search for new means of rendering the third dimension, with special emphasis being placed on the use of light and shade, achieved by the methods outlined above.

The decorative motifs most popular among the Macedonians include: (a) The "Herakles knot" (see, for example, catalogue nos. 88 and 162). This made its appearance in the fourth century and retained its popularity into the Roman Empire; the Argead dynasty, whose last and most glorious scion was Alexander, claimed its founders were the descendants of Herakles. (b) The star or sun, the emblem of the Macedonians that was linked with the mythical tradition surrounding the founding of the state. (c) Wreaths of oak leaves and acorns, the oak tree being sacred to the god Zeus, father of Herakles. (d) Figures from the Dionysiac cycle and scenes from the life of Dionysos, the most important deity in Macedonia both in life and after death.

This period probably also saw the beginnings of the habit that developed among the wealthy aristocracy of collecting sets of tableware made of precious metals. Passages in a number of Hellenistic authors refer to the existence of these sets, which were often shown off by their owners. The custom remained firmly established throughout the Hellenistic period, and it was subsequently adopted by the Romans and continued into the Renaissance.

Kings and other eminent personalities of the period also liked to own valuable tableware that they could take with them to their final resting place.

The majority of the objects exhibited come from graves and were discovered by chance or as the result of systematic excavations of cemeteries and individual tombs throughout the whole of northern Greece. The grave offerings (vases, jewelry, and weapons) come from the cemeteries of ancient Macedonian cities such as Aigai (Vergina), Veroia, Pella, Amphipolis, and Thessalonike, and also from the neighboring areas of northern Thessaly and Thrace. They fall into two categories: those actually used during life and placed in the tomb by the relatives of the dead man for his use in the afterlife, and those that were made specifically for burial, which were often mere imitations of the real objects and had no function; the gold wreaths (such as catalogue nos. 60 and 173), for example, were probably not worn in life but were designed either for burial or, in some cases, as votive offerings to be placed in shrines.

The quality and quantity of the offerings often stands in contrast to the simplicity of the tombs in which they were found — for example, the graves of Derveni and those in other suburbs of Thessalonike, which are simple cist graves or simple rectangular chamber tombs with flat slab roofs of limestone. Sometimes, however, the monumental structure of the tomb is entirely in keeping with the offerings found therein; the royal tombs at Vergina are such.

What is certain is that the Macedonians lavished their finest objects, and those that would be of the most use in the afterlife, on their tombs. According to their beliefs life continued after death, in another world where the dead were the equals of the gods, taking part in their banquets and living in houses resembling those of the gods (the monumental tombs in which prominent Macedonians rested after death were built in the shape of temples, reflecting the fact that temples were the dwellings of the gods). As a result, the decorative motifs used in the grave offerings and the categories of objects that were placed in graves were both directly connected with life after death. The themes connected with the legends of Dionysos and Aphrodite, who were worshipped as deities of the underworld, are symbolic of the eternal cycle of life and death.

The Macedonian banquets described by the ancient authors were renowned for their lavishness; the ladles, strainers, plates, *kantharoi,* cups, *phialai,* bowls, situlas, and elaborately decorated amphoras and kraters used in them accompanied the dead for use in the divine banquets of the afterlife, at which men who had been distinguished in life wore wreaths of solid gold or of gilded bronze.

Similarly, the women were accompanied to the grave by toilet articles such as *pyxides* and mirrors carved in relief.

When economic reasons intervened to prevent jewelry or objects of precious metal or other valuable material from being interred along with the dead, imitations in cheaper material, such as clay or lead, occasionally gilded, were substituted.

The nature of the artistic production was thus determined to some extent by Macedonian funerary customs and beliefs surrounding death.

Two descriptions in ancient authors associated with Alexander illustrate the lavish nature of the funeral rites and the grave offerings. One is the account of the burial of his beloved companion Hephaistion at Babylon (Diodorus XVII.115). The other is the account of the burial of Alexander himself.

After his death in Babylon, Alexander's body was embalmed and was not returned to Greece. The magnificent hearse in which it traveled is described by Diodorus (XVIII.26–8). It consisted of an Eastern covered wagon with Ionic columns carrying a vaulted ceiling (thus it resembled Macedonian tombs) above a cubicle whose walls were adorned with nets and embroideries. The cubicle contained a golden sarcophagus in the shape of a man, in which the body lay amid spices. The intention was to inter Alexander at Siwah, in Egypt, at the shrine of Zeus Ammon, the god with whom he was identified, but Ptolemy I intercepted the cortege at Memphis and buried the body there until a tomb could be built for him in Alexandria, the city he founded. Little is known of this tomb other than that the coffin was kept in the cella of a temple. A new resting place was built by Ptolemy IV, who erected a mausoleum in which Alexander's body was surrounded by those of the Ptolemies. By this date the golden coffin in which Alexander originally lay had been replaced by one made of crystal. The body lay in state in Alexandria for a long period, but at some unknown time it disappeared, perhaps during the riots in that city in the late third century.

THE ROYAL TOMBS AT VERGINA

A BRIEF ACCOUNT OF THE EXCAVATIONS

By MANOLIS ANDRONIKOS

The year 1977 marked the quarter-century anniversary of the first attempt to discover the secret of the Great Tumulus at Vergina through archaeological excavation. On November 8 that year, my colleagues and I entered a Macedonian tomb which had lain undisturbed under that great mass of earth for over 2300 years.

Forty years had gone by since I first came to that little village on the northern slopes of Pieria with my teacher, K. A. Rhomaios. My whole life is bound up with that place. As a student, from 1937 to 1940, I watched my teacher excavating the palace and discovering the fine Macedonian tomb of the third century B.C. with its imposing marble throne. The war found me there, and as soon as I returned to Greece in 1945, after the vicissitudes of the war years, my first thought was to visit the site of the excavation. And when I joined the Greek Archaeological Service, as destiny would have it, I was stationed in that district. Thus, almost inevitably, I began excavating at the very spot where my teacher first taught me, and, spurred on by him, I dug a first trial trench at the top of the Great Tumulus.

I have written the history of the Vergina excavations elsewhere (see Selected Bibliography). Suffice it to say that the Great Tumulus is located in a large cemetery of smaller mounds; excavation has yielded a rich harvest and shown that the earliest burials date to around 1000 B.C. and the latest to the end of the Hellenistic period. After the first limited excavation of the Great Tumulus in 1952, and after I had finished investigating the cemetery with the mounds, I made two further attempts, in 1962 and 1963, to uncover the grave which I believed lay under the tre-mendously large mound. My efforts were not rewarded; but quite a few fragments of broken marble gravestones, discarded as useless material, were found in the earth filling of the tumulus. When I had finished excavating the palace, I decided to concentrate my efforts on the Great Tumulus, completing the circuit of my archaeological activity where I had begun.

My final attempt began in 1976. The results of that year's digging were decisive; although I did not attain the long-sought goal, the excavation produced data which led me to the ideas and hypotheses that were decisive for continuing the excavation:

1. There was certain evidence in ancient sources that Aigai, the first capital city of the Macedonian rulers, must be in the area of Vergina, as the English historian Nicholas Hammond had suggested a few years previously.

2. This meant that the graves of the Macedonian kings, who were invariably buried at Aigai according to ancestral custom, must be in this area.

3. The Great Tumulus at Vergina was, in all probability, a royal monument and concealed the grave or graves of kings.

4. Further excavation promised to be of enormous interest because of the possibility of uncovering royal tombs, and indeed to uncovering the first unrobbed Macedonian tomb, and that a royal one.

In 1976 I published these hypotheses and predictions in two articles. Both ended with the statement that further excavation might yield the most unexpected rewards.

I started the excavation on August 31, 1977, in high hopes. A detailed chronicle would be out of place here. By the beginning of October three struc-

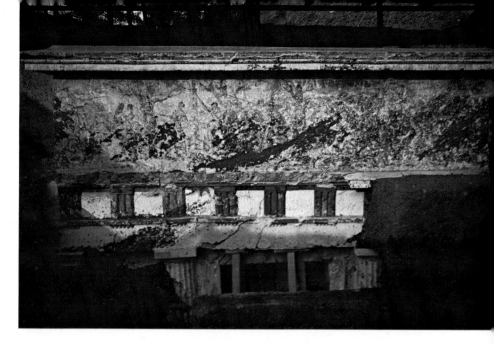

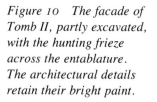

Figure 10 The facade of Tomb II, partly excavated, with the hunting frieze across the entablature. The architectural details retain their bright paint.

tures had been found below the earth fillings of the tumulus, and on November 8 my colleagues, Dr. Stella Drougou and Mrs. Chrysa Paliadeli, and I entered an unrobbed Macedonian tomb measuring approximately 10 by 5.5 meters, and 6 meters high.

Three structures were found at the time. One of them, a Heroön [sanctuary], was destroyed except for the foundations. The other two were intact and were underground graves. The first of these, Tomb I, is rectangular, measuring 3.50 by 2.09 meters, and 3 meters high; it has no entrance. The burial was effected through an opening at the top, which was later sealed up with big oblong blocks. This grave had been pillaged in antiquity and the robbers had removed all of the contents, leaving only a few sherds of pottery and some bones scattered around in disorderly fashion. The pottery dates the tomb to around the middle of the fourth century B.C., perhaps to about 340 B.C. The offerings must have been exceptionally rich and valuable, and their theft is a great loss, but the grave robbers who had inflicted such damage were not able to remove the most precious work of all, the wall paintings. The paintings provide an unforeseen compensation, not only because they are preserved in fairly good condition on three of the four walls, but also because this painting, especially that on the long north wall, gives us a unique work of monumental painting in the fourth century B.C. The subject is Pluto seizing Persephone. This wonderful composition is executed on a surface 3.50 meters long and 1 meter high. The god of the underworld is in his chariot, holding scepter and reins in his right hand; with his left arm he clutches the young goddess around her bare waist; her body and arms strain backward despairingly, and thus the spectator is given the

opportunity of delighting in the way the painter has depicted, in a wonderfully expressive manner, the vitally youthful body in a moment of stress. The god Hermes runs in front of the four-horse chariot, leading the horses to Hades. Behind the chariot Persephone's friend (Kyane?) kneels, fearfully watching, the flowers the two women had been picking but a moment before lying on the ground.

The artist's skill in drawing is breathtaking; the many preliminary sketches, which can be made out incised in the stucco, show that he worked free-hand, with absolute mastery of the medium. His final composition relies mainly on the design and on the fluent lines of the figures, imbued with expressive power. The artist drew effortlessly and very fast, as is evident from the brushstrokes, both the broader strokes and, especially, the short strokes on Pluto's face. But beyond the enchantment of the drawing, this wall painting is outstanding for brilliant color. With a limited palette of warm bright colors, among which the violet of the god's mantle, the red of the chariot, and the yellow for Kyane dominate, the artist enriches the line drawing with vibrant color, thus creating a composition of true grandeur.

Whoever stands in front of this composition realizes at once that it is the work of a great artist. The painting is in very good condition, having been cleaned and consolidated by the conservators of the Greek Archaeological Service under the expert supervision of the artist Ph. Zachariou. Information from ancient sources, taken in conjunction with my own observations, leads me to believe that the creator of this work is probably the famous artist of the mid fourth century B.C. known from the ancient written sources: Nikomachos.

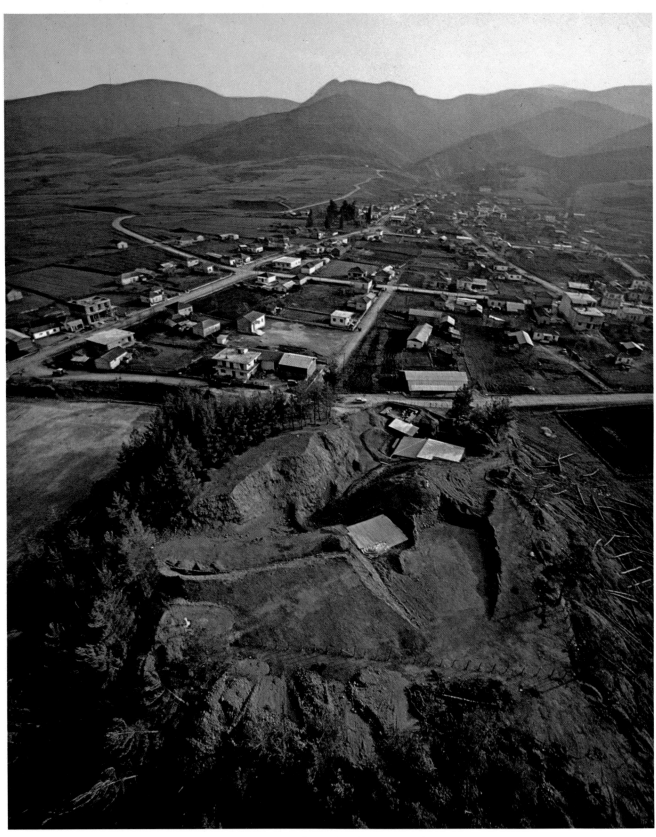

Figure 11 The Great Tumulus of Vergina from the north. Within the excavated area, the large tomb (Tomb II) is seen toward the top, with the small tomb with the frescoes just behind it. Nearer the foreground is the covering over the site of Tomb III. (Ph: Gordon Gahan © National Geographic Society)

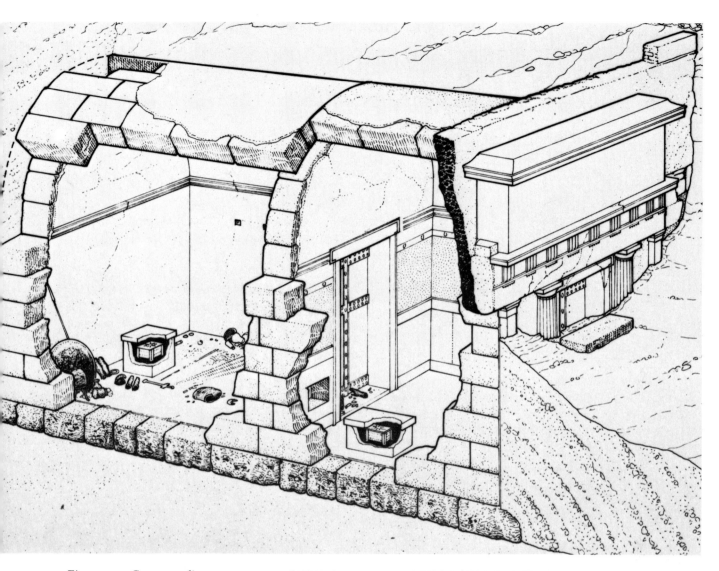

*Figure 12 Cut-away diagram
of Tomb II, the Royal Tomb (view
toward the north). At right, the tomb
shown under the Great Tumulus.*

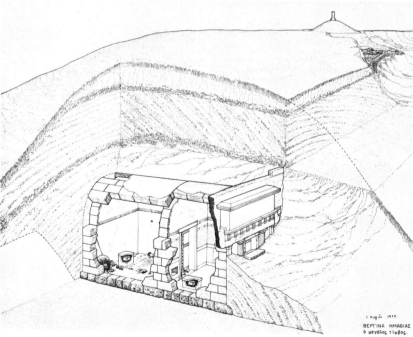

ΒΕΡΓΙΝΑ ΗΜΑΘΙΑΣ
ὁ μεγάλος τύμβος.

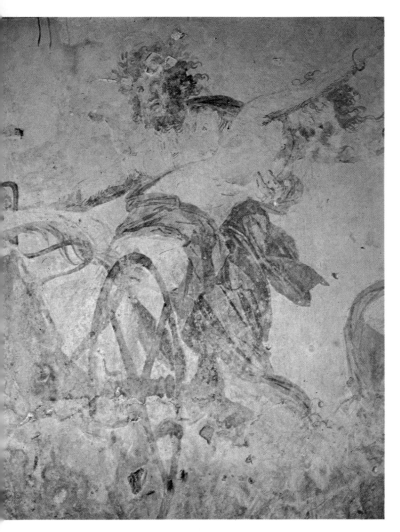

Figure 13 Pluto and Persephone, detail of the wall painting from the small tomb.

The paintings on the other walls are not so well preserved. A seated woman on the eastern back wall, probably the goddess Demeter, is fairly well preserved. On the southern side wall there are three seated female figures, of which the one in the eastern corner is the best preserved. These most probably represented the Three Fates, although their state of preservation prevents us from being absolutely certain about this. Perhaps further cleaning and study will lead to firmer conclusions.

A short distance northwest of the "little" tomb we found, as mentioned above, the cornice of a "Macedonian tomb" (Tomb II), as the large tombs with vaulted ceilings, found as a rule in Macedonia, are called. All of the Macedonian tombs found up until now had been pillaged; until we found the "little" tomb with the wall paintings looted, I had thought that there was a good chance of finding an unrobbed tomb below the enormous mass of earth of

the Great Tumulus (110 meters in diameter and 12 to 14 meters high). Now I began to be afraid that the burial of the Great Tumulus had not escaped the methodical grave robbers of antiquity.

With this in mind, I began clearing the facade of Tomb II, which turned out to have painted decoration. I immediately requested aid from specialists, who performed the delicate task of removing the earth from the walls; shortly afterward we found that there was a painted frieze below the cornice. When the crust had been removed we beheld a unique wall painting: a frieze, 5.56 meters long and 1.16 meters high, took up the whole breadth of the facade.

The subject was a remarkable hunting scene. At the left edge a stag is hit by a javelin; a little below is a man on foot, followed by a horseman moving to the left into the background; he is seen from the back in a three-quarter view with bold foreshortening. Then there is a leafless tree, a man on foot with a spear, a high stele, another man on foot moving right toward some animal (a boar?) attacked by dogs. Close by is another leafless tree and then — in the center of the composition and the tomb — a striking young rider with a spear in his right hand and a wreath in his hair; his pose recalls that of Alexander in the well-known mosaic from Pompeii in the Naples Museum. A third leafless tree frames this central figure. Just to the right of the tree the composition becomes more crowded, and the artist concentrates all of the action at this point. Two men on foot, one with a spear, the other with a hatchet, are about to attack the lion at bay who is already beset by the dogs. In the background, behind the lion at a higher level, a commanding-looking horseman is galloping forward with upraised spear, about to pierce the beast through. The rider's head is half hidden behind the horse's head, but one can see that he is a man in his prime — the only one in the whole composition — and that a portrait is intended. Two men on foot close the right side of the composition; the second man holds out a net to ensnare game.

This wall painting is unquestionably a first-rate pictorial composition; this and the wall painting of Pluto from Tomb I are the sole creations of major Greek painting known to us until now. Although the two works are nearly contemporary, there are important differences in style. The Hunt Painting does not have the bold, swift brushwork of the smaller painting, and it was more difficult to execute because of the larger surface and because of the demands of the composition itself. The artist evidently worked with deliberate care, first studying the surface to be

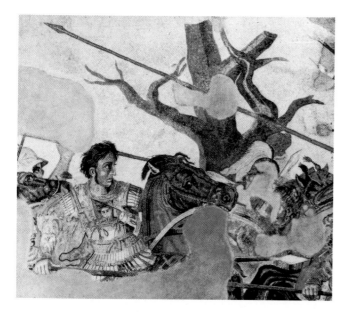

Figure 14 Detail of Alexander, from the mosaic of the Battle of Alexander found in Pompeii and now in the National Museum, Naples.

Figure 15 The excavator's first view into the great vaulted tomb after removing the keystone (below). The marble sarcophagus is directly below, the doors to the antechamber opposite.

painted, the possibilities it offered, and the difficulties to be circumvented. For the first time we behold the attempt to indicate landscape and the space in which the figures move: the stag running to the left, the rider galloping into the background, the trees, the stele, the rider coming forward from the back, and the placing of the beasts at different levels — all this creates a sense of space and landscape. I would even go so far as to say that there is a feeling for the third dimension beyond the conventions of foreshortening, although it is but halfheartedly realized.

Although we have not yet had the opportunity of studying the colors in detail, we can appreciate the rich palette ranging from the white of the background to the very dark trees and beasts, with intermediate shades of the warmer colors (orange-yellow, light red, brown, light violet to purple) and some of the cool colors (green, shades of blue). Many features of the drawing and composition, certain unusual motifs, such as the leafless trees, and the choice of colors, associate this work, I believe, with the painting of the Battle of Alexander that was probably the model for the Alexander Mosaic. If, as most scholars believe, the original painting must have been made about 320 B.C., then it is reasonable to consider that the same artist may have executed the Hunt Painting a few years earlier. The Battle of Alexander was evidently the more accomplished of the two, done with a surer hand and above all by a more experienced, mature artist. The Vergina wall painting is by an artist who is still experimenting and who has not yet reached the height of his powers. But it would be premature to go beyond these first impressions until the painting has

been completely cleaned. Yet we may state with certainty that it is an important work of major Greek art.

Assuming that the grave robbers had forced open the door of the tomb, I proceeded to excavate in the middle of the facade with the intention of clearing the upper part of the door opening, so that we could peer inside and, if possible, enter. After removing the earth we beheld the unexpected sight of the great two-leaved marble door in place, untouched — the only door from ancient Greece yet discovered that had remained intact through the centuries. This meant that most probably, almost certainly, the tomb had not been pillaged. The size of this tomb, the sensational wall painting, taken together with the discovery of the "small" tomb and the foundations of

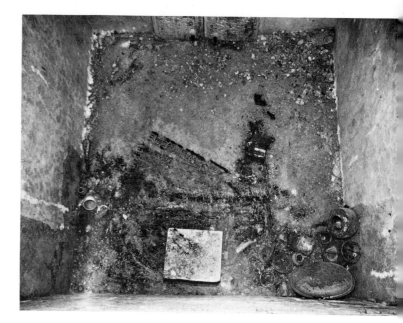

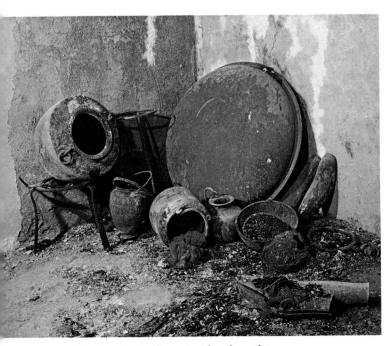

Figure 16 In the main chamber: the lantern lies beside the tripod and the diadem is on the floor at right (catalogue nos. 166, 160).

the Heroön, led us to think that this tomb must have belonged to an exceptionally important personage; the size of the Great Tumulus had persuaded us that we were in the area of the royal tombs; and the sherds found above the facade dated the tomb to around 340 B.C. With all this in mind it is no wonder that all those working there were overcome with excitement. The two brilliant wall paintings had already been an overwhelming find and now the tomb turned out to have kept its secrets and its contents hidden for two thousand three hundred years. The efforts of a quarter century were to be rewarded in the most incredible way.

Our excavation schedule changed immediately. It was nearing the end of October when the rainy season begins, and our excavation funds were running low; normally we would have closed the excavation down until the next year. But now that we were nearly sure that the tomb was untouched, we were obliged to continue excavating, not simply in the prospect of seeing what was inside, but above all because of my responsibility for keeping the tomb safe. As an archaeologist I faced vast responsibilities from that moment; I had to make decisions swiftly and, above all, unerringly.

The immediate question was how to effect an entrance into the tomb. It would be impossible to open the door without danger of its collapsing, thus risking the destruction of the facade of the building and serious damage to the painting. I decided there was only one way to enter. From long experience with Macedonian tombs I knew the method used by ancient grave robbers to enter a tomb easily, with no risk to themselves or to the structure. I would remove the central stone from the top of the vault at the back end — the keystone which was supported by the back wall of the tomb. This stone is always relatively small; during the construction of the vault it was always set in place last, and it is easy and safe to remove it. But to effect this it would be necessary to clear the whole vault, work which we had planned for the following year.

We started right away. When we got down to the level of the top of the vault, two new discoveries surprised us. First, the whole top of the vault was covered with a thick layer of stucco, something that had not been observed in any other Macedonian tomb up until now. Second, on the back of the vault (at the west end), we found a heap of sun-dried bricks which appeared to be the ruins of a rectangular structure on top of the vault, a kind of altar. Traces of fire and remains of a white coating on some of the bricks lent weight to this interpretation. Careful probing proved rewarding: in the midst of the heap of sun-dried brick and fallen earth we found two iron swords, a spearhead, and many iron fragments of horse trappings, all of them burned. All of these things must have been brought there from the pyre where the corpse was cremated. This means that horses had been sacrificed at the pyre, recalling the Homeric burial of Patroklos, where Achilles had sacrificed four horses to his friend. In addition to the iron objects we also found a few fragments of a gold wreath (fragments we now know belonged to the large wreath found inside the tomb together with the burned bones of the dead man) and many small pieces of ivory which had been through fire. Leaving the greater part of this structure in place, we removed the bricks covering the keystone of the vault.

Everything was ready for opening the tomb on Tuesday, November 8, 1977, the day on which the Greek Orthodox Church celebrates the feast-day of the archangels Michael and Gabriel. The assembled staff consisted of archaeologists, technicians from the Archaeological Museum at Thessalonike, two architects, specialists for reconstruction, specialists for preserving wall painting, and an archaeological photographer.

The moment the keystone was removed I looked first at the inside walls. The brilliant wall painting on

the facade had engendered hopes of finding something similar inside. It was a vast disappointment to find that the interior walls were coated with ugly rough stucco. Then I quickly glanced at the floor toward the western part of the chamber where all of the objects that had been deposited during the burial were still in place. On the floor were what were evidently remains of wooden furniture which had disintegrated, and metal objects in very good condition were at two sides of the chamber: on the viewer's left, silver vessels; on his right, bronze and iron armor and utensils. We could see that there was an antechamber closed off from the main chamber by a marble door like the door in the facade, also intact and in place. Directly below the opening in the vault there was a square marble sarcophagus very near the back (western) wall of the chamber. I thought that it must enclose the urn containing the ashes of the deceased.

The following days were filled with undreamed-of wonders, important additions to our knowledge and, sometimes, sensational discoveries. The task of inventorying the finds on the spot in their original positions meant that we had to proceed with the utmost care. It did not take long to grasp that the big bronze utensils and the bronze and iron armor had been deposited in the southwest corner of the room. There were two big bronze lebes, bronze libation bowls, a bronze wine jug, a bronze tripod, and an iron tripod. We were astounded to find a large sponge sticking out of the top of a fallen lebes. A pierced bronze container (catalogue no. 166) aroused our curiosity. The type was rare but not unknown; a few years ago a similar one had been found in a tomb near Thessalonike. No one had been able to figure out what it was for. Now, a look inside gave us the answer. There was a clay lamp attached to an iron base; it was a lantern.

A tremendous round bronze object like a shield was tilted up against one wall. Next to it was a pair of greaves, an iron helmet — the first Macedonian helmet which we had ever held in our hands — and another pair of bronze greaves was nearby. Next to the helmet was a large, gleaming, ring-like object of gold and silver; we had never seen anything like it. When we lifted the big bronze shield-shaped object, it was apparent that it could not be a shield because it had neither a handle nor any of the other appurtenances of a shield. Underneath this object, next to the wall, was a shapeless mass of various materials; one could make out bits of ivory and bands of gold with relief ornament. Our thoughts flew to the shield;

these fragments must be the remains of a shield made of wood and leather — materials that would perhaps have rotted — ornamented in ivory and gold. In that case the bronze object could hardly be anything other than the protective cover. From the first this shield gripped my imagination, and I declared that this must be the most remarkable find of all in the tomb. My instincts did not deceive me, because, now that the excellent conservator Mr. George Petkousis and his team have made good progress in restoring it, I know that the shield is truly unique. The outermost circle was a wave pattern made of ivory with very fine gold leaf covered by pieces of glass in the centers. The whole central part of the shield was gilded, and there was an ivory group in the very center, two figures about 0.35 meters high: a standing male holds a woman whose legs have buckled beneath her; she is about to fall to the ground (an Amazonomachy?). On the inside of the shield are four wide golden bands in the shape of a cross with reliefs of flying victories. In the middle, where the handle was, there is a wider, thin panel with a representation of four heraldic lions; other gold ornaments adorn the empty spaces between the bands. I hope that when restoration of this unparalled work of art is completed, those who see the shield will share the excavator's views, despite the unavoidable gaps and damage.

The iron cuirass, yet another unique piece of Macedonian armor, was found fallen to the floor a little south of the middle of the chamber. It is similar in type to the cuirass worn by Alexander the Great in the Naples mosaic. The main part was made of five pieces hinged together, making it easy to use, and the shoulder-pieces were made of four more sections, also jointed. The fine iron scales, mounted on leather and cloth, were bordered with narrow golden bands with relief decoration and wider horizontal golden bands adorned both front and back. Six golden lion heads adorned the front and served to anchor the leather thongs which fastened the shoulderpieces and the front to the sides, where there were two more lion heads. Below, the cuirass had fifty-eight gold lappets. All in all, it is a strikingly brilliant object. These two pieces of armor alone, the shield and the cuirass, sufficed to convince us that the man to whom they belonged was not just a king, but a king of exceptional magnificence and culture.

Silver vessels of the type used at symposia, mainly for wine, were found near the north wall. They are all works of art of very high quality and attest to a long artistic tradition. Comparison with a few similar objects found in other rich tombs

reveals their great distinction, allowing us to characterize them as masterpieces of Greek metalworking. In particular, one appreciates their full worth if one examines the little relief heads at the handles (see color plates 31, 32); these heads allow us to form a true picture of Greek sculpture of the fourth century B.C., which as a rule has come down to us in Roman copies that falsify the originals either by exaggerating charm and sweetness or through overstatement. Here we see the last harvest of the authentic classical tradition, before it was affected by the exciting but violent impetus of Hellenistic baroque which led to new international vistas. From this standpoint too, these works provide evidence for dating the tomb to a time before 330 B.C.

The fragments of disintegrated wooden furniture found in front of the square marble sarcophagus are probably from an ornate couch. The material was removed with utmost care, just as it was, to a workroom built at the site, owing to the personal interest of the Prime Minister of Greece, Mr. Constantin Karamanlis. As the cleaning progresses, we are in a position to judge how much has been lost through its destruction, but enough data have been retrieved to enable us to form an accurate picture of its appearance, at least in respect to those parts, such as the ivory, which have not completely disappeared. Fortunately, much of the decoration was of ivory and glass; thus we know that the couch must have had a frieze with mythological and human figures of ivory. The mythological figures are in very low relief and the human figures are in extremely high relief. The

Figure 17 The gold larnax in the antechamber as it lay in the marble sarcophagus.

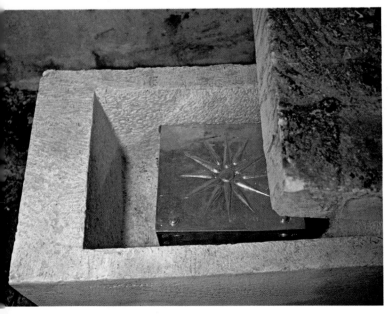

following have been put together so far from the first group: the upper part of a Muse playing the lyre, a lovely seated Dionysos, two herms, a choregic tripod, and so forth. There are hands and feet from the second group and quite a few small heads. These heads have obviously individualized features and thus are some of the earliest and best portraits of Greek sculpture of the fourth century B.C. Among the heads we may single out the most reliable portrait of Alexander the Great yet found, since it shows him a very young man and must have been made while he was still alive (catalogue no. 171). A second head, representing a bearded mature man, is, in my opinion, a first-rate portrait of Philip (catalogue no. 170). The powerful, slightly weary features of that great ruler, with almost imperceptible yet unequivocal indications that the right eye is blind, are strikingly like those of the portrait of Philip on the gold medallion from Tarsus of the Roman period. This head, together with that of Alexander, must have been created by a great artist, and it offers, I believe, valuable historical evidence for interpreting the whole complex of finds in the tomb. A third little head bearing a strong resemblance to the head of Alexander may be of his mother, Olympias. But since there are quite a few such heads, all of which are individual portraits, methodical investigation is needed before they can be identified with any degree of certainty. At the moment it may be affirmed that all of the ivory heads are fine works of art; by no means to be considered as the work of simple artisans, they were created by great artists who drew on uncommon resources of inspiration, intelligence, skill, and sensitivity.

Conservation has now yielded more information about the feet of the couch: they were ornamented with palmettes with leaves of glass set into ivory, the whole piece glued onto the wood of the couch. We also now know that the spirals on the legs were made of ivory with hemispherical glass gems in the center. There were tiny plaques of gold on the upper part of the legs and around the spirals; these have stamped reliefs of four-horse chariots, Maenads, Erotes, and so forth, covered by small sheets of glass which must have been transparent so that the gold reliefs could be seen.

It will take a long time to clean, reinforce, preserve, and restore all of this material, which mainly consists of countless fragments. Fragmentary as it is, it constitutes a unique source of information, because it is more than doubtful that we will ever again be lucky enough to find another such unbelievable archaeological treasure. Apart from their artistic value, these finds will enable us to become acquainted with

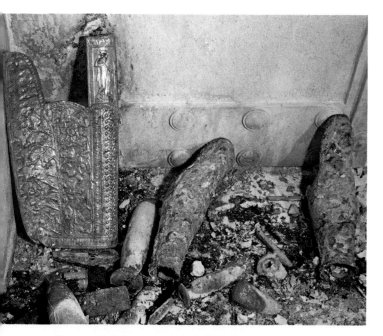

Figure 18 The gilded sheathing for a bow-and-arrow case and gilded greaves (catalogue nos. 160, 159) lying against the closed marble doors that lead from the antechamber into the main chamber of the great tomb.

the technology of classical Hellenism through artifacts of which we were entirely ignorant until now. For this reason I hope that the analyses now being carried out with the most up-to-date methods in laboratories in Greece and abroad will yield valuable information not only for archaeologists but also for specialists in many other fields.

We had not yet opened the marble sarcophagus, in which I expected to find the cremated remains in some kind of vase. The quality of the other finds had led me to suppose that the sarcophagus concealed something especially beautiful. But in my wildest dreams I never could have imagined what we saw when we raised the lid: A solid gold chest glittered inside; it bore the impressive star I knew from Macedonian coins and from representations of Macedonian shields. The sides of the chest were ornamented with lotus-and-palmette pattern, rosettes, tendrils, flowers, and leaves (catalogue no. 172). Our amazement and admiration turned to awe when we opened it: the burned bones which had been placed inside were perfectly clean, as if they had been washed; the bones on top had a deep blue color, the only trace of the purple cloth which had covered them. A costly gold wreath of oak leaves and acorns lay crushed and folded on top. Now restored to its original splendor,

it is revealed as most priceless, the grandest wreath that has come down to us from the ancient world (catalogue no. 173).

The gold chest with the bones again brought Homer to mind, the description of the burial of Hector with which the *Iliad* ends. The description fits the royal tomb of Vergina: the bones had been taken from the funeral pyre, had been washed and wrapped in a purple peplos and placed in a golden chest. For the first time we held such a golden chest in our hands; this unique coffin (weighing about eleven kilograms; twenty-four pounds) is the most precious one of the ancient Greek world that has survived to our day.

When these priceless objects had been taken to the Archaeological Museum of Thessalonike, we had yet another difficult task ahead: to find a way of entering the antechamber, since it was not possible to open the marble door without endangering the disintegrated material scattered around on the floor. The only feasible way was to remove a stone from the wall to the left or right of the door. This was relatively easy and safe from every point of view. We did not, in fact, have much hope of finding anything noteworthy in the antechamber, because of our experience of other Macedonian tombs (although, of course, they had been pillaged); we rather expected to see some painted decoration or some pottery which would furnish additional evidence for the date of the tomb.

When an opening had been made in the wall, a fresh surprise greeted us: a second marble sarcophagus, a little larger than the one in the main chamber, lay in front of us, very near the south wall. Beside it on the floor was a gold wreath, covered by fallen stucco. Thanks to the skilled work of the conservator D. Mathios, who succeeded in restoring this artifact as well as most of the others, we now have the joy of the most exquisite wreath of ancient times. The delicate myrtle leaves and wonderful flowers, perfectly matched, seem to grow out of the oval frame of the wreath in a way that is both natural and highly decorative, preserving the qualities of a living organism within the confines of artistic form.

The stucco in the antechamber, white below, red in the upper section, was well preserved. Pieces of stucco had fallen from the walls and ceiling and lay here and there on the floor. There were also abundant remains of disintegrated organic material, evidently parts of one or more pieces of wooden furniture or, perhaps, of textiles. The unusually large antechamber was literally crammed full of grave goods. Picking my way among them, my gaze was riveted on the

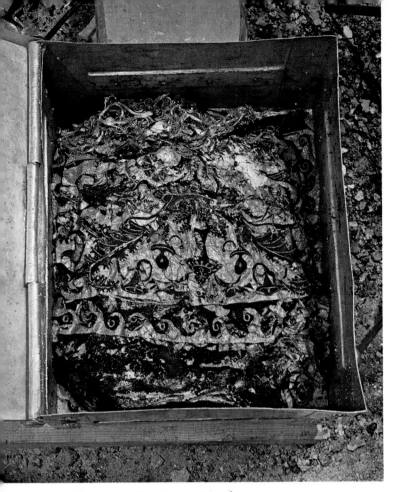

*Figure 19 The larnax from the
antechamber, opened, with the gold and
purple cloth that wrapped the bones of a
young woman.*

niche formed by the two marble piers flanking the inner marble door. There was a relief plaque in gold leaning against the left corner, and immediately I thought of Scythian *goryti* (bow-and-arrow cases) found in south Russia. A pair of greaves had been placed next to the plaque; they were of gilded bronze and the left greave was shaped differently from the right, being noticeably shorter. Ointment jars of alabaster lay on the floor in front of these striking objects; some of the alabastra were unbroken, others fragmentary. An amazing gold pectoral was on the floor at the northern wall; near it were two gold Medusas, as far as I know the most beautiful ones from classical times.

The plaque — the gilded sheathing of a gorytus — has three zones, two of which carry relief representations, while the third, which is the largest, has a guilloche pattern in relief; at the upper end is a standing warrior. The two zones have a single theme: warriors armed with shield, helmet, and sword are fighting, while women, some with children, run for their lives toward altars with statues of gods. It is evident that the capture of a city is depicted, the victors storming into the sanctuaries. At first glance it

would seem to be the Sack of Troy, a favorite subject in Greek art. But on closer examination this interpretation proves problematic, because one would expect to identify some of the figures in this representation with well-known figures present at the fall of Troy, but neither Priam nor Cassandra nor any of the Greek heroes can be recognized. Apparently the subject is some other legend less well known and less often portrayed in classical art.

The interpretation of the relief is one problem; another is the presence of a gorytus in a Macedonian tomb. We know that Scythian chieftains liked these sumptuous goryti, and quite a few have been found in the Scythian regions of south Russia. Seven fragments of such a gorytus, found in Karagodeuashkh, not only have the same subject matter but most probably come from the same mold as the one in Vergina, as I had conjectured from the start; this has now been confirmed by the Soviet archaeologist Mrs. A. Mantsevitch. This relationship is of paramount importance, and, in my view, the only likely explanation for the presence of a gorytus in the ancient capital of the Macedonians is that it came as booty after a Macedonian victory over the Scythians. We know for a fact that Philip campaigned against the Scyths in 339 B.C.; he triumphed over the aged King Ateas and took masses of booty. Could the Vergina gorytus be one of these captured pieces?

When the sarcophagus in the antechamber was opened, we met with yet another surprise. A second chest, a little smaller and more simply decorated than the first, dazzled us with its glittering gold. We took it out, set it, for the moment, on the plank on which we stood, and opened it. Surprise followed on surprise, each one surpassing the one before. A wellnigh incredible sight met our eyes: A marvelous gold and purple brocade shrouded the bones; the whole background was gold, with flowers, leaves, and stalks in purple, framed by a wave pattern in gold and purple. We found, first of all, that the gold threads had survived in fairly good condition, but that the purple had turned into a thin glutinous mass which threatened to evanesce. We hastened to make photographs to preserve the unrivaled sight we were privileged to behold and then immediately closed the lid air-tight.

One of the most difficult pieces of work achieved by the conservators of the Archaeological Service was saving this material. It had assumed the irregular forms of the bones it covered, the borders had been tucked down on the sides and many pieces had fallen in among the bones. Mr. T. Margaritov

was in charge of the operation, and together with his capable colleagues he not only succeeded in saving the section we saw on top intact, but also in restoring nearly all of the gold-and-purple cloth.

Another unique ornament had been placed in the chest with the bones and the shroud: a woman's gold diadem which is, without exaggeration, the most exquisite ornament we know from the ancient world. It surpasses all others, not only in its opulence, but above all in its delicacy, elegance, élan, and perfection of form. The springy stalks with their innumerable tendrils, the blossoms on their spiraling golden stems, the palmettes crowning the entire composition, and the bees gathering pollen from the flowers — all form a unique composition.

At the end of the excavation season in 1977 we reached the conclusion that this was a royal tomb; in the light of the finds I believe that this conclusion is not arbitrary, nor does it depend on exaggeration. It is the largest of all known Macedonian tombs; it has a remarkable painting, the work of a very great artist, it had an altar on top of the vault where evidence for horse sacrifice had been found; and, finally, the contents were uniquely valuable, not only in the literal meaning of the word but, above all, as art works. When we speak of a royal tomb, however, we do not necessarily mean the tomb of a king; it could be the tomb of some member of the royal family. The remarkable finds do, indeed, indicate that the tomb must have belonged to the head of the royal family. Nevertheless we cannot base our conclusions on the strength of these impressions. There is, however, at least one find which strongly supports our hypothesis that the man buried in the tomb was a king: the circular gold and silver object found beside the helmet in the main chamber. This is a diadem in the form of a hollow rod with the two ends joined by a separate piece which allowed the size to be adjusted (catalogue no. 162). This small separate piece has a relief of a Herakles knot on the outer surface and the ends of a fillet hang down on either side. There can be no doubt that this otherwise unparalleled object was designed to be worn on a man's head. The little fastener even shows how it was worn, because the Herakles knot and the fillet must have been in back. Among the Successors of Alexander the Great certain kings — for example, Antiochos III, Attalos III, Antigonos Gonatas — are shown wearing such a diadem in portraits. In certain portraits Alexander himself wears the diadem. This means that the diadem is the royal crown. Hence we reach the well-

nigh inevitable conclusion that the man buried in the tomb at Vergina was a king.

It is not difficult to determine the date of the objects in the tomb on the basis of the pottery, the shapes of the vases, the reliefs on the vases, the type of the tomb, and the wall painting. We may state that in all probability, verging on certainty, all of the finds date in the third quarter of the fourth century B.C., that is, between 350 and 325 B.C.

If the man buried in the tomb was in fact a king, and if the date we have given is correct, we come to the inevitable conclusion — apparently sensational, but by no means arbitrary — that the tomb must be that of Philip II, the father of Alexander the Great. This conclusion is supported by strong archaeological evidence and I have not yet encountered any evidence to the contrary. On the other hand, anthropological examination of the bones shows that they belong to a man forty to fifty years old; we know that Philip was assassinated when he was forty-six. Other features of the tomb would naturally accord with this identification; it would explain the presence of the couch with its splendid decoration including the portraits of Alexander and Philip; the figures in the painting on the facade would also be easily explained, and the whole composition illuminated by historical reality. As for the bones in the chest in the antechamber, I had thought from the beginning that they must belong to a young woman because of the wonderful woman's diadem and the exquisite myrtle wreath. This has been confirmed by the anthropologists, with the added information that the woman must have been between twenty-three and twenty-seven years old. Which of Philip's wives (except for Olympias) she could be is a question that awaits a reply from historians rather than archaeologists.

Whoever the man and woman buried in the tomb may be, I feel impelled to repeat what I have consistently stated from the start: the gain from the excavations at Vergina is first and foremost the finds themselves, which provide us with the clearest and most magnificent picture of Macedonian and, beyond that, of Hellenic civilization in the fourth century B.C.

In 1978 further excavation uncovered yet another unpillaged tomb (Tomb III) a little to the northwest of the first one. The investigation is not yet completed; in the light of our present knowledge it is reasonable to suppose that some member of the royal family was buried in this tomb.

The tomb is smaller than the other, but it too has

both chamber and antechamber. The painting on the facade has utterly perished because it was not painted on stucco but on a separate panel, probably made of wood and leather, attached to the facade. Compensating for this loss is a narrow frieze in the antechamber showing two-horse chariots. Although this decorative painting bears no comparison with the great compositions previously described, it is, nevertheless, the work of a craftsman who was good at his profession, skilled in figure painting, experienced in the problems of perspective, and with enough imagination to vary the arrangement of the chariots so as to avoid monotonous repetition. His color range reveals sensitivity born of long experience.

The chamber was apparently filled with various objects, as the remains of disintegrated organic materials cover almost the entire floor. One wing of the inside marble door fell into the main chamber; it probably broke the objects now underneath it. Most of the silver vases were found together in very good condition in the northeast corner of the room. Twenty-eight have been found so far, and we do not know if others lie below the fallen door. When they had been cleaned, we saw that although they are not of the high quality of those in Tomb II, they are, nevertheless, excellent examples of their kind. Some of them have extremely unusual shapes and others have shapes appearing here for the first time in silver. There are two or three true masterpieces; a patera with a ram's head at the end of the handle is an outstanding example of metalwork of the fourth century B.C.

The tomb contained other noteworthy objects: a silver-plated iron lampstand and two large silver-plated bronze vessels. The lower part of a gilded spear was an entirely unexpected find and, as far as I know, unique in the ancient Greek world. The five gilded bronze strigils (scrapers) are also unusual; they were found near the spear with four iron scrapers. The greaves found in the chamber are also gilded, and they have fine relief decoration on the lower edges. Some sort of costume made of leather or cloth worked with gold was found on the floor in very poor condition. It is not possible to say any more about it until the technicians have managed to extract it and begin conservation measures. A golden wreath with oak leaves and acorns had been placed around the shoulder of the silver hydria containing the cremated bones of the man buried in the tomb. It is indeed neither as heavy nor as splendid as the oak wreath in the first tomb, but it is one of the finest wreaths from ancient times, perhaps a close second to the latter.

It is almost certain that there was a wooden couch with ivory decor in this tomb too. Only two sections, the portions which were in danger of decaying, have been extracted from the mass of material on the floor. These parts probably came from the decoration of the couch feet. Thanks to Mr. Petkousis' resourceful skill, some marvelous ivory ornamental moldings and a group of three relief figures in ivory have been recovered. This relief shows the god Pan and a rapturous Dionysiac pair moving to the left; the mature man holds a torch and leans on a young woman's shoulder. The relief is of incomparable quality: the masterly handling of the volumes, the keen sensitivity of the carving, the melodic flow of the drapery, the counterbalance of grace and expressive power allow us to characterize this little group as the most outstanding ivory work in the ancient world and to comprehend Greek sculpture of the fourth century B.C. in all its innocent loveliness.

Now that the bones have been examined, we know that a boy twelve to fourteen years old was buried in the tomb. The mere fact that a tomb like this was constructed for a boy would be enough to identify it as a royal tomb. If, however, skepticism lingers, the finds themselves will dispel it; above all there is the evidence of the couch, which speaks the language of great art.

The visitor to this exhibition has the opportunity of admiring some of the most typical works associated with the world of Alexander the Great. The finds from the royal tombs at Vergina are creations closely and directly related to Alexander himself if, as I have indicated above, they belong to his own family. Some of the most typical ones are in the exhibition. Nevertheless, only the whole complex of finds will persuade the viewer that the archaeologist who had the good fortune to find them is not exaggerating when he insists that for the archaeologist, for the historian, and for the cultivated layman these finds offer the most authentic picture of Greek civilization at one of its high points and at a critical moment in its history: the moment when Hellenism, with the dynamic visionary leadership of the young Macedonian king, would surge onward toward the East, where it was to hand on its cultural tradition and values, paving the way for the Christian message through the medium of the Greek language and for the transformation of the ancient world into the European society to come.

November 1979

COLOR PLATES

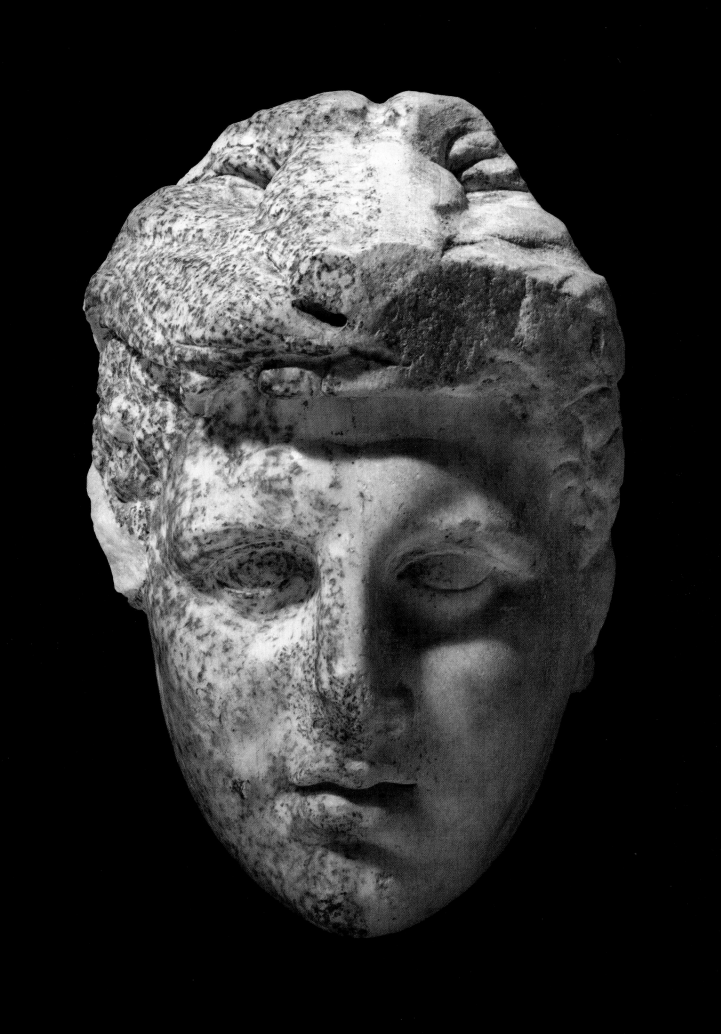

1 The youthful Alexander the Great
appears in the guise of his hero Herakles,
the skin of the Nemean lion worn as
a cap. Found in a shrine at Sparta in the
Peloponnesus, this likeness, both
ideal and strong, has been attributed to the
court portraitist, Lysippos, and shows
the young Macedonian king about the time
he set forth to conquer the Persian
Empire. This marble and the head from
the Athenian Acropolis identified
with the sculptor Leochares are perhaps
the only two monumental portraits
of Alexander surviving from his lifetime.
(Catalogue no. 5)

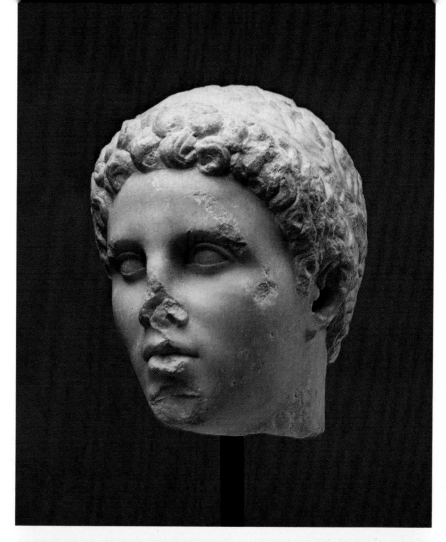

2 Just-over-life-sized heads of Alexander
(*right*) and his heroic companion
Hephaistion were evidently part of a large
commemorative or votive monument.
While Alexander's features have long been
known from coins, monumental
sculptures, and other works of art, those
of his able friend who died in the last
campaigns in the East and was accorded a
hero's worship have been harder to
identify. A relief of a divine lady pouring a
libation to Hephaistion, the
dedication of one Diogenes (now in the
Archaeological Museum, Thessalonike),
shows how part of the group
from which these heads came must have
appeared. (Catalogue nos. 13, 6)

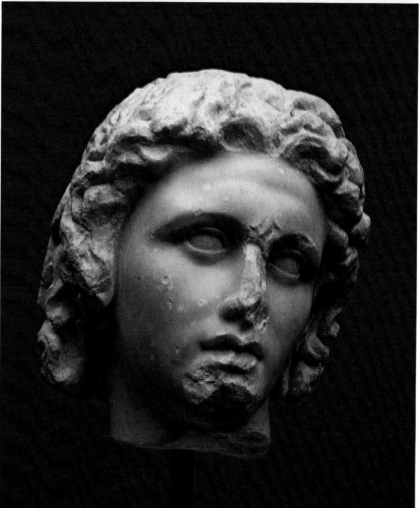

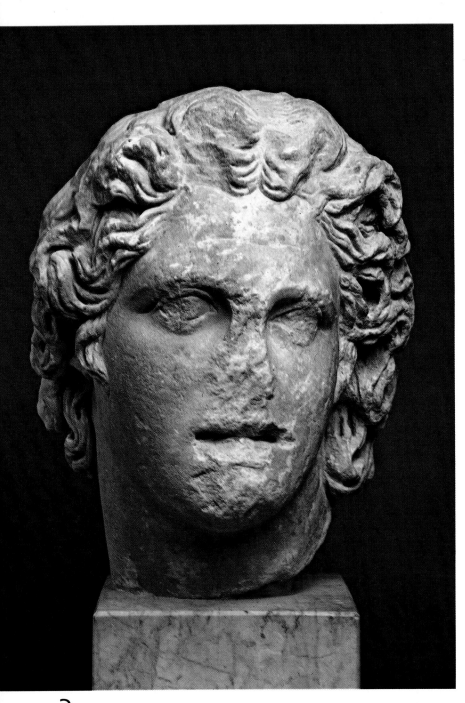

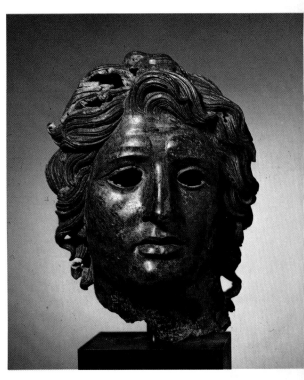

4 The Hellenistic and Roman imperial cities of Asia Minor saw Alexander in an aura of romantic divinity. A large head in bronze, eyes once inset in another material, was part of a heroic nude statue based freely on Alexander with the Lance by Lysippos. The head's style takes the restless grandeur of Lysippos and interprets it in the light of Pergamene and Rhodian baroque artistic experiences. (Catalogue no. 9)

3 The spirited, Hellenistic view of Alexander is embodied in a marble head found at Volantza, seemingly from a monument in the region of Olympia in Elis, long a focus of Macedonian aspirations in the Greek world. The date is about 200 B.C., when the artistic influences of Pergamon in Asia Minor and Rhodes off its coast were felt all over the Mediterranean. Alexander's Macedonian successors from northern Greece to Mesopotamia used his emotional likeness as a means of engendering local enthusiasms for their own rule in the face of Rome's march eastward. (Catalogue no. 7)

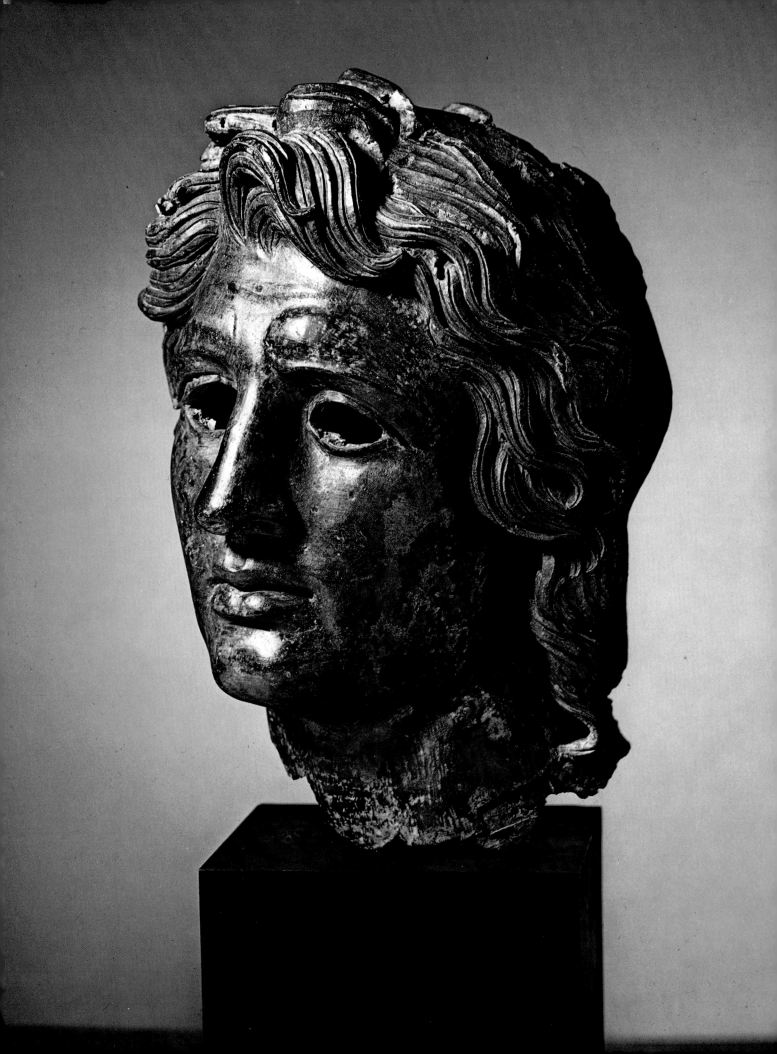

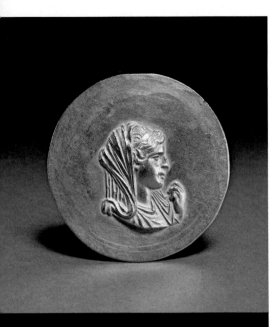

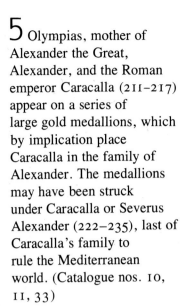

5 Olympias, mother of
Alexander the Great,
Alexander, and the Roman
emperor Caracalla (211–217)
appear on a series of
large gold medallions, which
by implication place
Caracalla in the family of
Alexander. The medallions
may have been struck
under Caracalla or Severus
Alexander (222–235), last of
Caracalla's family to
rule the Mediterranean
world. (Catalogue nos. 10,
11, 33)

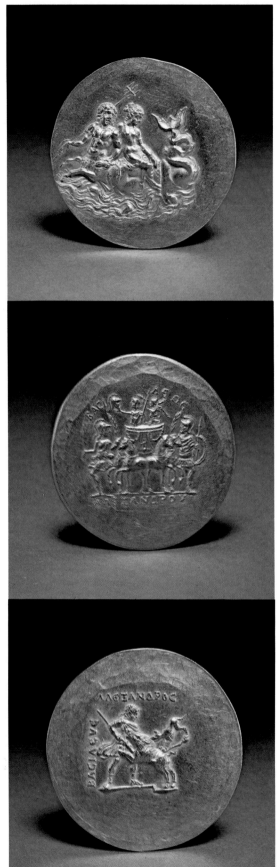

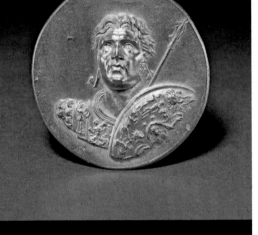

6 A silver rhyton, or
drinking-horn (*opposite*), in
the shape of a deer's head. A
scene of mythological combat
in the tradition of paintings on
vases and architectural friezes
appears on the neck, in
front of the vessel's curved
handle. Painted ceramic
examples tell us that such
rhyta became popular in
the Greek world around 500
to 490 B.C., at the time
of the Persian Wars in the
area of the Aegean.
(Catalogue no. 53)

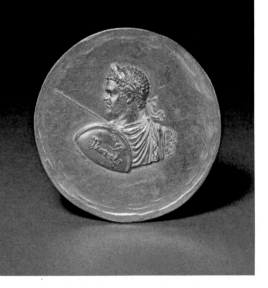

7 The leg of a marble couch, found
in a "Macedonian" tomb at Kerdyllia,
features intricate carving in imitation of
work in metal, wood, or even bone.
The funerary art of northern Greece
abounds in scenes of banqueting, in this
world or the next, and couches
such as this symbolized the eternal
symposium, with the deceased elevated
to the ranks of the gods and heroes.
Many Roman copies of such legs as this
survive, but they invariably lack
the spirited freshness and precision of
detail seen here. (Catalogue no. 47)

8 The painted marble funerary stele
or tombstone of about 200 B.C.
commemorates one Menelaos from
Amphipolis, who was buried
at Demetrias in Thessaly. Below the
inscription is a painted scene
of the deceased reclining at a banquet,
attended at the left by his young ·
servant. (Catalogue no. 48)

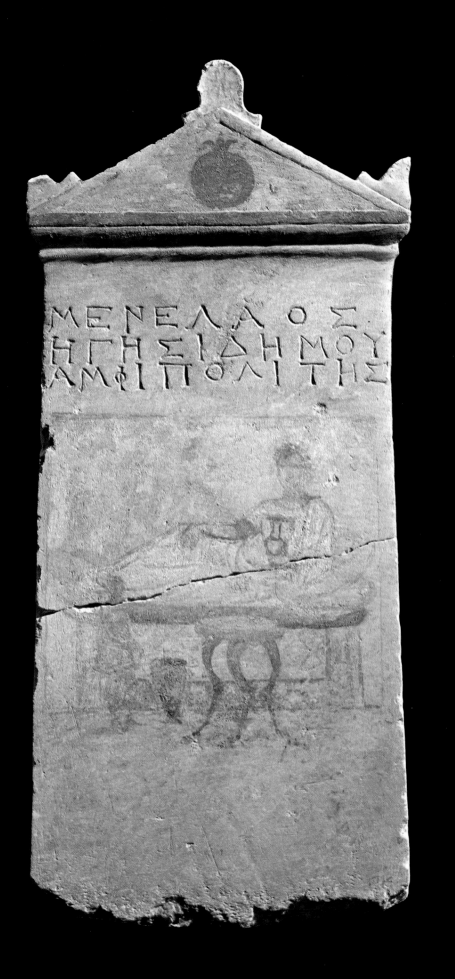

9 Like the three ears of wheat opposite, a double-snake bracelet with a large garnet in the center of its Herakles knot and an earring with a Nike pendant exemplify the richness and diversity of craftsmanship in gold in the age of Philip II, Alexander the Great, and their successors into the third century B.C. Such masterpieces as these were found from Thrace to Sicily and expressed the international aspects of Greek art in the days of Macedonian power and glory. (Catalogue nos. 66, 63)

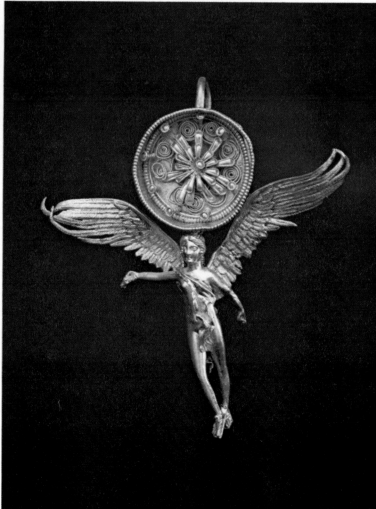

10 The naturalistic, life-sized ears of wheat must have been a votive or funerary offering invoking Demeter as goddess of regeneration. (A small part of the lower stem is not shown in the illustration.) (Catalogue no. 65)

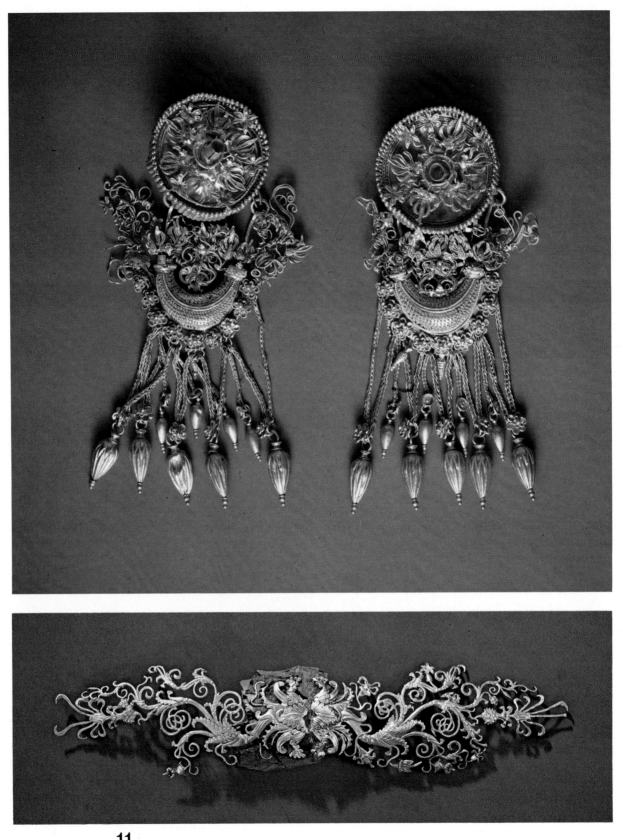

11 A pair of sumptuous gold ''boat'' earrings from a grave at Derveni, a gold
ornament from Stavroupoli, and a golden olive wreath from Sedes all illustrate
the imaginative luxury of funerary art from the tombs of the Thessalonike area in the
second half of the fourth century B.C. Cassander founded Thessalonike, named
after his wife, a younger half-sister of Alexander, in 316–315 B.C., near the important
city of Therme on the Thermaic Gulf. (Catalogue nos. 138, 114, 60)

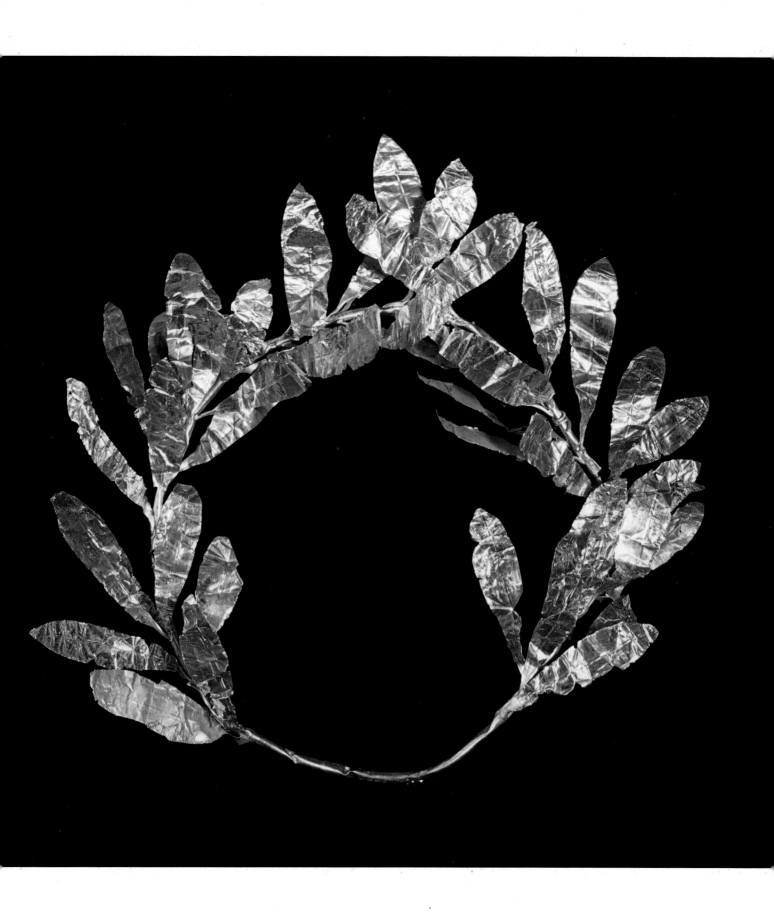

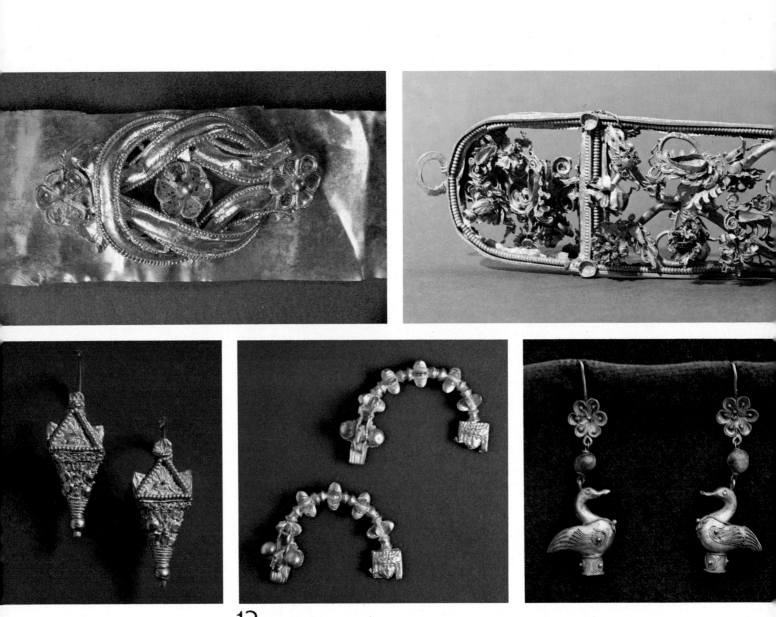

12 Gold of every conceivable form is associated with the ages of Philip II
and Alexander or the Successors. The Herakles knot (*top*), a detail of a simple gold-
band diadem, often appears as the central element of such jewelry from the
fourth century into Roman times. Richly detailed earrings (*below*) are in the form
of pyramidal pendants, a type with a long history in Greek lands. A pair
of gold bow fibulae — pins — is at center, above. Another pair of earrings has
pendants in the form of stylized geese. (Catalogue nos. 88, 89, 55, 71)

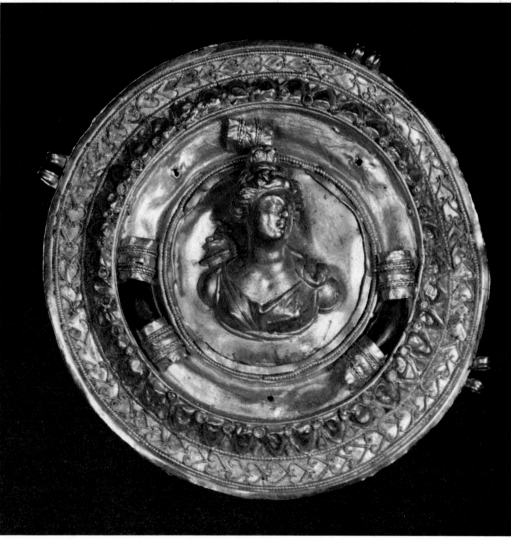

13 The gold pendant from a Derveni grave may show a very idealized Philip II as Herakles, the hero so often associated with the portraiture of Alexander the Great. The fragmentary diadem (*center*) from the Tomb of the Erotes at Eretria continues the floral traditions of the golden cloth, ''queen's'' diadem, and other objects from both chambers of the Royal Tomb at Vergina. Snakes coil around the hoop of a finger-ring set with a red garnet (*above*). The big roundel with bust of Artemis, from Thessaly, links the goldwork of the height of the Hellenistic age with that of Pompeii in the days of the last Queen Cleopatra. (Catalogue nos. 139, 92, 90, 78)

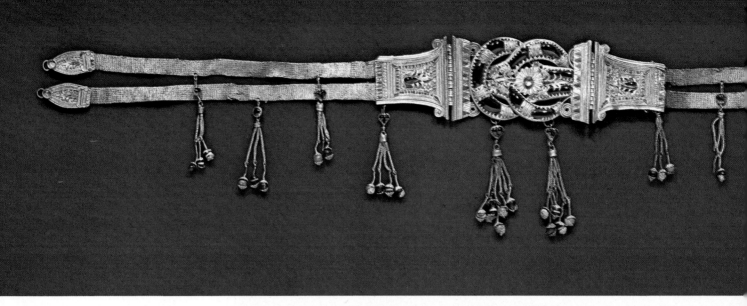

14 Gold, garnet, and enamel diadem. A sumptuous Herakles knot with inlaid plaques and bands leads to strands of looped chains. A master jeweler made this diadem and others from northern Greece and the Black Sea area about 300 B.C., when Alexander's Successors were consolidating their kingdoms. The knot was an allusion to the force of love or the power of love over force. (Catalogue no. 79A)

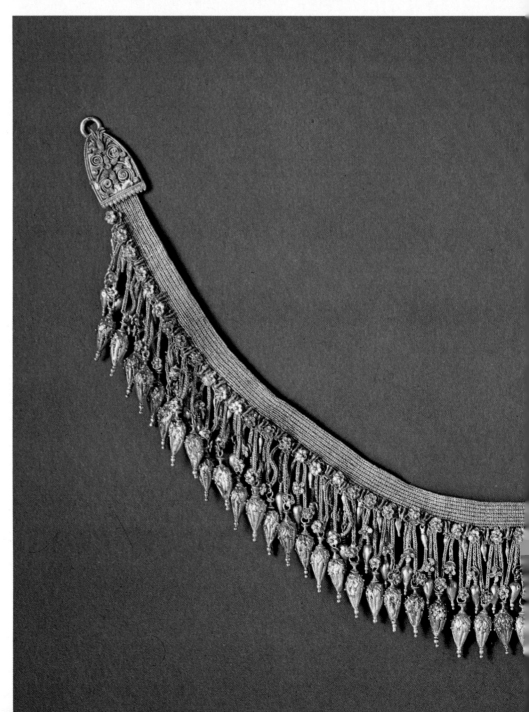

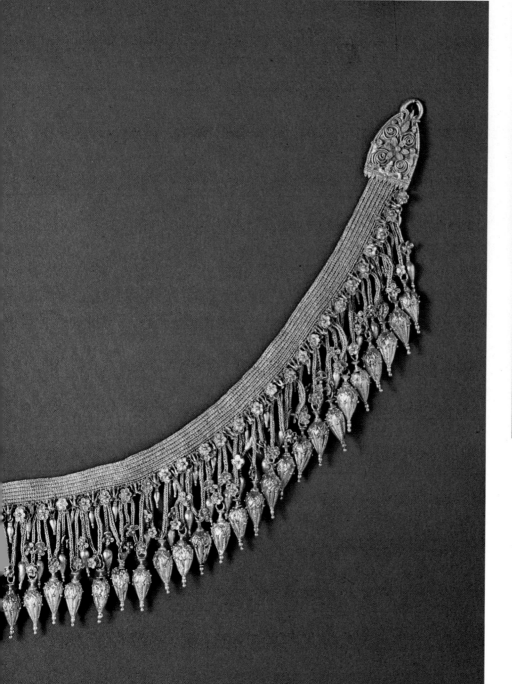

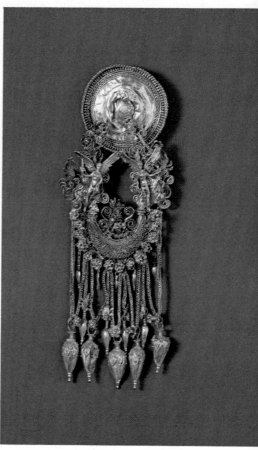

15 Gold earrings and necklace. A complex boat-shaped pendant with extensive granulation forms the heart of this earring of the late fourth century B.C. Plant ornaments and slender Erotes with long wings give this delicate creation a sense of flying restlessness. The necklace also features vegetation minutely rendered in precious metal, a type of enrichment seen on several objects from the Royal Tomb at Vergina. (Catalogue nos. 61, 62)

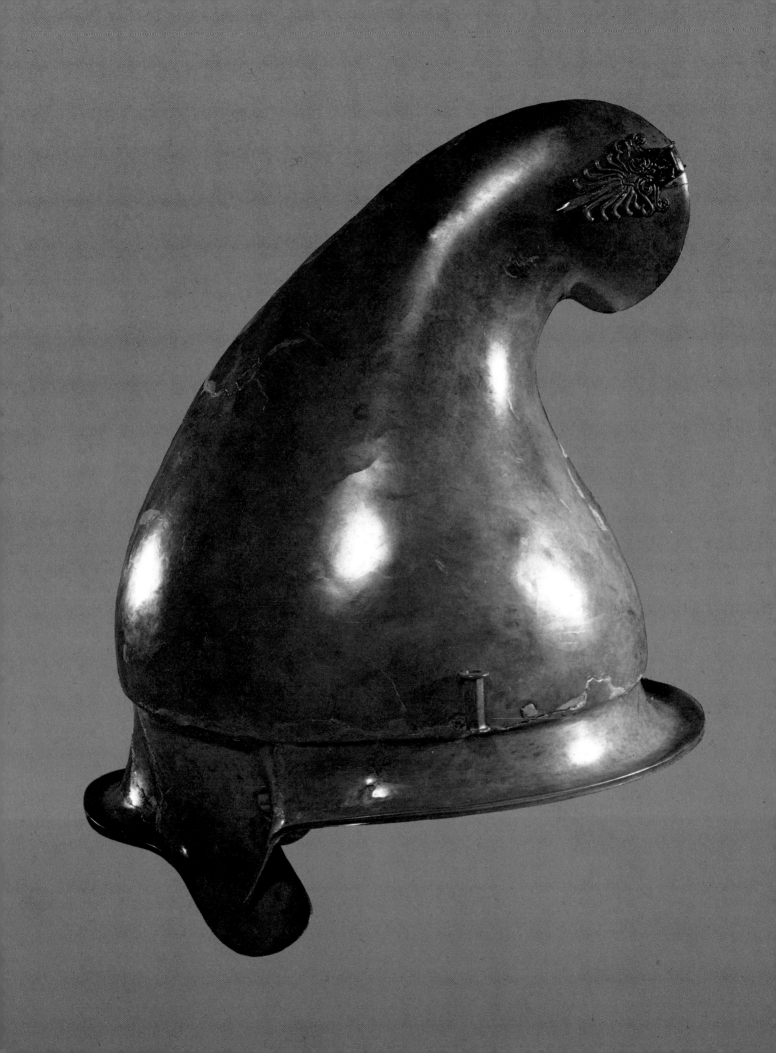

16 The arrowhead, a bronze helmet (*below*) of Chalkidian type from the Hebros River area, and a showy "Phrygian," or Thracian helmet, also in bronze, from Vitsa in Epiros, suggest the diversity of the soldier's missiles and their protection in the worlds of northern Greece. The "Phrygian" helmet opposite, which would have carried a crest in the small spools at temple and peak, marched with Alexander's armies all over the East, and is found in burials or on works of art from the Black Sea to Phoenicia. (Catalogue nos. 103, 104, 105)

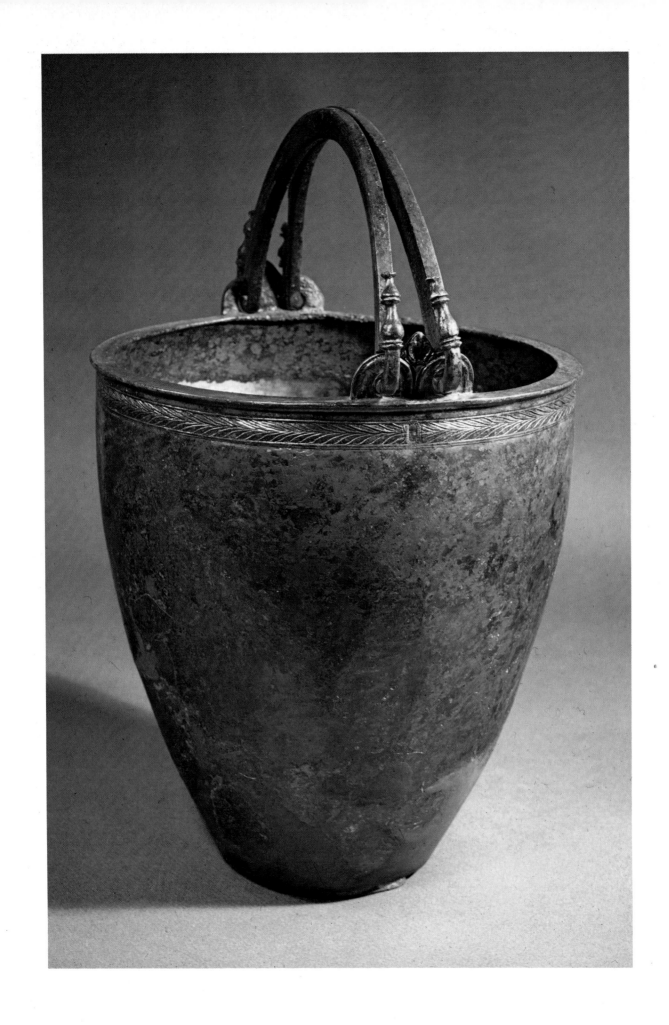

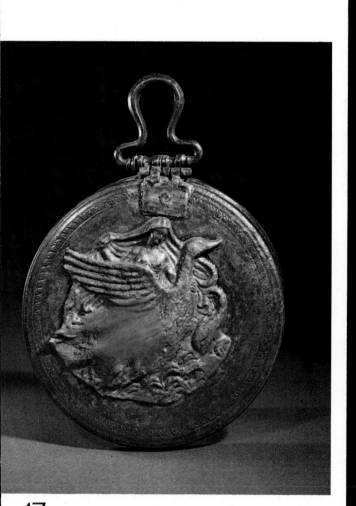

17 The containers and cases or vessels of
Alexander's world represent diversity
of metals (here bronze and silver) and shapes
or uses: the ritual bucket, the mirror and case in
bronze, and the alabastron, or perfume container,
in silver. This last has the rather heavy
figures and crowded designs of work near the
beginning of the end of the Hellenistic age,
or somewhere around 100 B.C. The mirror and
case were found at Larissa in Thessaly,
and the bronze bucket, or situla, was uncovered
in the same tumulus at Arzos in the
Hebros district as the Chalkidian helmet on
Plate 16. (Catalogue nos. 107, 113, 110)

18 A bronze krater from Stavroupoli, Thessalonike, a bronze situla from Nikesiani, and a bronze amphora from Derveni show the florid handles and bulging, smooth bodies of the larger vessels found in tombs. These three containers are of a fourth-century Greek style as fine as anything found from Etruria to Asia Minor in the latter part of the fourth century B.C. A detail of the amphora's figured handle bears this out. (Catalogue nos. 116, 122, 134)

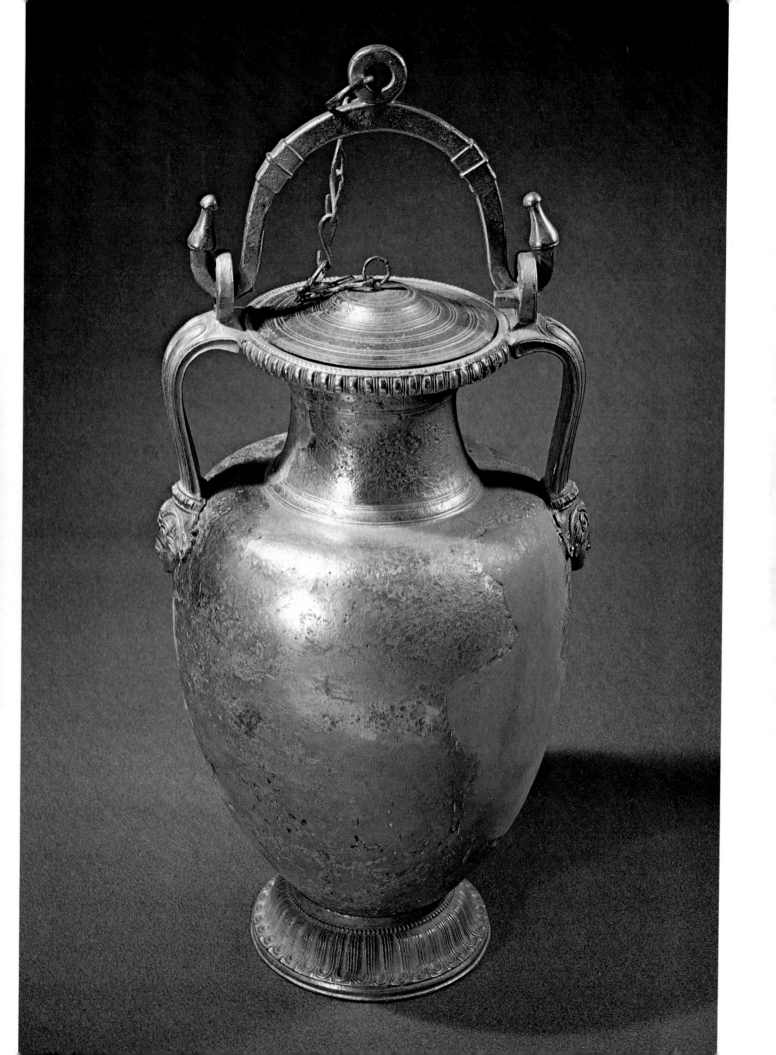

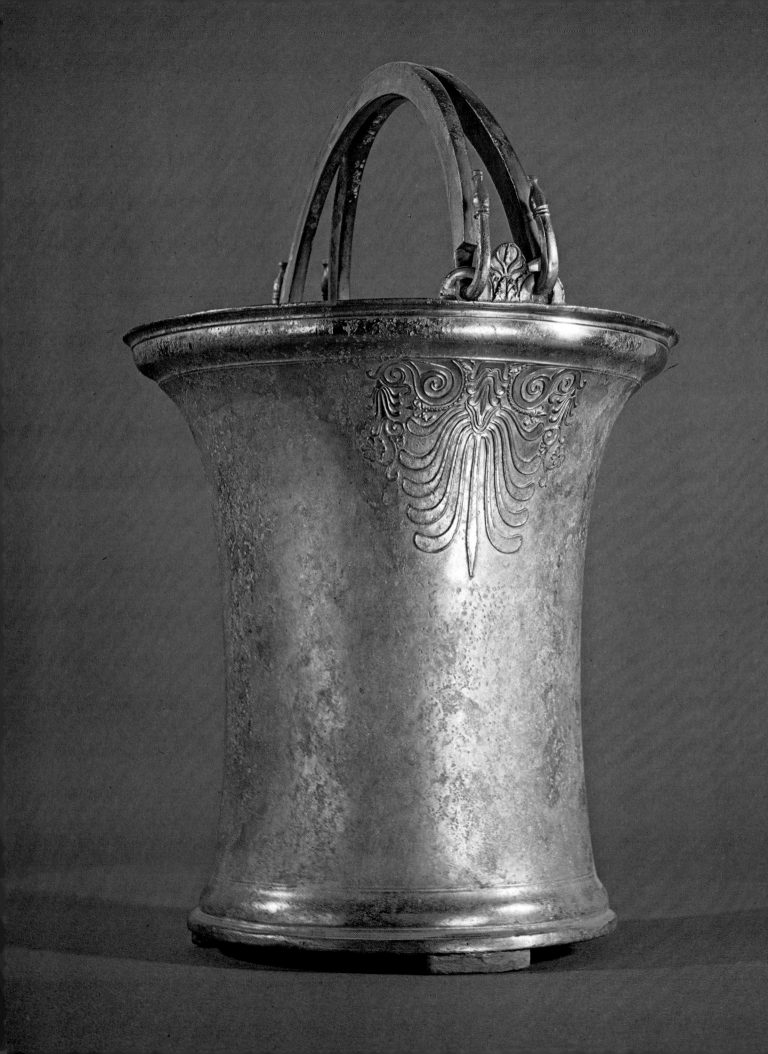

19 These splendid utensils, of differing sizes and shapes, are all from one tomb of the second half of the fourth century B.C., Grave *Beta* at Derveni, near Thessalonike. Opposite, a bronze situla with swinging handles and palmette decoration. At right, a small lekythos (perfume vase), bronze with a golden luster, is shown nearly actual size. The silver askos (*below*) was purely ceremonial, as there is no opening for liquid. A detail of a silver wine strainer shows its handles in the form of duck's or swan's heads. (Catalogue nos. 135, 133, 129, 130)

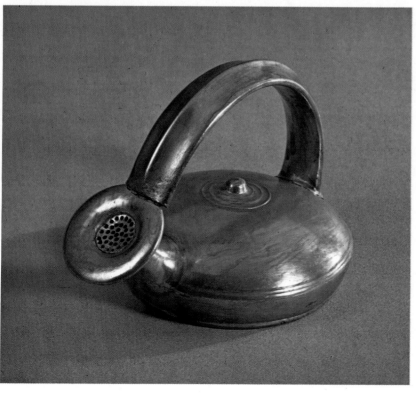

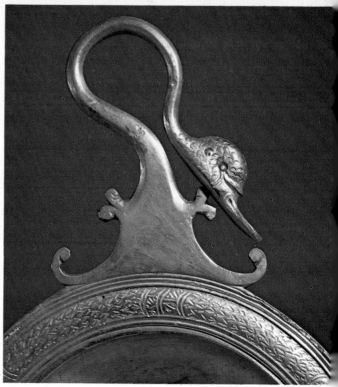

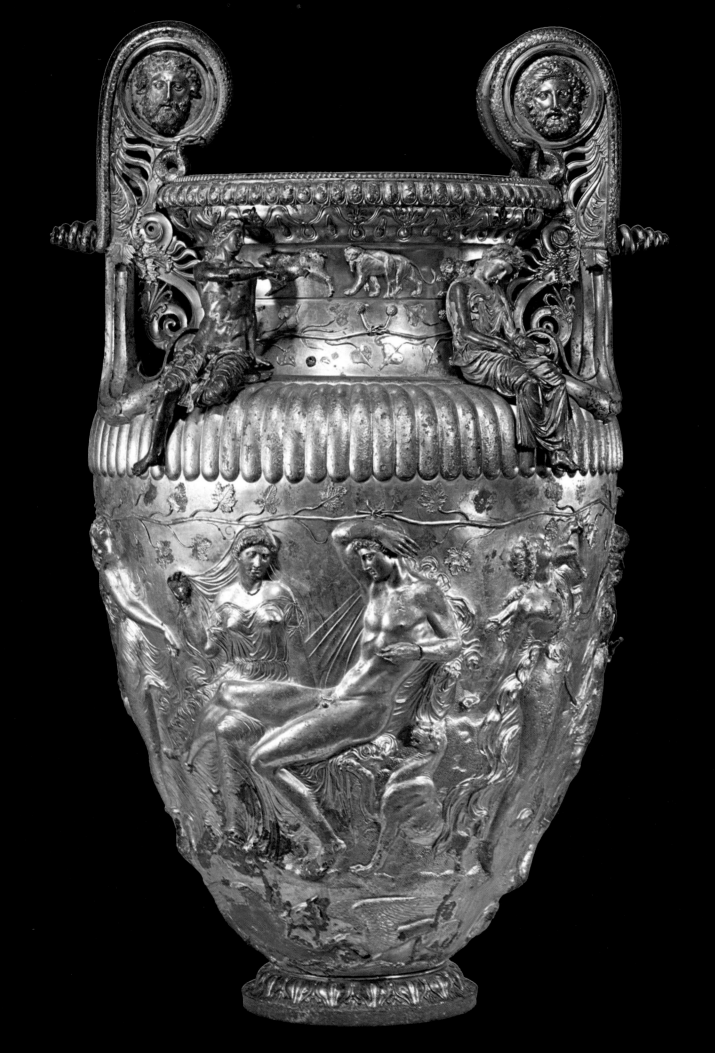

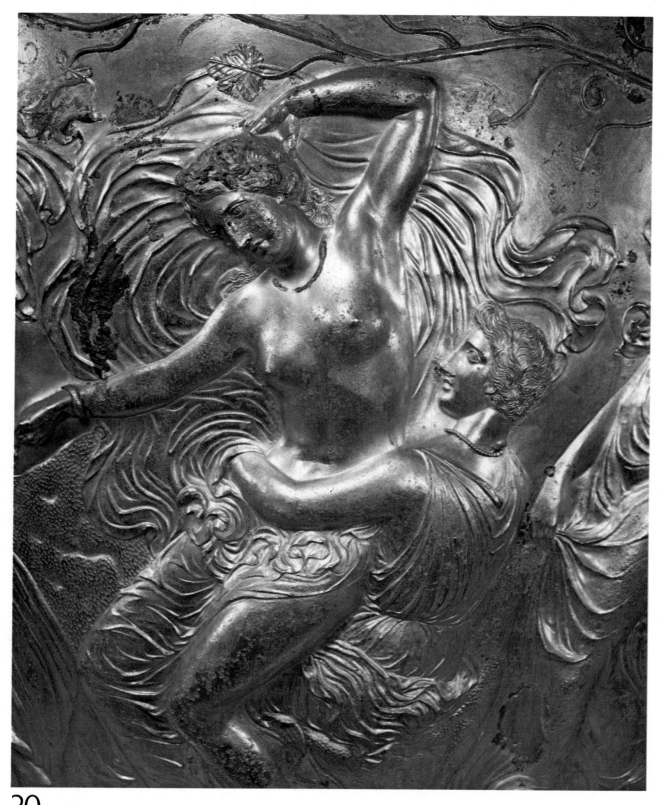

20 A full view and various details present the famous bronze krater from Grave *Beta* at Derveni.
This huge vessel (three feet high) with its riot of Dionysiac figures on the body seems to
have contained the cremated remains of one Astion from Larissa in Thessaly. Dionysos and
Ariadne are represented on the front, and a Dionysiac couple from the back is shown
opposite. The bearded man with a sandal on one foot on the back of the krater (see illustration in
catalogue section) may be Pentheus, or Lycurgus, king of Thrace. (Catalogue no. 127)

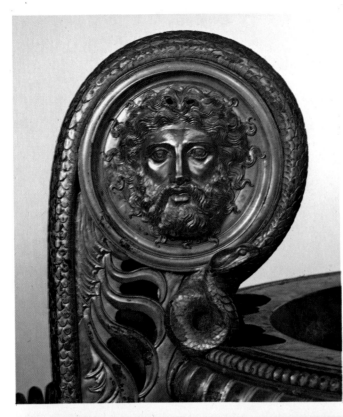

21 Details from the Derveni
krater: the handle decorated
with a mask; and separately cast
figures on the shoulder, a
Silenos and a Maenad in poses
recalling the sculptures
of Michelangelo. (Catalogue
no. 127)

22 Various terra-cotta figurines
and a black-glaze pyxis
from tombs at Pella and Veroia
illustrate the diversity of
divine and human experience in
the Hellenistic age. Aphrodite
in various forms is the subject of
three of these terra-cotta
statuettes; an elegant lady appears
as the fourth. Such statuettes
(these are 11 to 15 inches tall) were
common votive or funerary
offerings. (Catalogue nos. 142, 143,
147, 148)

23 A rich, emotional head of
Medusa appears in relief
on the lid of the pyxis, or jar, from
the East Cemetery, Pella. It
was made in Athens very late in
the ceramic history of that
famous city. (Catalogue no. 146)

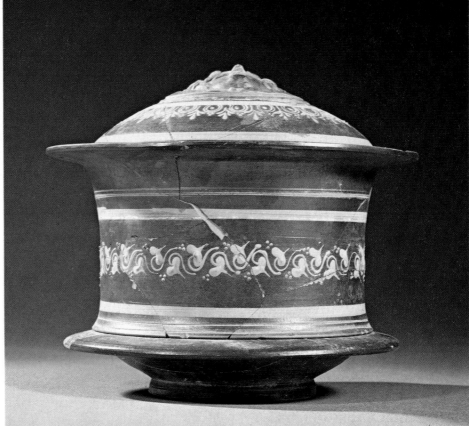

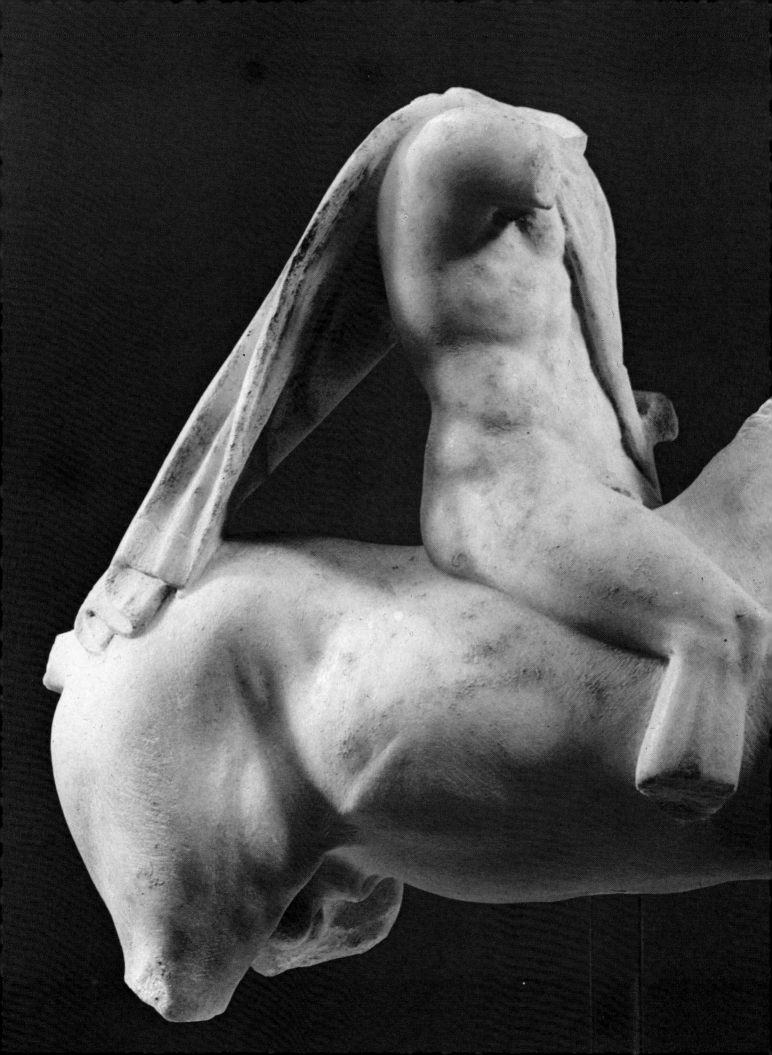

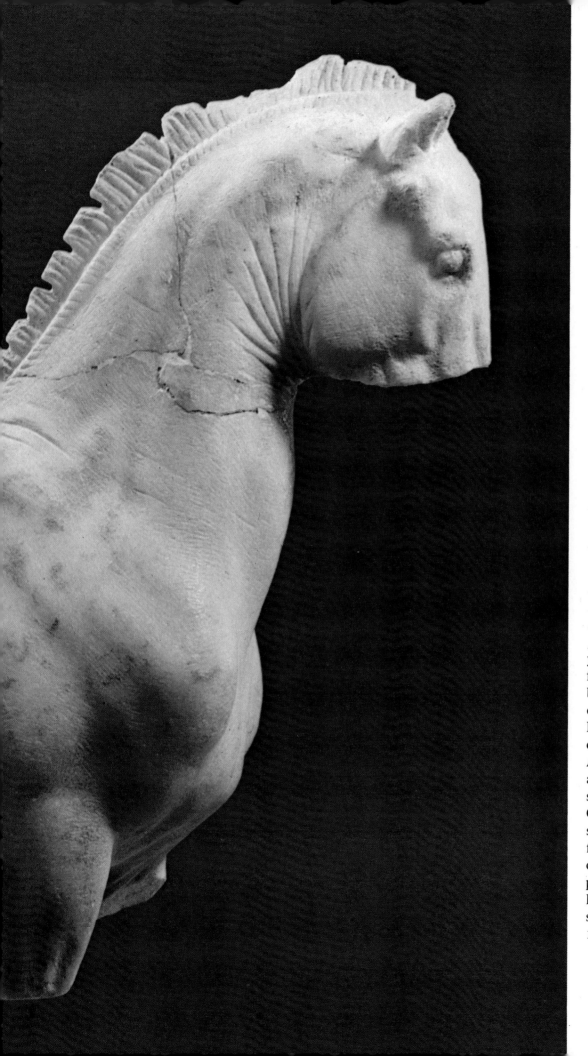

24 A small statue of a youth on horseback comes from Pella and may have been a work of art in one of the houses of the late Hellenistic period or part of a funerary monument. A mythological hero such as Achilles or the semidivine Alexander the Great may have been the subject of this equestrian figure, a young man riding or standing in dignified pose and clad only in a long cloak over the shoulder. (Catalogue no. 152)

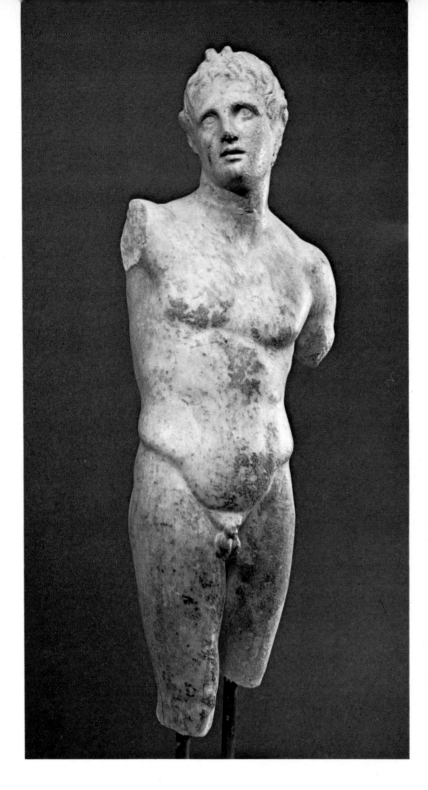

25 Three masterpieces of Hellenistic art from Pella echo images of Alexander the Great and the gods of the Macedonian royal house. The youthful Alexander appears with the horns of Pan on his forehead (*left*), one of the many instances of royal association with a popular divinity. Poseidon, a large bronze statuette (*below*), reflects the statue created by Lysippos for the shrine of the god of the seas near Corinth and shown on the reverses of Macedonian royal coins in the generation after Alexander. The head of Alexander from Pella tells us how the last kings of Macedonia, Philip V and Perseus in the second century B.C., wanted to remember the greatest of their predecessors. Based generally on the fourth-century portraits of Lysippos, this marble incorporates something of the romantic divinity identified with Alexander in Hellenistic times. (Catalogue nos. 153, 154, 155)

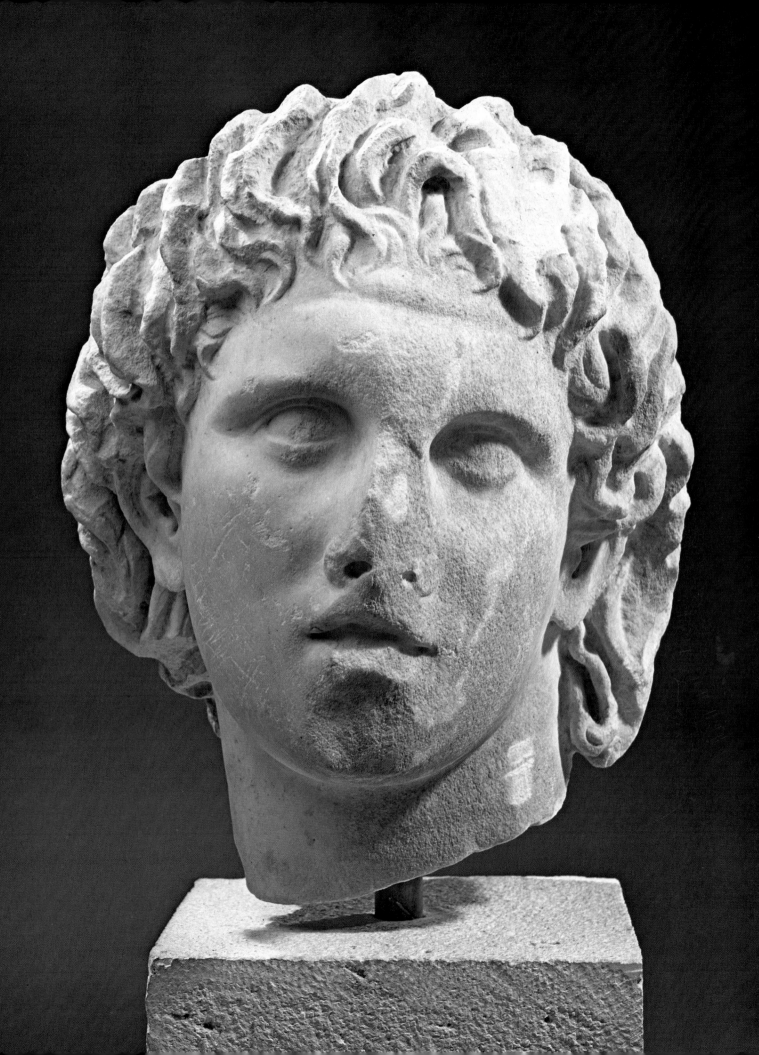

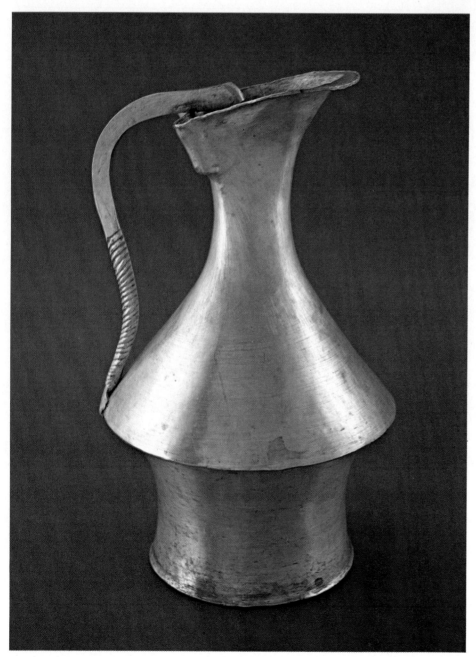

26 Three vases in silver, a situla, or bucket (*opposite*), an oinochoë, or pitcher (*below*), and a miniature kantharos, or drinking cup, come from Tomb III at Vergina. They were created about the third quarter of the fourth century B.C. and are undoubtedly the kind of vessels Philip II and Alexander the Great used for wines and cool mountain waters at state banquets. Such vases were created in precious metals for royalty and high nobility, in gilded bronze for the same folk and for a wider audience, and, finally, in glazed and painted pottery for daily use and from the tombs of lesser mortals. (Catalogue nos. 157, 158, 156)

27 The gilded bronze greaves
from the antechamber of Tomb II
(the Royal Tomb) at Vergina,
and an iron spear head from the
main chamber. Macedonian
superiority at impressive diplomatic
ceremonies or on the battlefield
came in part from the high
quality of the arms and armor
manufactured for Philip II,
Alexander, and the Successors.
(Catalogue nos. 159, 169)

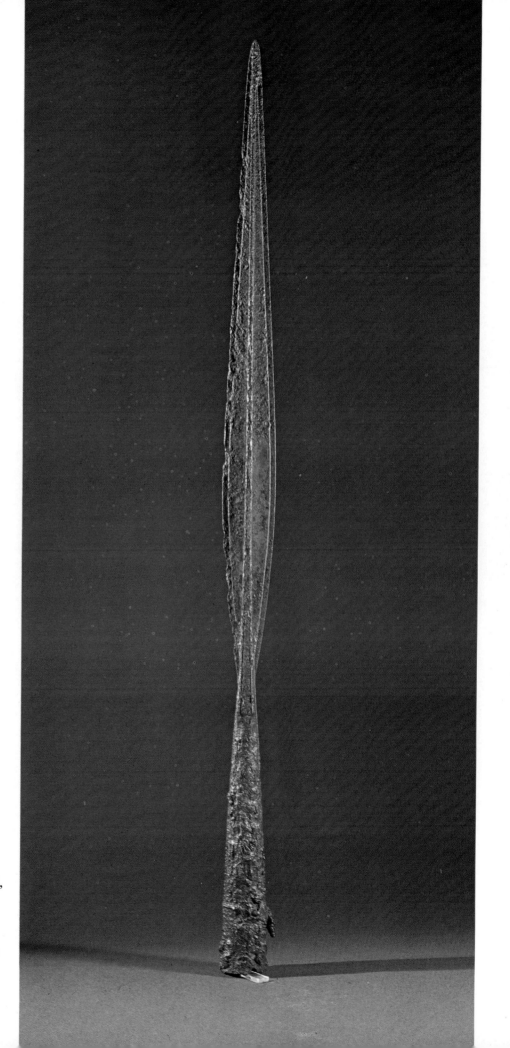

(overleaf)

28 The gilded silver gorytus
(bow-and-arrow case) found in the
antechamber of Tomb II at
Vergina. This object is most unusual,
the equipment of a Scythian, a
Thracian, or a Macedonian
fighter. The scenes in relief
have not yet been identified, but they
might allude to the heroic deeds of a
father and son. (Catalogue no. 160)

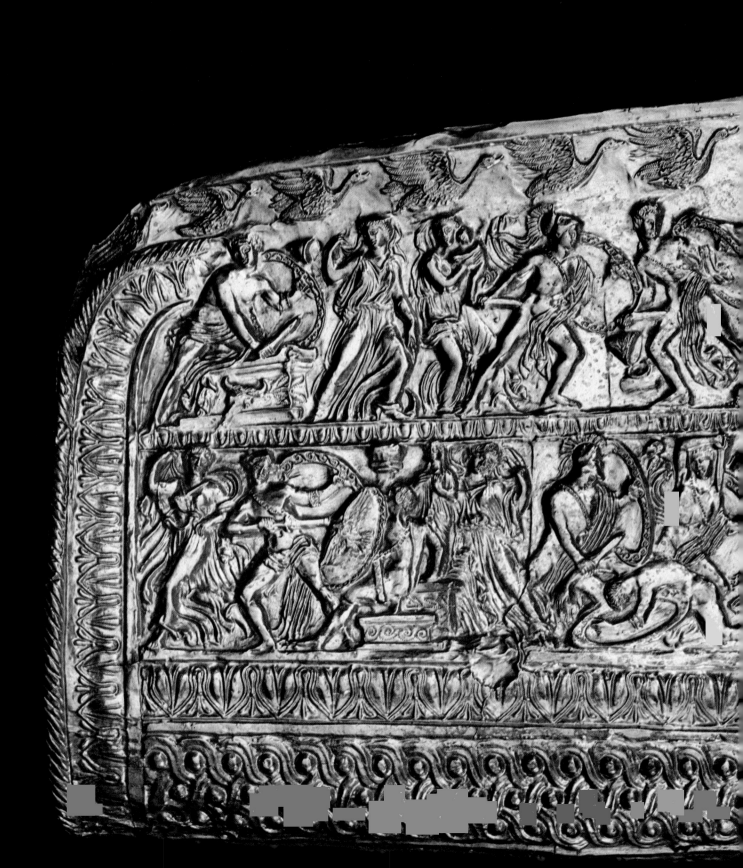

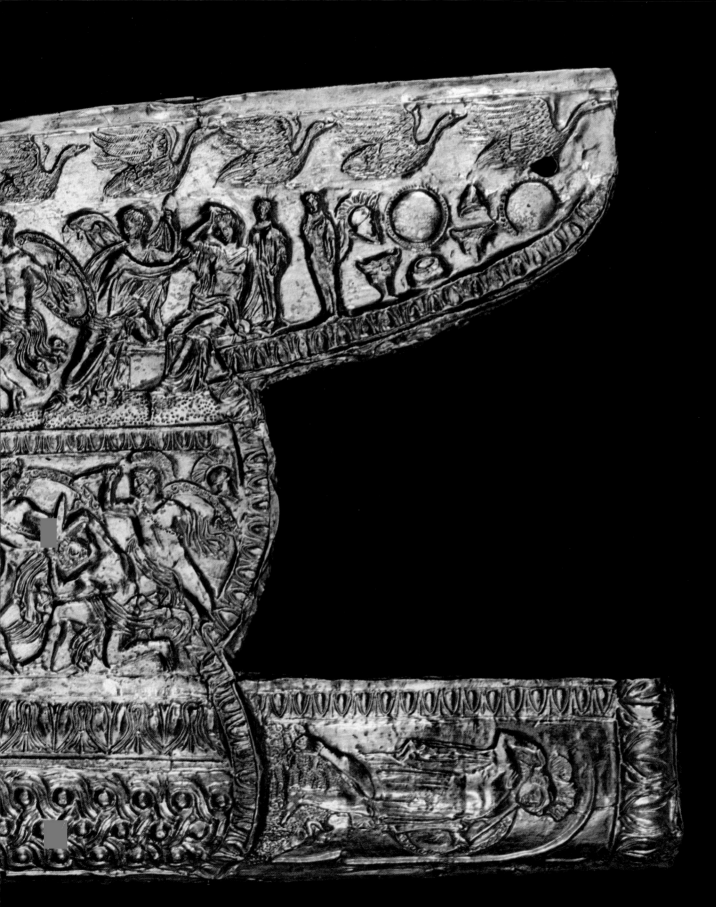

29 The gilded silver diadem from the main chamber of Tomb II at Vergina. The over-life-sized head of Alexander from Upper Egypt (catalogue no. 8) shows that Alexander the Great assumed just such a diadem after he was secure in his conquest of the Persian Empire. (Catalogue no. 162)

30 Three gold discs with the
Macedonian royal star, found in the
antechamber of Tomb II at
Vergina. The Macedonian starburst
became the coat-of-arms of all
later Hellenistic kings, even those
around the Black Sea with
only the slightest connections with
Alexander's followers, down
to the time of Julius Caesar and
Augustus (50 to 30 B.C.) (Catalogue
no. 161)

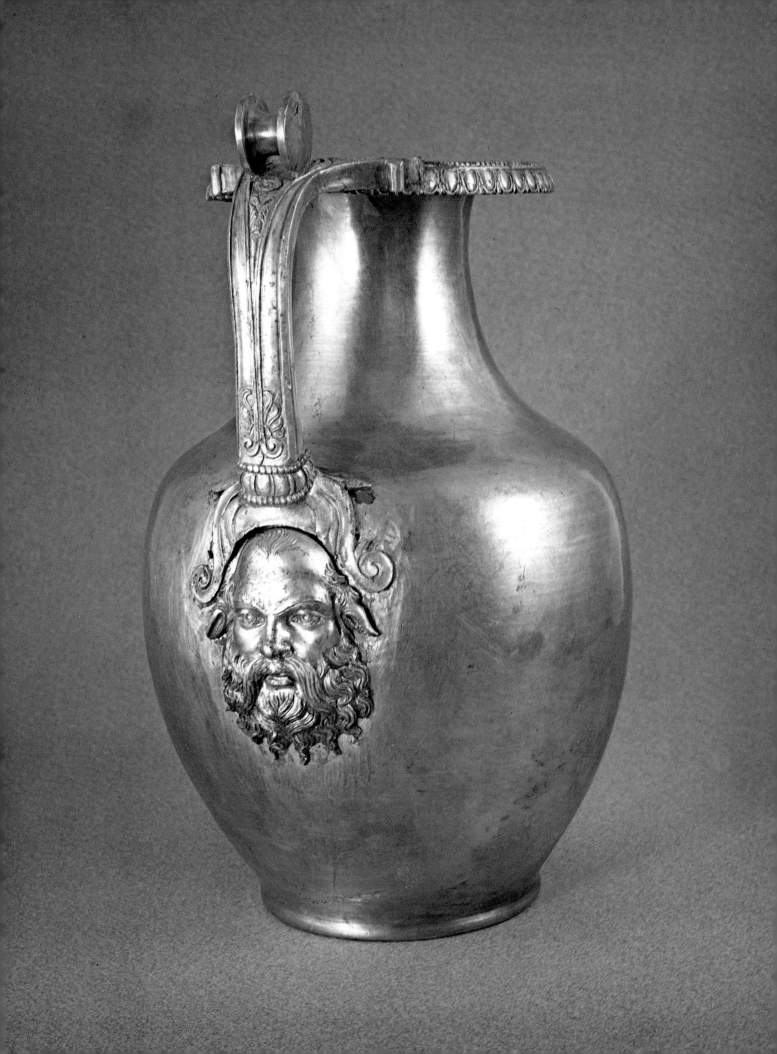

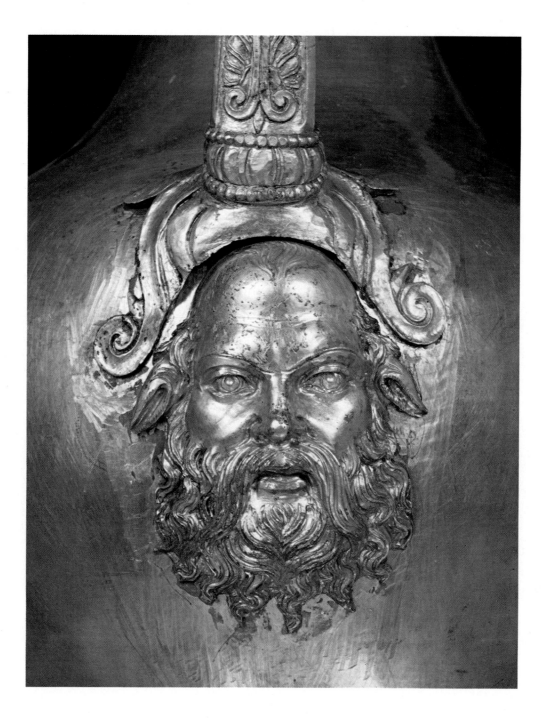

31 Silver oinochoë (jug for wine or water) found
in the main chamber of Tomb II at Vergina.
The head of the old Silenos, mythological follower
of Dionysos, at the base of the handle is
forceful and accomplished, reminding us of the
creatures on the great bronze krater (Plates 20,
21) from Derveni. (Catalogue no. 163)

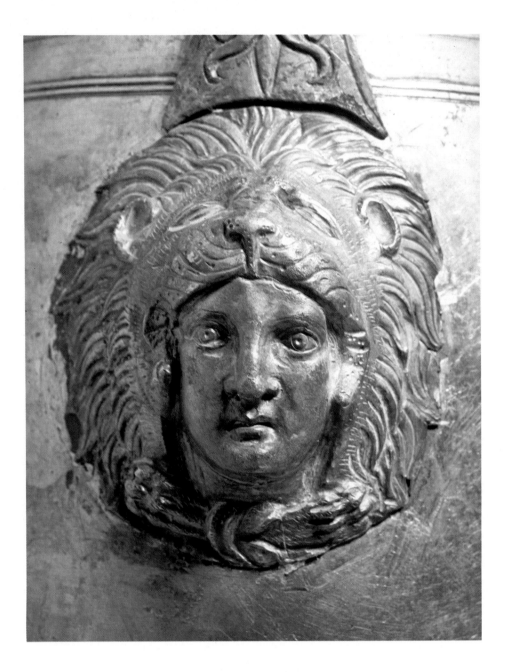

32 Silver alabastron (jar) with lid and chain
from the main chamber of Tomb II at
Vergina. The heads of Herakles in the skin of
the Nemean lion, at the base of each
handle, when viewed in profile, resemble such
likenesses of Alexander the Great at the
height of his career. (Catalogue no. 165)

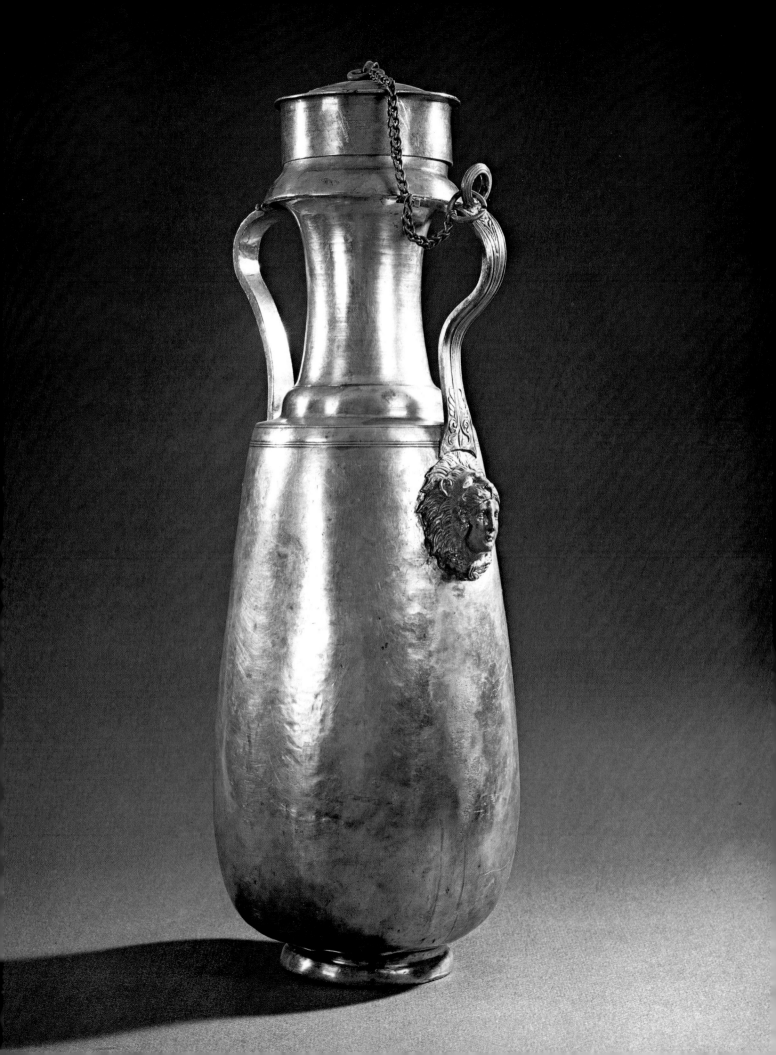

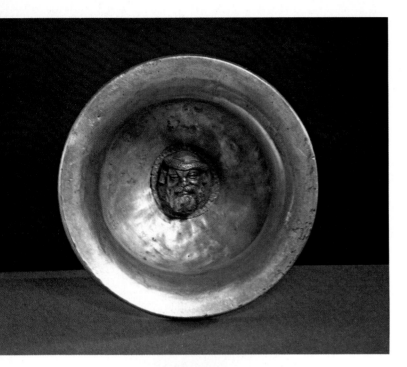

33 Silver drinking bowl with a head of Silenos in the center, from the main chamber of Tomb II at Vergina. The bronze lantern with lid (*opposite,* with detail of Pan, *below*) is also from the main chamber. The light from the clay lamp which was inside would have shown through the perforations. (Catalogue nos. 164, 166)

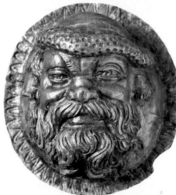

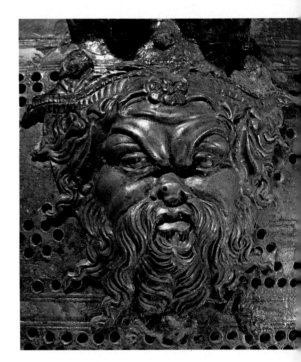

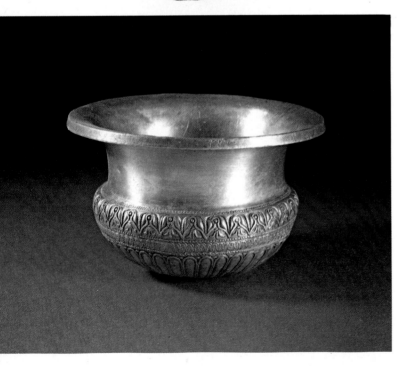

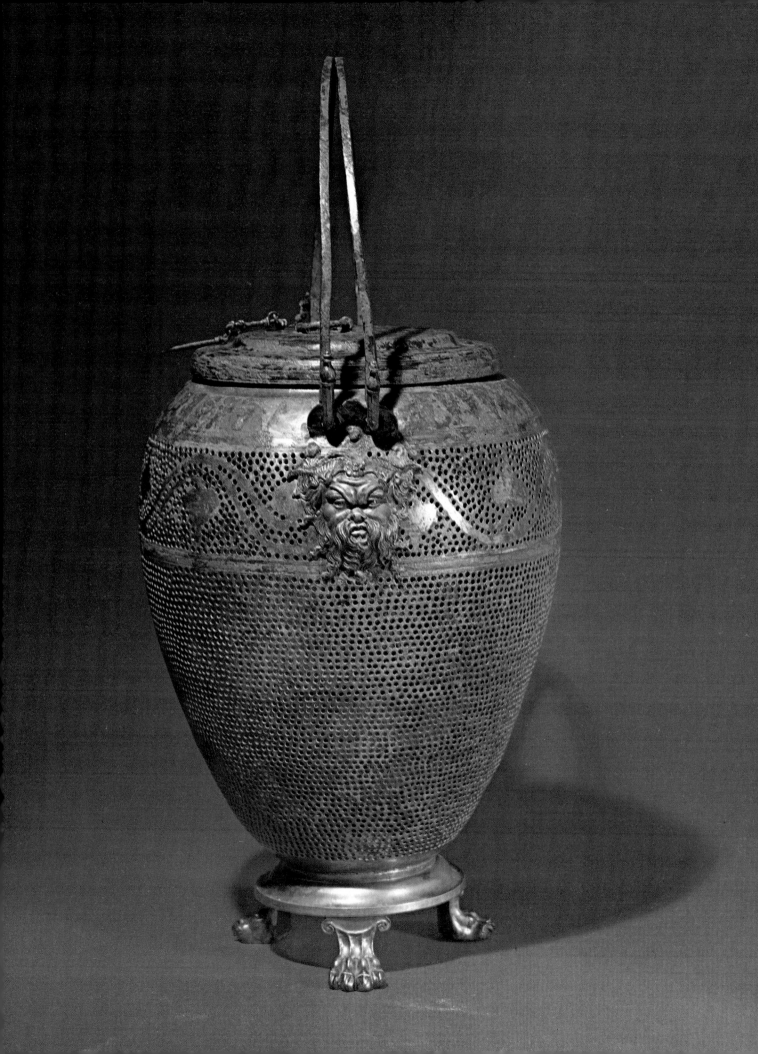

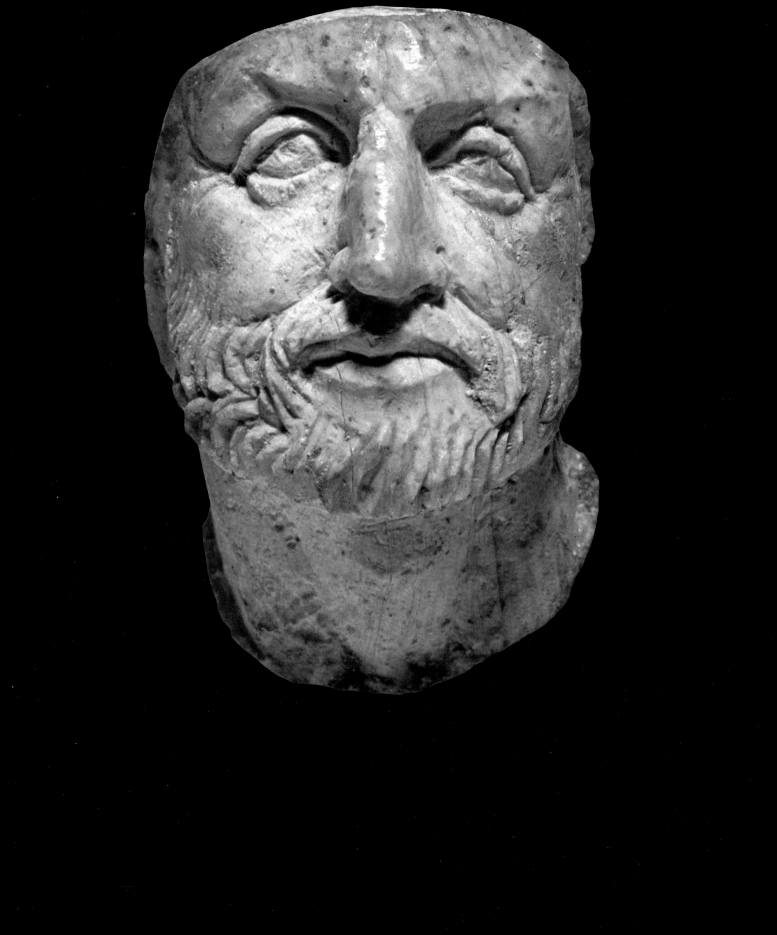

34 Philip II and Alexander the Great, two of the many small ivory heads from the wooden couch or bier in the main chamber of Tomb II at Vergina. These miniature portraits (less than an inch and a half high) are impressive in their combination of incisive detail and overall monumental impact. (Catalogue nos. 170, 171)

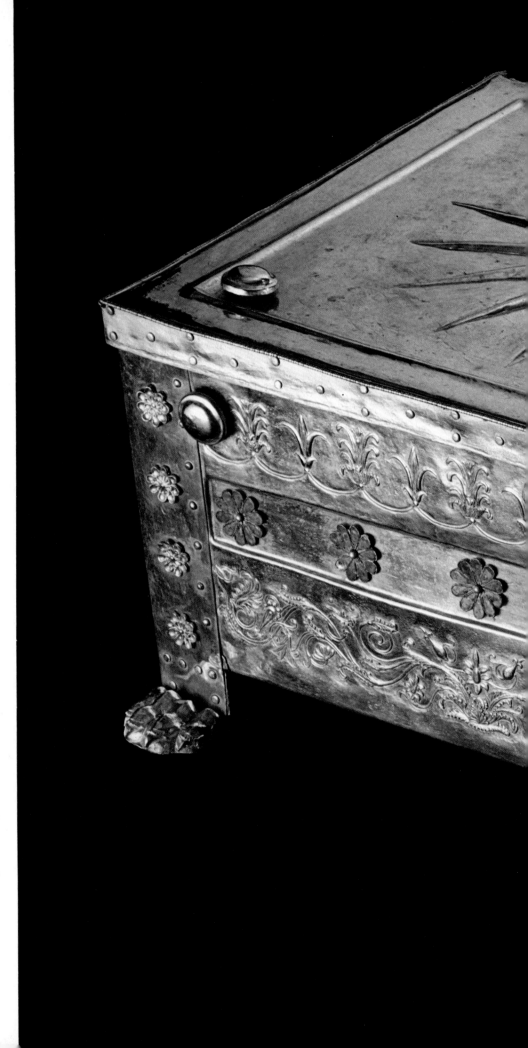

35 The gold chest (larnax)
found in the main
chamber of Tomb II at Vergina.
The Macedonian starburst
has a rosette with petals of blue
glass in its center, and
similar rosettes appear in the
central band on the front.
The gold wreath with oak leaves
and acorns (Plate 36) was
found inside this chest, as were
the cremated bones of a man
in early middle age.
(Catalogue no. 172)

(*overleaf*)

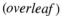

36 The large gold wreath
of oak leaves and acorns
(*overleaf*) found inside the
golden chest in the main chamber
of Tomb II at Vergina.
Overwhelming in its richness
and faithfulness to minute detail,
the oak-leaf wreath speaks of
connections with Zeus.
A wreath of this kind must
surely have been worn by Philip
II, whose admiration for Zeus
is evident from his coinage.
(Catalogue no. 173)

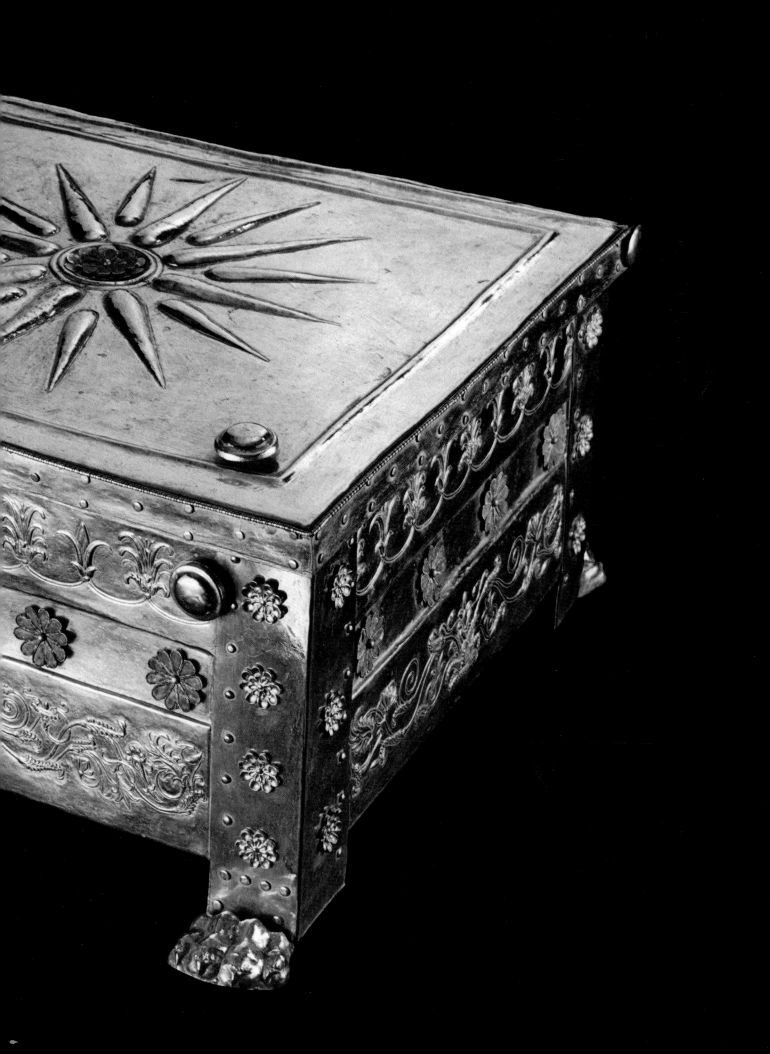

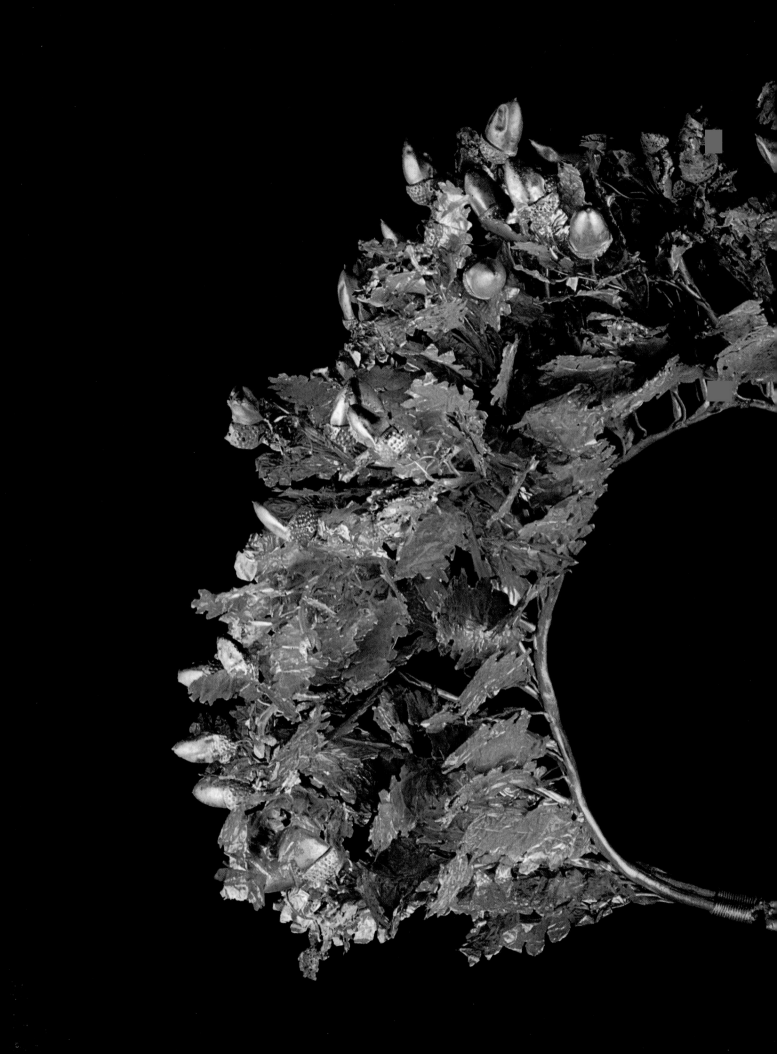

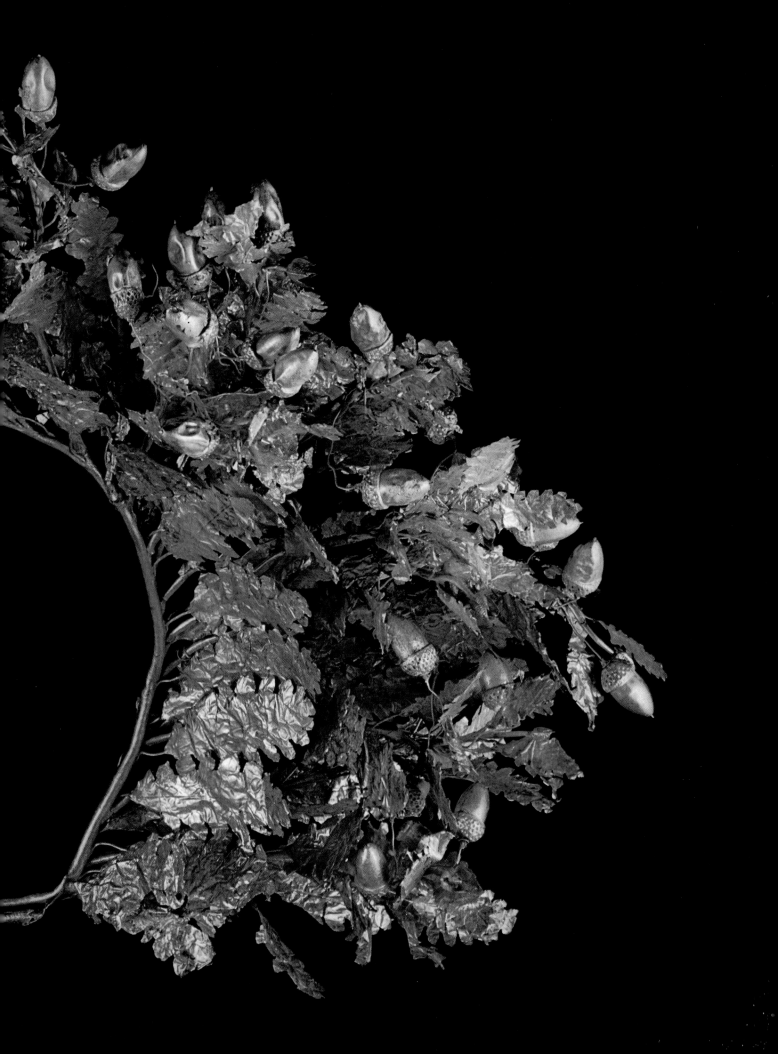

THE CATALOGUE

Entries for loans from Greece

General Editor:

KATERINA RHOMIOPOULOU
DIRECTOR
Archaeological Museum of Thessalonike

Entries for loans from Europe and the United States

General Editors:

ARIEL HERRMANN
FELLOW FOR RESEARCH

CORNELIUS VERMEULE
CURATOR
Department of Classical Art, Museum of Fine Arts, Boston

CONTRIBUTORS TO THE CATALOGUE

Entries for loans from Greece

H. Chrysanthaki, Ephor of Antiquities of Eastern Macedonia and Curator, Kavalla Museum: 88, 89, 90, 118, 120, 121, 122, 123, 135

Olga Gratziou, Assistant Curator, Ministry of Culture: Related works, pages 190–191, A–D

G. Kokkorou-Alevras, Assistant Curator, Ministry of Culture: 4, 7, 48, 50, 145

Chrysa Paliadeli, University of Thessalonike, Assistant to Professor Andronikos at Vergina excavations: 156, 157, 158, 159, 160, 161, 162, 163, 164, 165, 166, 167, 168, 169, 170, 171, 172, 173

Katerina Rhomiopoulou, Director, Archaeological Museum of Thessalonike: 47, 49, 50, 51, 52, 55, 60, 67, 68, 100, 101, 102, 103, 104, 109, 110, 111, 112, 113, 114, 115, 127, 128, 129, 130, 131, 132, 136, 137, 138, 139, 145

M. Siganidou, Ephor of Antiquities of Western Macedonia and Curator, Pella Museum: 116, 117, 124, 125, 126, 133, 134, 136, 140, 141, 142, 143, 144, 146, 147, 148, 149, 150, 151, 152, 153, 154, 155

D. Triantafyllos, Curator, Komotini Museum: 59, 105, 106, 107, 108, 119

Entries for loans from Europe and the United States

Miriam G. Braverman, Research Assistant, Department of Classical Art, Museum of Fine Arts, Boston: 15

Ariel Herrmann, Fellow for Research, Department of Classical Art, Museum of Fine Arts Boston: 2, 3, 5, 8, 12, 14, 39, 41, 42, 44, 45, 46, 53, 54, 56, 57, 58, 61, 62, 63, 64, 65, 66, 69, 70, 71, 72, 73, 74, 75, 76, 77, 78, 79, 80, 81, 82, 83, 84, 85, 86, 87, 91, 92, 93, 94, 95–8, 99

Flemming Johansen, Director, Ny Carlsberg Glyptotek, Copenhagen: 1

Cornelius Vermeule, Curator, Department of Classical Art, Museum of Fine Arts, Boston: 6, 9, 10, 11, 13, 16, 17, 18, 19, 20, 21, 22, 23, 24, 25, 26, 27, 28, 29, 30, 31, 32, 33, 34, 35, 36, 37, 38, 40, 43

Also Greek loans 50A, 72A, 79A

Research and coordination for loans from Europe and the United States:

Kristin Anderson, Department Assistant;
Mary B. Comstock, Associate Curator and Keeper of Coins;
John J. Herrmann, Jr., Assistant Curator;
Florence Z. Wolsky, Research Assistant;
Emily T. Vermeule, Fellow for Research;
Department of Classical Art, Museum of Fine Arts, Boston

Color Captions:

Cornelius Vermeule

SHORT TITLE LIST

AA Archäologischer Anzeiger

AAA Athens Annals of Archaeology

ActaA Acta Archaeologica, Copenhagen

AE Archaiologiki Ephimeris (in Greek)

AJA American Journal of Archaeology

AK Antike Kunst

AM Mitteilungen des Deutschen Archäologischen Instituts, Athenische Abteilung

BCH Bulletin de Correspondance hellénique

Bronzes in Yugoslavia Antička bronza u Jugoslaviji. English title: *Greek, Roman, and Early Christian Bronzes in Yugoslavia* (Belgrade, 1969)

Catalogue of the Jewellery . . . British Museum F. Marshall, *Catalogue of the Jewellery, Greek, Etruscan and Roman, etc* (London, 1911)

Chase-Vermeule G. Chase & C. Vermeule, *Greek, Etruscan & Roman Art. The Classical Collections of the Museum of Fine Arts, Boston* (Boston, 1963)

Comstock-Vermeule, *Greek Coins* M. Comstock & C. Vermeule, *Greek Coins, 1950–1963, Museum of Fine Arts, Boston* (Boston, 1964)

Comstock-Vermeule, *Greek . . . Bronzes* M. Comstock & C. Vermeule, *Greek, Etruscan & Roman Bronzes in the Museum of Fine Arts, Boston* (Boston, 1971)

Deltion Archaiologikon Deltion (in Greek)

Greek Gold H. Hoffmann & P. F. Davidson, *Greek Gold: Jewelry from the Age of Alexander* (Mainz, 1965)

Greifenhagen, *Schmuckarbeiten* A. Greifenhagen, *Schmuckarbeiten in Edelmetall* (Berlin, 1975)

Hamburger Beiträge Hamburger Beiträge zur Archäologie

JdI Jahrbuch des deutschen archäologischen Instituts

JHS Journal of Hellenic Studies

Oreficerie antiche G. Becatti, *Oreficerie antiche dalle minoiche alle barbariche* (Roma, 1955)

Praktika Praktika tes Archaiologikis Etaireias (in Greek)

RM Mitteilungen des Deutschen Archäologischen Instituts, Römische Abteilung

TAM Treasures of Ancient Macedonia, published by the Greek Ministry of Culture and Sciences (catalogue of the exhibition at the Archaeological Museum of Thessalonike which opened in August, 1978) (Athens, 1979)

1

1

PHILIP II

Height .34m. (13⅜ in.)
Greek marble. Herm
Ny Carlsberg Glyptotek, Copenhagen. Acquired 1909 from Rome
Said to have been found in Rome

Head and neck are unbroken on the fragmentary shoulders. The nose is broken off, and there are small injuries to lips, right ear, and frontal hair. In the top of the head is a hole, .085m. long and broad, .04m. deep, for securing an attribute, maybe a modius, symbol of fertility.

The stern face with lined forehead has a short beard. In the hair is a diadem.

The head is a Roman copy from a Greek original from 350–325 B.C. In 1950 Vagn Poulsen gave the name of Philip II to the head, formerly called "Barbarian prince of the Hellenistic period." The ancient authors tell us that Philip II was blind in the right eye, and we also know he had a beard. Several statues of Philip in Athens and Olympia are recorded by Pausanias, Pliny, and Arrian.

The lifted eyebrows, the mouth and the shape of the beard show strong resemblances to the ivory head of Philip II (catalogue no. 170).

Frederik Poulsen, *Catalogue of Ancient Sculpture in the Ny Carlsberg Glyptotek,* 1951, no. 450a; Vagn Poulsen, *Kunstmuseets Aarsskrift,* XXXVII, 1950, p. 49; idem, *Les Portraits grecs,* 1954, no. 18, pl. xv; G. M. A. Richter, *The Portraits of the Greeks* (1965), vol. 3, p. 253, fig. 1708; H. von Heintze, *RM* 68 (1961): 182ff.; V. von Graeve, *AA* (1973), pp. 244ff.; *Et nyt gravfund i Makedonien,* I. 11.1978–30.I.1979, Ny Carlsberg Glyptotek, fig. 21.

2

HEAD OF ALEXANDER THE GREAT

Height .37m. (14½ in.)
Marble
Erkinger Schwarzenberg collection, Vienna
Said to be from Tivoli

Alexander turns his head slightly to his right. His hair, almost straight, streams back in irregular, windblown locks. The head is cut off close to the base of the neck, as though for the high, round neckline of an armored statue or possibly one with a chlamys pinned around the neck. The portrait could also have been set into a herm, but after the mid first century A.D. herm heads were almost always worked in one piece with the whole upper part of the shaft, rather than inserted as they sometimes were earlier. The nose, pieced in antiquity, is missing. Though the tight, sober treatment of the face suggests Julio-Claudian work, the facile way the hair is undercut for deep and effective shadowing seems to place the copyist's technique in the early second century A.D.

The Schwarzenberg head differs from both the exaggerated late representations of Alexander and the fleshy-faced, barely individualized ones made close to his lifetime. There

2

3

are some links with works thought to copy originals by Lysippos. The lean cheeks, the clear-eyed gaze recall the much more conventional Azara herm (catalogue no. 3); the pointed, quill-like locks of hair with their asymmetrical movement, the forehead, rather flat for this time, and the short-chinned but bony, square-jawed structure of the face are unusual and have affinities with the Vatican Apoxyomenos. Above all, the innovative and convincing image makes attribution of the original to a famous artist tempting. Ancient writers believed that "Alexander gave to Lysippos the sole authorization for making all his statues, because he alone expressed in bronze his character (ethos), and in his features represented the brilliance of his virtues, while others, who sought to imitate the turning of his neck and the liquid softness and brightness of his eyes, were unable to preserve the manliness and lion-like fierceness of his countenance" (Plutarch, *De Alexandri Magni Fortuna aut Virtute*). While the completeness of this ban on other sculptors is probably exaggerated, one can at least conclude that Lysippos, the last in the line of great Classical sculptors of athletic statues, was the preferred artist. His work would have been in no sense a literal record. Lysippos

cannot have followed Alexander on the distant campaigns that occupied most of his reign — especially not with the cumbersome tools of the sculptor's trade — though it is possible that Lysippos was among the Greek artists Alexander summoned to Ecbatana. In any case, Alexander's real appearance would have been only the point of departure for the creation of an ideal type. Even as interpreted by a later copyist, the portrait expresses, brilliantly, what the artist of the original knew and felt about Alexander.

Roman copy, probably of the early second century A.D., after an original of the late fourth century B.C.

E. Schwarzenberg, *Bonner Jahrbücher* 167 (1967): 86–92; T. Hölscher, *Ideal und Wirklichkeit in den Bildnissen Alexanders d. Gr.* (1971), pp. 9ff.; E. Berger, *AK* 14 (1971): 142; E. Schwarzenberg in *Alexandre le Grand,* Fondation Hardt, Entretiens 22 (1975): 223–278; E. Paribeni, *L'arte dell'antichità classica* I (1976): no. 496; K. Vierneisel & P. Zanker, *Die Bildnisse des Augustus* (1978), no. 7.1.

3

MARBLE HERM PORTRAIT OF ALEXANDER THE GREAT

Height .68m (26¾ in.)
Musée du Louvre, Paris, no. MA 436
From Tivoli

The herm is inscribed "Ἀλέξανδρος | Φιλίππου | Μακε[δων]" (Alexander son of Philip, the Macedonian). Alexander has an oblong face with steady, narrowed eyes. His hair, springing back from the forehead in the characteristic *anastole,* frames the face in midlength, irregularly curling locks. Smooth on top, the coiffure has no diadem, though it is indented as if to accommodate one. The whole surface is much eroded, with possibly some retouching of details. Nose, lips, parts of the brows and the lock of hair above the left eyebrow are restored in plaster.

The piece, found by the eighteenth-century Spanish ambassador José Nicolás Azara and later presented to Napoleon, has long been the basis for identification of Alexander portraits because it is inscribed. There is another replica, with closely corresponding hair arrangement though with the whole face restored, in the Louvre, and a third was identified by Lippold in the Palazzo del Drago at Rome. A weak version in the British Museum is perhaps not ancient. The very banality and correctness of the Azara piece and

its replicas suggest that they reproduce a canonical work, one accessible in the original or through plaster casts to the copyists' ateliers working for Roman patrons. This is quite likely to have been a statue by Alexander's court sculptor, Lysippos. Such special qualities as shine through the listless workmanship and eroded surface of the Azara portrait support the attribution; one can find something serious and unstylized about the square-jawed, flat-cheeked face, the hesitantly elaborated hair arrangement.

Roman copy of the second century A.D., probably after an original of the late fourth century B.C.

Louvre, *Catalogue sommaire* (1922), no. 436, p. 25; F. P. Johnson, *Lysippos* (1927), pp. 213ff.; L. Laurenzi, *Ritratti greci* (1941), no. 38; M. Bieber, *Alexander the Great in Greek and Roman Art* (1964), pp. 32ff., fig. 14; G. M. A. Richter, *The Portraits of the Greeks* (1965), vol. 3, p. 255, figs. 1733–1735 for Azara replica, figs. 1730–1732 for second Louvre example, MA 234; E. Schwarzenberg, "The Portraiture of Alexander," in *Alexandre le Grand,* Fondation Hardt, Entretiens 22 (1975): 254 for an up-to-date review of the problem.

4

ALEXANDER THE GREAT

Height .28m. (11 in.)
Pentelic marble
National Museum, Athens, no. 366
Found in the Kerameikos in 1875

Missing: back of head and neck, nose. Breaks at the mouth, brows, and right eye. Surface fairly well preserved. The incised letters OA on the cheeks and below the eyes and the unintelligible incisions on the lower right of the lion skin are later additions. Beneath the lion skin, curling hair at the temples.

The slight turn of the head to the left, the bulging forehead with the deep horizontal crease, the parted lips, the look of intensity in the deep-set eyes are hallmarks of portraits of Alexander the Great. The lion skin. known from representations of the Macedonian king on coins, links him with his mythical ancestor, Herakles. Alexander the Great wears the lion skin on the so-called Alexander Sarcophagus and also in other portraits, such as catalogue no. 5.

A good work, probably of the early third century B.C.

M. Bieber, *Alexander the Great in Greek and Roman Art* (1964), p. 52, fig. 37; S. Karouzou, *National Archaeological Museum, Collection of Sculpture,* Athens (1968), p. 171, no. 366.

5 (*Color plate 1*)

HEAD OF ALEXANDER-HERAKLES

Height .24m. (9½ in.)
Marble
Museum of Fine Arts, Boston, no. 52.1741. From the J. Hazard and D. H. Reese collections. Otis Norcross Fund
Said to have been found at Sparta

The piece is split off as a masklike fragment. It would have belonged to a complete statue, probably standing and nude except for the lion skin.

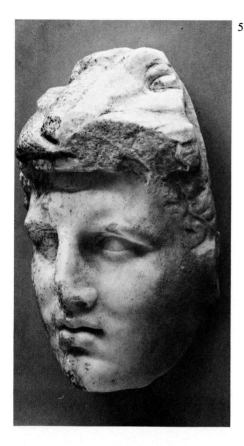

5

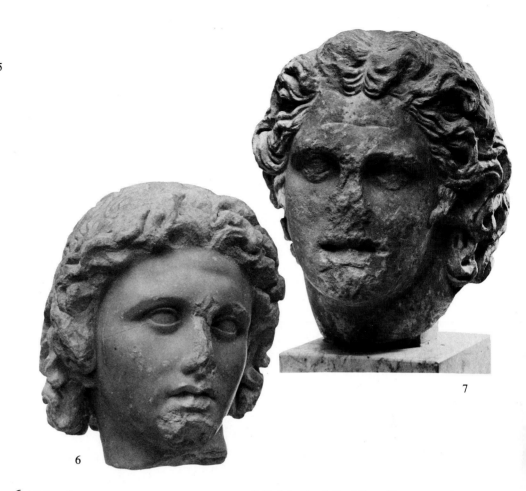

7

6

Gentle, self-assured workmanship shows that the piece is an original of the late fourth century B.C. The likeness is a conservative one, honoring the young conqueror by lending his features to a demigod. The rather long oval face, the narrow, deepset eyes are Alexander's, quite different from the broad countenance and the rounded eyes, beaming with energy or wide with fatigue and pathos, that always characterize Herakles. The lion-skin headdress, an archaic attribute unusual by now in representations of the real Herakles, is adopted by Alexander in the Macedonian portrait coins struck during his lifetime, as well as in the battle scene of the Alexander Sarcophagus and in two apparently early portrait heads from Athens (catalogue no. 4 and Acropolis Museum). The fleshy but virile features, and the deemphasis of the hair agree with the Alexander Mosaic from Pompeii and other relatively realistic representations whose originals were created close to Alexander's lifetime.

Probably late fourth century B.C.

L. D. Caskey, *Bulletin of the Museum of Fine Arts* 8 (1910): 25–28; E. Sjöqvist, *Bulletin of the Museum of Fine Arts* 51 (1953): 30–33 on the identification; M. Bieber, *Alexander the Great in Greek and Roman Art* (1964), p. 52, figs. 39 A–B; M. Comstock & C. Vermeule, *Sculpture in Stone* (1976), no. 127, with full citation of earlier literature. *See* M. Bieber, *op. cit.*, fig. 38 for the head in the Acropolis Museum, found in the Ilissos.

6 (*Color plate 2*)

ALEXANDER THE GREAT

Height .28m. (11 in.)
Greek marble (Pentelic)
The J. Paul Getty Museum, Malibu, no. 73.AA.27
From a commemorative or funerary monument in the eastern Mediterranean

The likeness does not correspond with those fashioned by the court sculptor Lysippos but, rather, seems to be a creation of the decade following Alexander's death. The style of the sculpture is that of Athenian funerary portraiture during the lifetime of Alexander.

This head of Alexander and the related head of his heroic companion Hephaistion (catalogue no. 13) were evidently part of a large monument most likely constructed for commemorative purposes, although the donor may have associated his own tomb with the dedication. Statues of the Macedonian conquerors were flanked by a young female (a princess as Tyche, or goddess of good fortune), a flutist, and animals and birds. The relief to "Hero Hephaistion" in Thessalonike gives an abbreviated, two-dimensional idea of how the monument appeared.

J. Frel, in *The J. Paul Getty Museum*, section titled "Greek and Roman Antiquities" (1975), pp. 26–27; idem, in *Guidebook, The J. Paul Getty Museum* (1976), pp. 47–48; (1978), pp. 29–30; idem, *Antiquities in the J. Paul Getty Museum, A Checklist, Sculpture*, I. *Greek Originals*, p. 7, nos. 20, 21; C. Vermeule, *Greek Art: Socrates to Sulla* (1980), p. 59, fig. 71.

7 (*Color plate 3*)

ALEXANDER THE GREAT

Height .35m. (13¾ in.)
Marble
Archaeological Museum of Olympia, no. *Lambda* 245 (BE 99)
Found at Volantsa

Head and part of neck preserved. Missing: nose, part of the hair above the forehead, and small pieces of the hair at sides and back. Breaks at the eyes, mouth, and chin.

The thick wavy hair is fairly long, suggesting the leonine quality of the subject. The way in which the back is worked shows that a diadem was added. The "anastole" — the upswept central curls above the forehead, a typical feature of Alexander portraits — is not shown here. However, the other typical features, also seen in catalogue no. 4, are rendered in the spirit of the ripe Hellenistic period, creating a high-voltage, emotional portrait of the Macedonian king.

Last quarter of the third century B.C.

101

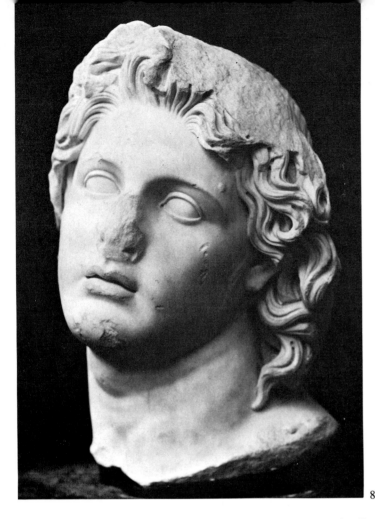

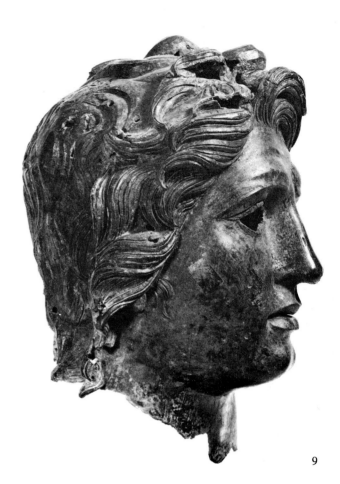

8

9

K. Gebauer, ''Alexanderbildnis und Alexandertypus,'' *AM* 63/4 (1938/39): 79, 105, K 80; E. Buschor, *Das hellenistische Bildnis* (1971), pp. 26, 32, fig. 23; Index zu Buschor, *Hellenistische Bildnis,* Freiburg, Archäologisches Institut der Universität, p. 57; L. Alscher, *Griechische Plastik,* vol. 4 (1957), pp. 149ff., 151, 153, 154, 182n, and Chapter IV, pp. 16, 18, 19b, fig. 72.

8

HEAD OF ALEXANDER

Height .47m. (18½ in.)
Fine-grained white marble
Museum of Fine Arts, Boston, no. 95.68.
Catharine Page Perkins Fund
Said to be from Ptolemais Hermiu (El Menschiye), Upper Egypt

Alexander, his eyes rolling upward, his lips slightly parted, turns his head toward the viewer's right. Long, windblown hair frames his face and is confined by a tubular diadem. Nose tip and pieces of hair, especially at the front, are missing. Though pieces are broken away at the sides and front of the neck, the ancient rim surviving at the back and the cut lower surface show that the sculpture was made as a bust, of shallower form than that normal for Antonine-Severan times. Overcleaning is thought to account for the lack of patina.

The piece is a replica, though without attachment holes for solar rays, of the famous head of Alexander-Helios in the Capitoline Museum. A related over-life-sized bust, also representing the sun god with the features of the young Alexander, has recently been excavated in the Athenian Agora. The flying hair and fiery expression of Helios, traditional even before Alexander, are combined with the features of the Macedonian prince. The assimilation perhaps began with Lysippos' famous sculpture, made for the Rhodians, of Helios driving his sun chariot, and with the Colossus of Rhodes, a towering figure of Helios by Lysippos' pupil Chares of Lindos. The early Hellenistic metope of an Alexander-like, long-maned Helios from the temple of Athena at Ilion shows the type already well established. Many representations of Helios are cut off at chest level, a convenient way of excerpting the driver from the chariot group, but also a form suggesting the morning sun's appearance on the horizon. This iconographic idea might explain the unusual way the Boston piece is cut off.

The porcelainlike surface of the flesh and the finely drilled channels which define the long, curling locks have their best ancient parallels in ambitious work of Antonine-Severan times, first of all in the Capitoline Helios, but also in the Tritons found with the Commodus-Hercules of the Horti Lamiani, or in the colossal Aesculapius head and other sculptures from the Baths of Caracalla. Many imposing copies of the Hellenistic Alexander-Helios types date from this period, attesting to a revival of the imagery in connection with the Roman Sol Invictus.

Probably late second–early third century A.D. after a prototype of the second century B.C.

W. Helbig, *Monumenti antichi* 6 (1895): cols. 73–88 (figs. 1–2 show how the piece is cut off behind and below); *Annual Report,* Museum of Fine Arts, Boston, (1896), p. 21; *Bulletin of the Museum of Fine Arts* I (1903): 14; M. Bieber, *AJA* 49 (1945): 425ff. (defends authenticity); H. P. l'Orange, *Apotheosis in Ancient Portraiture* (1947), pp. 34–37; H. Hoffmann, *Journal of the American Research Center in Egypt* 2 (1963): pl. xxv for Boston head, pp. 117ff. for the iconography of Alexander-Helios in general; M. Comstock & C. Vermeule, *Sculpture in Stone* (1976), no. 127 with full citation of earlier literature. See H. Stuart Jones, *The Sculptures of the Museo Capitolino* (1912), p. 341, no. 3, pl. 85, and H. von Steuben in Helbig, *Führer durch die öffentlichen Sammlungen,* 4th edition (1966), II, no. 1423 for the Capitoline replica; T. L. Shear, *Hesperia* 40 (1971): 274ff., pl. 58b for the Alexander-Helios from the Athenian agora; H. Jucker, *AA* (1969), pp. 248ff. on the Helios metope from Ilion and its date.

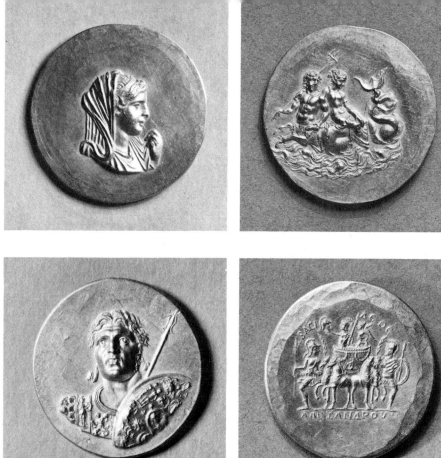

10

11

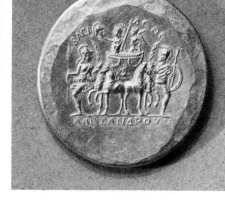

9 (*Color plate 4*)

ALEXANDER THE GREAT

Height .385m. (15⅛ in.)
Bronze with a green patina
Private collection, Switzerland
Said by some to have been found at Boubon
(or Bubon) in Lycia, in a building dedicated
to the Roman emperors

Head and neck have been broken from a
heroic statue. The eyes were inset in another
material. Such technique was used in
the Hellenistic period and in imperial times when famous likenesses were
created anew by Greek imperial artists.

This romantic conception of the Macedonian conqueror, with hair fuller and longer
than he ever wore it in his lifetime, suited the
cult of Alexander as encouraged in the cities
of Roman Asia Minor. Such cities traced
their foundations or their new prosperity back
to Hellenistic times, when they were settled
by Macedonians and ruled by descendants of
Alexander's generals. Since this head (or
complete statue in the heroic traditions of Lysippos) seems to have been placed among
portraits of Marcus Aurelius, Lucius Verus,
Septimius Severus, and Caracalla, the Antonine and Severan rulers of the Roman Empire could see themselves on terms of
equality with the progenitor of Hellenism
throughout all the East.

Frédérique van der Wielen, in José Dörig, *Art
Antique, Collections privées de la Suisse Romande* (1975), no. 384 and bibliography; J.

Inan, in *Istanbuler Mitteilungen* 27/28
(1977/1978): 274, pl. 79, 1, 2 (confused reference). C. Vermeule, "The Late Antonine
and Severan Bronze Portraits from Southwest
Asia Minor," in R. A. Stucky and I. Jucker,
*Eikones, Studien zum Griechischen und
Römischen Bildnis, Hans Jucker zum Sechzigsten Geburtstag Gewidmet* (1979/1980),
pp. 188–190. In a recent letter to the owner,
Denys Haynes proposes a Hellenistic date.

10, 11 (*Color plate 5*)

TWO GOLD MEDALLIONS:
OLYMPIAS, ALEXANDER

The Walters Art Gallery, Baltimore, nos.
59.2, 59.1. From the Kyticas collection, Cairo
Found at the beginning of the present century
in the vicinity of Aboukir, near Alexandria in
Egypt

(For related Caracalla medallion, see
catalogue no. 33.)

The Severan Emperor Caracalla, sole ruler
from 212 to 217, commissioned a series of
large gold medallions from one of the Greek
imperial mints, perhaps Ephesos in western
Àsia Minor. Their purpose was to place Caracalla in the family of Alexander the Great,
including Alexander's mother, Olympias, and
father, Philip. Nereids on sea beasts as a reverse design for Olympias were chosen to

equate Olympias with Thetis, mother of
Achilles, and, by implication, Caracalla with
Alexander-Achilles. In his own lifetime,
Caracalla could appear as one with the real
and mythological victors of Greek literature.

Caracalla and his Severan successors
heaped honors on Macedonia, Alexander's
homeland. The last of the Severans, Caracalla's first cousin once removed, reigned as
Severus Alexander (222 to 235). In 231 he
reconfirmed Macedonia, and particularly
Thessalonike, in ancient privileges, and this
occasion may have called for striking of these
medallions. If so, Caracalla was placed on a
semidivine plateau with Achilles-Alexander
and Olympias. The reverse of the Caracalla
medallion, showing Alexander hunting the
boar, links him with the ill-fated mythological heroes, most notably Meleager, and exploitation of this theme, also applicable to
Caracalla if the medallions are posthumous,
parallels that on the marble relief from Syrian
Antioch in the Alsdorf Foundation, Chicago
(catalogue no. 40).

OLYMPIAS, MOTHER
OF ALEXANDER THE GREAT

Diameter .054m. (2⅛ in.); weight 62 grams

O/ Veiled, draped bust of a woman to the
right. (She has been identified as Olympias.)
R/ A Nereid (Thetis?) riding on a Hippocamp.

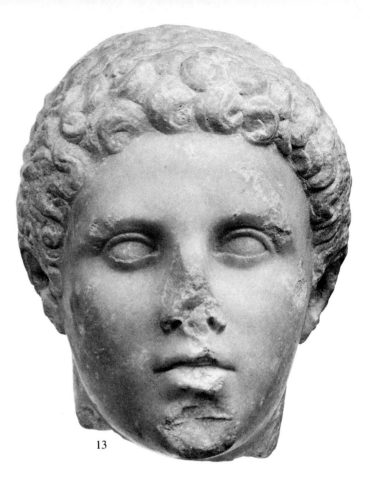

13

ALEXANDER THE GREAT

Diameter .054m. (2⅛ in.); weight 95 grams

O/ Bust of Alexander facing, his gaze directed heavenward. He wears a sculptured cuirass (Nike on shoulder strap, scene of warriors (?) on the chest) and carries a ceremonial spear and a shield enriched with signs of the Zodiac.

R/ Alexander and Nike ride in a quadriga, escorted by Roma, or Virtus, and Ares. Inscribed ΒΑΣΙΛΕΩΣ ΑΛΕΞΑΝΔΡΟΥ (King Alexander).

G. Dattari, *I venti medaglioni d'Aboukir* (1908; also in *Rassegna numismatica* [1909], pp. 43, 85, 104ff.); H. Dressel, *Fünf Goldmedaillons aus dem Funde von Abukir* (Abh. K. Preuss. Akad. d. Wiss., 1906): Olympias is p. 19; Alexander, p. 14, no. L; and Caracalla, p. 20. Also *Zeitschrift für Numismatik* (1908), pp. 137 ff.

12 (not reproduced)

COLOSSAL HEAD OF A PRINCE OR GOD

Height .45m. (17⅝ in.)
Bronze
The Prado, Madrid. From the Odescalchi collection, Rome

The bronze head belonged to a statue of almost twice normal human size. The eyes were once inlaid, the lips probably overlaid with copper. Casting flaws are repaired in the usual ancient manner with square patches, one of which, between the eyes, is missing. The nose tip has been flattened by a blow and the whole head crushed from side to side, producing vertical cracks and some distortion of the features. The regular way the head is broken off, mostly along the jawline and the lower edge of the hair, suggests that it sheared off along an ancient seam. A separately cast head was likely to be joined at this line to a statue whose upper torso was nude; if there was drapery or armor, the seam came at the neckline.

The turbulent, cartilaginous look of the regular but fleshy features, with swelling lower forehead, nose broad across the top, puffy, curving lips, hair blown back from a still rather low and evenly arched hairline, are in the style of the first generation after Alexander. Parallels include the portraits of Demetrios Poliorketes and Lysimachos (see catalogue nos. 14, 22); a close relative is the ruler portrait, known from a copy in gray marble, in the Venice Museo Archeologico. The Prado head appears to be an original. The huge size, the rather superficial but vigorous and unpedantic workmanship speak for this, as does the treatment of the hair, almost entirely in terms of modeling, with the chisel used for light surface texturing rather than to define the locks.

The piece has been seen as a ruler portrait, either of Alexander himself or of a Successor; it wears no royal *taenia* but could represent a young commander-heir apparent like Demetrios Poliorketes. Another possibility is that a deity or a local hero was shown with the features of a contemporary ruler; one of the Dioskouroi, Hermes, or the youthful Herakles all come to mind.

The head comes from Rome, where it was likely to have been brought in antiquity as booty from some site in the Greek world. Republican Rome, especially, admired the huge gods of conquered cities. It was an exception when the Tarentines were allowed to keep their colossal Zeus by Lysippos. Chares of Lindos, Lysippos' pupil, seems to have specialized in huge figures (see catalogue no. 29); an outsize head by him, already separated from its body, was exhibited on the Capitoline in Pliny the Elder's day (*N.H.* XXXIV, 44). One can imagine Chares's work as having the same post-Lysippian style and the same flamboyant yet slightly retardataire quality as the Prado head.

Early Hellenistic

J. Winckelmann, *Werke* (1812) vol. 5, p. 151 and p. 450, n. 659; E. Hübner, *Die antiken Bildwerke in Madrid* (1862), p. 113; P. Arndt, H. Brunn & F. Bruckmann, *Griechische und römische Porträts,* pls. 491–493; E. Buschor, *Das hellenistische Bildnis,* p. 9; A. Blanco, *Museo del Prado, Catalogo de la escultura* (1957), no. 99E.

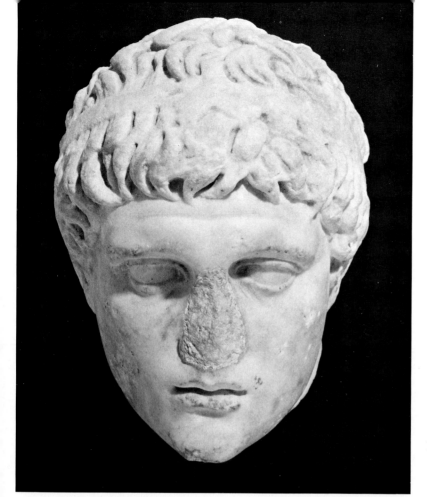

14

See also G. M. A. Richter, *The Portraits of the Greeks* (1965), vol. 3, figs. 1741–1743 for Demetrios Poliorketes, 1751–1754 for Lysimachos; G. Traversari, *Museo Archeologico di Venezia, I ritratti* (1968), no. 2 for the gray marble head.

13 *(Color plate 2)*

HEPHAISTION

Height .26m. (10¼ in.)
Greek marble (Pentelic)
The J. Paul Getty Museum, Malibu,
no. 73.AA.28
From a commemorative or funerary monument in the eastern Mediterranean

Both the related head of Alexander (catalogue no. 6) and this ideal likeness of his closest companion, who died during the last adventures in the East, were repaired in ancient times. The monument may have suffered in an earthquake and was of sufficient importance to have been repaired with care.

While portraits of Alexander the Great have long been identified from coins and inscribed sculptures, those of his friend who shunned power for himself have been harder to isolate, depending in instances on association with likenesses of Alexander (the "Alexander Sarcophagus" in Istanbul, from Sidon, for instance). There is, however, a marble

votive relief of about 300 B.C. or later in Thessalonike in which one Diogenes makes a dedication to "Hero Hephaistion." The hero's features correspond to those of this just-over-life-sized head.

See bibliography for catalogue no. 6; for the votive relief in Thessalonike see C. Vermeule, *Greek Art: Socrates to Sulla* (1980), p. 59, fig. 72.

14

HEAD OF LYSIMACHOS

Height .248m. (9¾ in.)
Marble
Private collection, on loan to the Museum of Fine Arts, Boston, Temporary Loan no. 36.1979. From the M. Gutzwiller collection.

The head is that of a young, regular-featured man, beardless and with medium-short, wavy hair, which is combed forward all around and confined by a flat fillet. The nose is missing; an old restoration in marble has been removed and the trimmed surface disguised. There are minor chips elsewhere, especially on the mouth.

This head is a Roman copy of a portrait known from another replica in Geneva. The restrained likeness is clearly that of an early Hellenistic ruler, and has been identified as Lysimachos (c. 360–281 B.C.), a member of Alexander's bodyguard who eventually became king of Thrace. There is some resem-

blance to the only coin type issued by Lysimachos, which may be his own rather than Alexander's likeness. A magnificent over-life-sized Hellenistic ruler portrait recently excavated at Ephesos probably represents Lysimachos, who was honored there as founder of the Hellenistic city on the site. While not a replica of the Boston-Geneva portrait, it has a similarly rounded, boyish face and could be intended as the same person. If so, Lysimachos, who was over fifty when he assumed the royal diadem, must have wished to emphasize his early career as a comrade-in-arms of Alexander; these official images present him as a very young man.

Roman copy, second century A.D., after an original probably of the early third century B.C.

O. Brendel, *Die Antike* 4 (1928): 314ff.; E. Pfuhl, *JdI* 45 (1930): 9, fig. 4; L. Laurenzi, *Ritratti greci* (1941), no. 49; H. Bloesch, *Antike Kunst in der Schweiz* (1943), no. 60; G. M. A. Richter, *Portraits of the Greeks* (1965), vol. 3, p. 257, figs. 1751–2. See S. Türkoğlu & E. Atalay, *Türk Arkeoloji Dergisi* 19 (1970): 213ff. for the newly found head identified as Lysimachos, at Ephesos.

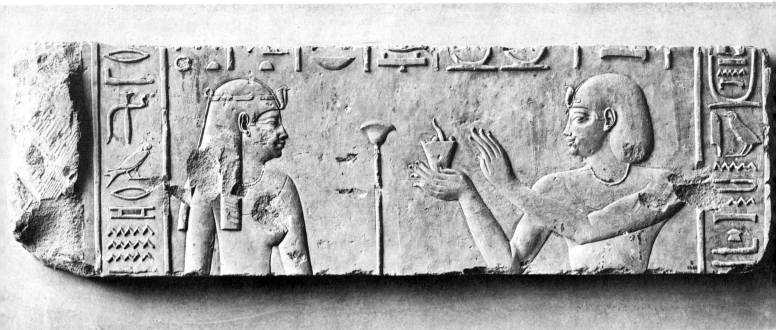

15

RELIEF OF PTOLEMY I SOTER BEFORE HATHOR

Height .36m. (14¹/₅ in.); length 1.27m.
(50 in.)
Limestone
Museum of Fine Arts, Boston, no. 89.559.
Gift of the Egypt Exploration Fund
From Tarraneh in the Western Delta of Egypt

Ptolemy I, Alexander's successor and the
founder of the Ptolemaic Dynasty in Egypt, is
shown offering incense to the goddess
Hathor. A small brazier complete with two
incense pellets and a wisp of smoke is held
by the king. Only traces of the inscription
above the offering scene remain. The king's
names are carved above him; the legend be-
hind him includes his cartouches, and an in-
vocation to the deity. To the left of Hathor,
there is a prayer that she may have dominion
over the land "as far as the great green," the
Egyptian term for the Mediterranean. There is

a demotic graffito lightly scratched into the
stone behind the head of Hathor. A lower part
of this relief is now in Glasgow.

A low relief of very fine quality, this was
carved in a mannered and elegant style devel-
oped during the last dynasties of Egyptian
rule.

W. S. Smith, *Ancient Egypt as Represented
in the Museum of Fine Arts, Boston* (1960),
pp. 181–182, fig. 118; B. V. Bothmer,
"Ptolemaic Reliefs II, Temple Decorations of
Ptolemy I Soter," *Bulletin of the Museum of
Fine Arts* 50 (1952): 49–56.

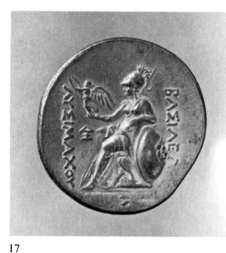

16

17

16

SILVER TETRADRACHM,
PHILIP II (359–336 B.C.)

Macedonia, struck at Pella
Diameter .026m. (1 in.); weight 14.36 grams
Museum of Fine Arts, Boston, no. 00.166.
Catharine Page Perkins Fund

O/ Laureate head to Zeus to right.
R/ ΦΙΛΙΠΠΟΥ (Of Philip). Young
jockey on a victorious race horse walking to
the right. He holds a palm in his right hand
and the reins in the left. There is a victor's
fillet on the horse's neck. The thunderbolt of
Zeus appears between the horse's legs, and
the letter N is visible in the area below the
groundline.

The head of Zeus is a modernized reflection
of the Zeus by Pheidias at Olympia, a place
which figured strongly in Philip's Panhellenic
policies and in his political benefactions. The
reverse alludes to a horse race won by Philip
in 356. Portraits of rulers had been introduced
on coins by satraps of the Persian Empire, but
the notion of self-representation had to wait
the worldwide ambitions of Alexander the
Great and his Successors in Greece, Asia
Minor, Syria, Egypt, and the East.

Brett Catalogue, no. 649.

17

SILVER TETRADRACHM,
LYSIMACHOS

Thrace, mint of Lampsakos in Mysia.
300–298 B.C.
Diameter .032m. (1¼ in.); weight 16.877
grams
Museum of Fine Arts, Boston, no. 35.215.
From the Prowe collection. Anonymous gift
in memory of Zoë Wilbour (1864–1885)

O/ Head of deified Alexander right with
horn of Ammon and fillet in hair. Beaded
border.
R/ Athena Nikephoros seated left; in field,
below Nike: monogram; to right of Athena:
ΒΑΣΙΛΕΩ[Σ] ΛΥΣΙΜΑΧΟΥ.
In exergue: crescent(?)

The likeness of Alexander on the coinage of
his general and Thracian successor Lysima-
chos in the decades after the conqueror's
death documented transformation of
his image into that of an inspired god. Up-
turned eyes, long and unruly hair, and the
ram's horns of the Egyptian Zeus Ammon
showed all peoples, Greek and otherwise, of
the Hellenistic world how they should imag-
ine the king who had marched from the Dan-
ube to the Indus. Victorious Athena on the
reverse symbolized Macedonia's role in the
founding of new cities all over the ancient
East.

Brett Catalogue, no. 824.

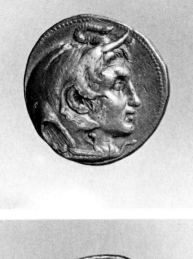

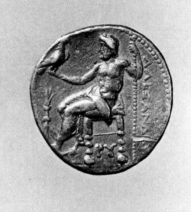

18

19

20

18

SILVER TETRADRACHM, PTOLEMY I SOTER

Egypt, mint of Alexandria. 318–315/4 B.C.
Diameter .027m. (1 in.); weight 17.04 grams
Museum of Fine Arts, Boston, no. 04.1181.
From the Greenwell collection. Purchased of
E. P. Warren, from the Henry Pierce Fund

O/ Male head (Alexander?) to right with
Ammon's horns, elephant skin, and aegis tied
at neck. Broad fillet in hair.
R/ Zeus seated to left on throne without
back, right foot drawn back on footstool, left
hand raised on beaded scepter, right hand
holding eagle to right with closed wings; over
his knees is a mantle. At left in field a
thunderbolt; under throne, PY; at right
ΑΛΕΞΑΝΔΡΟΥ. Beaded border.

Ptolemy of Macedonia was one of Alexander's most successful generals and closest
companions. In 322 he intercepted the funeral
procession taking Alexander's body from
Babylon to Macedonia and led it off to
Egypt. There Ptolemy founded a royal dy-
nasty which lasted until the suicide of Cleopatra in 31 B.C. and the incorporation of
Egypt into the Roman Empire. Struck at
Alexandria in Egypt, this four-drachma piece
shows Alexander with an elephant-skin cap,
in addition to the aegis or goatskin of Athena
or Zeus and the ram's horn of Zeus Ammon.

Brett Catalogue, no. 2248; Bieber, *Alexander
the Great in Greek and Roman Art* (1964),
p. 52, note 35 and fig. 40; G. Le Rider, *Suse
sous les Séleucides et les Parthes* (1965),
p. 301, note 6.

19

SILVER DRACHM, SELEUCUS I (312–280 B.C.)

Syria, of an undetermined mint, perhaps
Bactra.
Diameter .017m. (⅔ in.); weight 4.04 grams
Museum of Fine Arts, Boston, no. 62.649.
Theodora Wilbour Fund in Memory of Zoë
Wilbour

O/ Horned and bridled horse's head to
right.
R/ ΒΑΣΙΛΕΩΣ ΣΕΛΕΥΚΟΥ (King
Seleucus), left and right. An anchor.

Bactra, on a branch of the Oxus river near the
northeastern limits of the early Seleucid kingdom (and north of modern Kabul in Afghanistan), has been suggested as the city where
Seleucus I and, more extensively, his son Antiochus I (280–261 B.C.) issued series of
coins with the horse's head as the principal
design on one side.

Scenes of Alexander's hunts and the evidence of equestrian statues (such as that of
Demetrios Poliorketes in the Athenian Agora
or the small bronzes from the buried cities on
the bay of Naples) suggest each of Alexander's Successors had his favorite charger, but
it is tempting to identify a horse given such
numismatic prominence and horns of divinity
with Alexander's Bucephalas. Alexander's
favorite horse died of old age after the battle
on the Hydaspes in 326 B.C., and the conqueror founded the town of Bucephala in his
memory near the battlefield (northwest of Lahore in Pakistan).

The anchor was a special symbol of the
Seleucid dynasty, and the cities of Asia
Minor named Ancyra (most notably Ankara
in Galatia, the present capital of Turkey)
could claim early associations with Alexander's royal followers on the continent of
Asia.

Comstock–Vermeule, *Greek Coins*, no. 261.

21

20

ELECTRUM STATER, THE TYRANNICIDES

Cyzicus in Mysia. Struck after 460 and before 400 B.C.
Diameter .02m. (4/5 in.); weight 16.02 grams
Museum of Fine Arts, Boston, no. 04.1343.
From the Greenwell collection. Purchased of E. P. Warren, from the Henry Pierce Fund

O/ Two nude youths (Harmodios and Aristogeiton) hasten to right; the front one is unbearded and holds sword in lowered right hand and left arm is extended with chlamys; the back one wears a crested helmet and lowers his right hand (with sword?). Tunny fish to right below.
R/ Quadripartite incuse square, mill-sail type, granulated.

The Tyrannicides Harmodios and Aristogeiton, slayers of Hipparchos in 514 B.C., were honored shortly thereafter with statues in the late Archaic style by Antenor. These were carried off to Persia by the Great King Xerxes after his capture of Athens in 480 B.C. Three years later, Kritios made a new set of bronze statutes for the marketplace of Athens, and these figures are shown as they stood side by side on a nearly contemporary coin of Athens' client-city of Cyzicus in northwest Asia Minor. After the Macedonian conquest of the Persian Empire, Alexander the Great or one of his generals restored Antenor's statues to Athens, winning the citizens' gratitude. Until the Herulians sacked the Athenian Agora in

A.D. 267, the late Archaic and the early Classical groups were monuments to Greek freedom and heroic events in which Alexander played a part.

G. M. A. Richter, *AJA* 32 (1928): 4; Brett Catalogue, no. 1496.

21

SILVER DEKADRACHM, ALEXANDER THE GREAT

Seemingly struck at Babylon
Diameter .032m. (1¼ in.); weight 39.62 grams
London, British Museum

O/ Alexander in his plumed helmet and armor, rides to the right on horseback and attacks a formidable adversary with a lance.

The opponent is probably the Indian King Porus, who is seated with his mahout on a retreating elephant. The driver, mounted just behind the elephant's neck, turns to throw a spear with his right hand and holds two additional spears in his lowered left. Both king and subject are bearded and wear high, conical helmets or hats. A letter appears in the field above.
R/ Alexander is being crowned with a wreath by Nike, who flies down from the

upper left. He wears a Greek or Macedonian helmet topped by a royal Persian headdress with tall plumes and holds a thunderbolt in the outstretched right hand, a spear vertically in the left. Alexander's costume otherwise is that of a general, with cloak, cuirass, tunic, and sheathed sword. The monogram BAB (here obliterated) appeared in the field.

This medallic coin commemorates Alexander's expedition into the Punjab and his defeat of the local King Porus. The scene here is a romantic version of a personal encounter, more artistic than actual, created to rival the earlier attack on the Great King Darius, as reflected in paintings, mosaics, and minor artifacts of the Hellenistic age. On the reverse, Alexander is identified with Zeus, whose thunderbolt he holds, and the Macedonian conqueror also wore just such a helmet with plumes as he campaigned through Asia Minor, from the battle of the Granicus to the victories in the heart of the Persian Empire. The purpose was to dramatize Alexander's claim to the Achaemenid patrimony. The court painter Apelles immortalized Alexander in a series of paintings with these divine and royal attributes.

A Guide to the Principal Coins of the Greeks, British Museum, Department of Coins and Medals (1959), pl. 27, no. 4, p. 49; N. Davis, C. M. Kraay, & P. Frank Purvey, *The Hellenistic Kingdoms, Portrait Coins and History* (1973), p. 29, figs. 10–12.

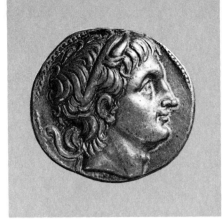
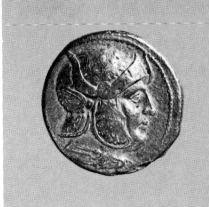
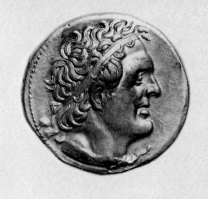

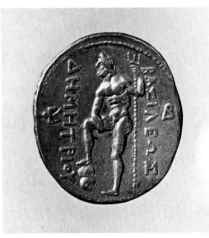

22
23
24

22

SILVER TETRADRACHM, DEMETRIOS POLIORKETES

Macedonia, struck at Amphipolis in Macedonia. 289–288 B.C.
Diameter .03om. (1¹/₅ in.); weight 17.20 grams
Museum of Fine Arts, Boston, no. 00.173. Catharine Page Perkins Fund. Purchased of E. P. Warren, 1900

O/ Head of Demetrios to right, wearing a diadem with fluttering ends and the bull's horn of Dionysos (in imitation of Alexander's ram's horns of Zeus Ammon).
R/ ΒΑΣΙΛΕΩΣ ΔΗΜΗΤΡΙΟΥ (King Demetrios) right and left. Monograms left and right. Poseidon, god of the sea, a similar diadem in his hair, stands to left, right foot on the rocky land, right hand resting on his thigh, his trident in the raised left hand.

Famous artists vied for the privilege of portraying Demetrios, son of Antigonos, the latter one of Alexander's foremost generals. Demetrios was styled "Besieger of Cities" because he spent his career on land and sea fighting every other Successor of Alexander the Great. From 294 to 288 Demetrios was king of Macedonia and Greece. He ended his days as a prisoner of Seleucus, who en-

couraged him to share the fate of Alexander the Great: death from too much drink.
Poseidon on the reverse is modeled on a celebrated statue by Alexander's court sculptor Lysippos for the god's shrine at the Isthmus of Corinth. Demetrios Poliorketes had made the "League of Corinth" a keystone in his quest for power, which extended from mainland Greece, through the Dodekanese to Cyprus.

Brett Catalogue, no. 709.

23

SILVER TETRADRACHM, SELEUCUS I

Syria, struck at Persepolis or Susa in Persia. 303–300 B.C.
Diameter .027m. (1 in.); weight 16.63 grams
Museum of Fine Arts, Boston, no. 35.155. Anonymous Gift in Memory of Zoë Wilbour

O/ Head of Seleucus to right, wearing a helmet covered with a panther's skin. The helmet has a visor, lowered cheekpieces, and the horns and ears of a bull. Seleucus also wears a panther's skin around his shoulders, the paws knotted on his neck.
R/ ΒΑΣΙΛΕΩΣ ΣΕΛΕΥΚΟΥ (King Seleucus) at right and left. Monograms at left and right. Nike stands to right, crowning a trophy with a wreath. The trophy comprises a tree stump and branch on which are a helmet, sword, cuirass, and round shield. The royal Macedonian star appears in the center of the shield.

Seleucus wears the complex costume of a conqueror of India, in the traditions of Dionysos and Alexander the Great. He campaigned in those parts from 305 to 304 B.C. The reverse seems to allude to a victory over a fellow Macedonian, perhaps the battle of Ipsos in 301 where Antigonos was slain and Demetrios lost his power in Asia Minor.

Brett Catalogue, no. 2148; A. Houghton, *Schweizerische Numismatische Rundschau* (1980).

24

SILVER OCTODRACHM, PTOLEMY I SOTER

Egypt. 305–285 B.C.
Diameter .035m. (1⅓ in.); weight 27.94 grams
Museum of Fine Arts, Boston, no. 58.520. Theodora Wilbour, in Memory of Zoë Wilbour

O/ Head of Ptolemy I, right, diademed and wearing aegis; border of dots. The Δ (Delta) in the curl behind the ear may be the artist's signature.
R/ ΠΤΟΛΕΜΑΙΟΥ ΒΑΣΙΛΕΩΣ. Eagle standing left on thunderbolt; at left, monogram.

When Ptolemy felt secure in his possession of the southeastern Mediterranean portions of Alexander's empire, he placed his own

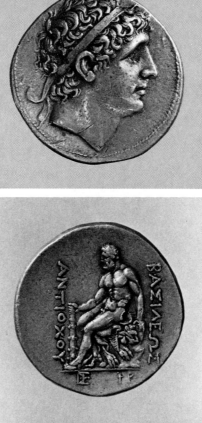

25 26

craggy, heavy-jawed profile on the coinage. Ptolemy wears the royal diadem in his hair and the aegis of Zeus and Athena tied around his neck. The reverse hails Ptolemy as king and is dominated by the emblem of the eagle and thunderbolt of Zeus. The eight-drachma silver piece was an exceptional coin in the Hellenistic world, a small hoard having been found in 1956 near Phacous (not far from Zagazig) in the Nile Delta.

Chase–Vermeule, fig. 170; *Archaeology* 12 (1959): 5, illus.; Comstock–Vermeule, *Greek Coins,* no. 319; E. Pegan, *ARGO* 4–6 (1965–1967):33.

25

GOLD PENTADRACHM, PTOLEMY I SOTER

Egypt, struck at Alexandria in Egypt.
305–285 B.C.
Diameter .022m. (⅞ in.); weight 18.81 grams
Museum of Fine Arts, Boston, no. 35.151.
Anonymous Gift in Memory of Zoë Wilbour

O/ Diademed head of Ptolemy I to right. A small Δ (the artist's signature?) behind the ear.

R/ ΠΤΟΛΕΜΑΙΟΥ ΒΑΣΙΛΕΩΣ (King Ptolemy) left and right. Monogram at the left. Eagle, with wings slightly raised, stands on a thunderbolt.

Taking advantage of the heightened prosperity of the early Hellenistic world, Ptolemy I and his descendants increased the size and diversity of the gold and silver coinage. The eagle of Zeus on the reverse was one of the last visual links with Olympia, the oasis of Ammon, and the various cults of the father of the gods fostered by Philip II and Alexander.

Brett Catalogue, no. 2263

26

SILVER TETRADRACHM, ANTIOCHUS I (280–261 B.C.)

Syria, probably struck at Magnesia ad Sipylum between Smyrna and Sardis in western Asia Minor. Circa 265–261 B.C.
Diameter .0305m. (1⅕ in.); weight 16.93 grams
Museum of Fine Arts, Boston, no. 59.41.
Theodora Wilbour Fund in Memory of Zoë Wilbour

O/ Diademed head of Antiochus I to right.

R/ ΒΑΣΙΛΕΩΣ ΑΝΤΙΟΧΟΥ (King Antiochus) right and left. Monograms below the groundline. Herakles seated to left, on the skin of the Nemean lion, which is draped over the rocks. He holds his club downwards in his right hand.

Antiochus, son of Seleucus, was born the year before Alexander died. Like his predecessors, he was a great founder of cities that bear his name (the same as his grandfather's), his father's name, that of his mother, the Bactrian Apama, and that of Stratonice, Seleucus' young wife, whom Antiochus inherited. King Antiochus consolidated his father's territories from the borders of Asia Minor eastward. His title "Soter," or Saviour, came from his defeat of the Gauls in Asia Minor about 273 B.C.

The seated Herakles on the reverse, like the Poseidon of Demetrios Poliorketes (catalogue no. 22), also reflects a famous statue by Lysippos of Sikyon. The Successors of Alexander the Great saw the political and religious value in portraying their gods and their city-images in terms of the works of art created during the lifetimes of Philip and Alexander.

Comstock–Vermeule, *Greek Coins,* no. 264.

111

27

SILVER TETRADRACHM, ALEXANDER THE GREAT

Macedonia, mint of Amphipolis.
336–334 B.C.
Diameter .025m. (1 in.); weight 17.23 grams
Museum of Fine Arts, Boston, no. 03.960.
Purchased of E. P. Warren. Francis Bartlett
Donation

O/ Head of Herakles, right, wearing
lion's skin.
R/ Zeus seated left, with eagle in right
hand, spear in left. Symbol, thunderbolt.
ΑΛΕΞΑΝΔΡΟΥ

The famous four-drachma silver coins of
Alexander the Great followed him from Ma-
cedonia to the East on his conquests and
became a universal coinage of the ancient
world, in succession to the silver "owls" of
Athens and the Persian coins showing the
Great King as a kneeling archer. Herakles in
his lion's skin is an ideal likeness of the
young conqueror, the numismatic parallel to
the marble head of Alexander as Herakles
from a shrine at Sparta. The image of Zeus
on the coin's reverse is a free interpretation of
the gold-and-ivory cult-statue by Pheidias in
the temple at Olympia. Alexander's father,
Philip, had made this Zeus a symbol of
Macedonian hegemony in the Hellenic world.

Chase–Vermeule, fig. 145. Brett Catalogue,
no. 664.

28

SILVER TETRADRACHM, SELEUCUS I

Syria, struck by Philetaerus of Pergamon.
Circa 279–274 B.C.
Diameter .0295m. (1⅛ in.); weight 16.85
grams
Museum of Fine Arts, Boston, no. 62.1143.
Theodora Wilbour Fund in Memory of Zoë
Wilbour

O/ Head of Herakles to right, wearing the
skin of the Nemean lion.
R/ At right: ΣΕΛΕΥΚΟΥ . ΒΑΣΙΛΕΩΣ .
(King Seleucus) below. Zeus seated to left,
holding eagle on outstretched right hand,
scepter in raised left. In field at left, helmeted
head of Athena (the emblem of the city of
Pergamon in Mysia, northwest Asia Minor).
Crescent below throne.

Characterized as one of the ablest and most
humane of Alexander's generals and Succes-
sors, Seleucus, titled Nikator, or Victor,
emerged from the wars of succession as ruler
of the Hellenistic world from Asia Minor to
India. Founder of a great dynasty and many
cities, notably Antioch in Syria, he died try-
ing to incorporate Macedonia into his king-
dom. Philetaerus ruled the key city of
Pergamon under the Seleucids, struck this te-
tradrachm in memory of his patron, and even-
tually founded his own independent dynasty,
that of the Attalids.

The coin's obverse and reverse are still
those of Alexander the Great, with the hero's
features visible in the guise of Herakles. The

eye looks upward, foreshadowing the aura of
apotheosis so evident in portraits of Alex-
ander in the three-dimensional media. A co-
lossal Zeus of this type, with Olympian and
Macedonian associations, was commissioned
by Seleucus as a temple image for his new
city of Syrian Antioch (300 B.C.).

Comstock–Vermeule, *Greek Coins,* no. 263.

29

SILVER DIDRACHM, HEAD OF HELIOS

Rhodes. Third and second centuries B.C.
Diameter .02m. (4/5 in.); weight 6.71 grams
Museum of Fine Arts, Boston, no. 04.1106.
From the Greenwell collection. Purchased of
E. P. Warren, from the Henry Pierce Fund
O/ Head of Helios radiate slightly to right
of full front; hair in loose locks.
R/ In depression, rose with bud at right;
at left small nude Apollo to right, lyre in left
hand. Above, POΔION; below, ΑΚΕΣ/ΙΣ
(the magistrate). Beaded border.

The radiate head of the sun god, looking out
from the hill above Rhodes toward Anatolia,
was based on the colossal statue fashioned in
bronze by Chares of Lindos about 290 B.C.,
one of the seven wonders of the ancient

world. As elsewhere when Helios was repre-
sented in Hellenistic art, the features of the
patron god of the island of Rhodes were
based on those of Alexander the Great. The
rose on the reverse honored the nymph
Rhodos, wife of Helios and daughter of
Aphrodite. The island of Rhodes was one of
the naval and commercial powers of the Hel-
lenistic world until the advent of Roman gov-
ernment in the East.

Brett Catalogue, no. 2053.

30

SILVER TETRADRACHM, SELEUCUS I (312–280 B.C.)

Syria, perhaps struck at Seleucia on the Tigris
Diameter .028m. (1¹/₁₀ in.); weight 17.04
grams
Museum of Fine Arts, Boston, no. 60.521.
Theodora Wilbour Fund in Memory of Zoë
Wilbour

O/ Wreathed head of Zeus to right.
R/ ΒΑΣΙΛΕΩΣ ΣΕΛΕΥΚΟΥ (King
Seleucus) at left and below. An anchor and a
monogram appear above. Athena in full
armor strikes a fighting pose as she rides to
the right in a quadriga of elephants.

The introduction of the elephant into Olym-
pian mythology follows the appearance of
these animals on the battlefields of Alexander
the Great and his Macedonian Successors.
Seleucia on the Tigris (Tel Umar in Iraq) was

31

32

33 (lifesize)

founded by Seleucus at the narrowest point between the Tigris and the Euphrates rivers, not far south of modern Baghdad. Such cities were keystones in the Seleucid system of trade, colonization, and defense from one end of the kingdom to the other.

Comstock–Vermeule, *Greek Coins*, no. 258.

31

SILVER TETRADRACHM, PTOLEMY I SOTER

Egypt, mint of Alexandria. 315/4–300 B.C.
Diameter .028m. (1 in.); weight 15.64 grams
Museum of Fine Arts, Boston, no. 04.1185.
From the Greenwell collection. Purchased of
E. P. Warren, from the Henry Pierce Fund

O/ Male head to right with Ammon's horns, broad band in hair, hair covered by elephant skin with beaded edge below, and aegis tied at throat. Beaded border.
R/ Athena Alkidemos advancing to right, spear in raised right hand, shield on left arm; she wears crested Attic helmet, chiton girded over overfold, and a scarf with "swallow tail" ends which passes forward from the back, is drawn up and thrown back again over both shoulders. ΑΛΕΞΑΝΔΡΟΥ at left; at right, monogram HP and Corinthian helmet over small eagle with closed wings to right on thunderbolt.

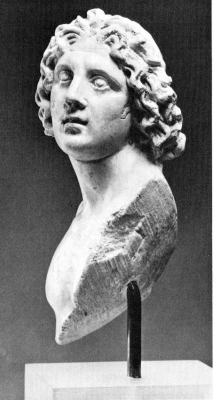

38

ALEXANDER WITH THE LANCE

Height .10m. (4 in.)
Bronze
Fogg Museum of Art, Harvard University,
no. 1956.20. Gift of C. Ruxton Love, Jr.
From the collections of A. J. Nelidow and
C. Ruxton Love, Jr.
From Macedonia by way of the Istanbul
bazaar

Alexander stands on his right leg, left bent
back (all below both knees is restoration). His
right hand is planted firmly on his hip, and he
was leaning on a spear (or lance, if he had
dismounted) which he grasped in his raised
left hand.

This tiny image is a clear reflection of the
statue of Alexander with his lance which was
created by his court sculptor Lysippos during

the conqueror's lifetime or shortly after his
death. The statue itself, a life-sized or slightly
larger bronze, has disappeared, but there are
versions used for Roman generals and rulers
(and perhaps now-fragmentary copies for
Alexander himself) surviving from Italy and
Asia Minor. The muscular body and at-
tenuated limbs were hallmarks of Lysippos,
who had introduced restlessness into Greek
athletic sculpture.

The stylistic relationship between this
statuette and over-life-sized versions of the
Alexander by Lysippos suggests the Alex-
ander Nelidow was created in the third cen-
tury of the Roman Empire. A Macedonian
soldier in the service of Severus Alexander
(A.D. 222–235) could have placed this
statuette in his household shrine.

Some have suggested the Alexander Neli-
dow might be a Renaissance (Cinquecento?)
version of a late Hellenistic or Roman impe-
rial statuette. Because Italian Mannerists ad-
mired bronzes with the proportions seen in
the ancient parts of this figure, this Alexander
has been identified with later ages, a judg-
ment no doubt helped aesthetically by the res-
torations. Allowing for its smallness of scale,
this statuette gives a canonical view of how
later Greek artists reduced the innovations of

Lysippos to minor art. A Renaissance sculp-
tor would have made the proportions more
disjointed and smoothed the surfaces.

L. Pollak, *Klassisch-Antike Goldschmiedear-
beiten im Besitze Sr. Excellenz A. J. von Ne-
lidow* (1903), pp. 3 (front), 139 (back), 184
(profile to right), 198 (text); *Ancient Art in
American Private Collections,* Fogg Art Mu-
seum (1954), pp. 31–32, no. 220, pl. 62; D.
Buitron, "The Alexander Nelidow: A Renais-
sance Bronze?," *The Art Bulletin* 55, no. 3
(1973), pp. 393–400.

39

BUST OF ALEXANDER-HELIOS

Height .105m. (4⅛ in.)
Alabaster
The Brooklyn Museum, no. 54.162. Charles
Edwin Wilbour Fund
From Egypt

The piece belonged to a draped statuette
whose clothing was of another material.
Alexander, with long, curling hair, turns his
head sharply toward the viewer's right. Ends
of a fillet hang on his shoulders; around his
head are attachment holes for the rays of He-
lios's solar crown.

This is a baroque Alexander, with emo-
tional, idealized features and exaggeratedly
turbulent hair (cf. catalogue no. 8, probably
another Alexander-Helios). The workmanship

The reverse of this four-drachma coin, struck on a standard made popular by the city of Rhodes off the southwestern coast of Asia Minor, shows the Macedonian image of Athena Alkidemos prepared to defend the peoples of Alexander's "empire." The little eagle standing on the thunderbolt of Zeus at the lower right soon became the emblem of King Ptolemy's dynasty in Egypt, on Cyprus, and elsewhere in the East.

Brett Catalogue, no. 2257.

32

SILVER TETRADRACHM, DEMETRIOS POLIORKETES

Macedonia, struck at Salamis on Cyprus. 300–295 B.C.
Diameter .028m. (1⅛ in.); weight 17.12 grams
Museum of Fine Arts, Boston, no. 30.413. Harriet Otis Cruft Fund

O/ Nike has alighted on the prow of a naval vessel, a galley. She blows a trumpet held on her outstretched right hand and holds a naval standard in her drawn-back left hand. The monumental prow is richly decorated, including a large human eye, as it moves through a pattern of waves.

R/ At right and below ΔΗΜΗΤΡΙΟΥ ΒΑΣΙΛΕΩΣ (King Demetrios). A double axe appears at the left and monogram below. Poseidon, seen from the rear, hurls his trident with his raised right hand, while holding out his left arm, which is wrapped in his chlamys or cloak.

This four-drachma piece commemorated the naval victory of Demetrios over Ptolemy I of Egypt off Salamis in 306. The *akrostolion*, or topmost part of the curved *stolos,* of this galley, one of Ptolemy's, has been cut off and carried away as a token of Macedonian victory. As a result of the victory Antigonos and his son Demetrios ruled Cyprus for twelve years, but the former was killed at Ipsos in Phrygia in 301 and the latter abandoned the island in 295. In the following year, Ptolemy I conquered Cyprus, and it remained part of the Ptolemaic kingdom until M. Porcius Cato took possession of the island for the Romans in 58 B.C.

The concept of Nike on the prow of a vessel of war was a popular one in the Hellenistic age, the most famous example being the great marble fountain group of about 190–180 B.C. from the island of Samothrace and now in the Musée du Louvre, Paris. At one time the coin of Demetrios Poliorketes and the Nike of Samothrace were thought to have been contemporary, but this is a clear case of a composition appearing on the coinage before its survival in the monumental arts. Perhaps just such a marble group of Nike alighting on a prow was set up by Antigonos and Demetrios on the Greek mainland or at Cypriote Salamis.

Brett Catalogue, no. 705.

33

GOLD MEDALLION: THE ROMAN EMPEROR CARACALLA (211–217)

The Walters Art Gallery, Baltimore, no. 59.3.
Diameter .057m. (2¼ in.); weight 70 grams
See related medallions, catalogue nos. 10, 11.
For bibliography, see entry for catalogue nos. 10, 11

O/ Laureate, draped, and cuirassed bust, seen from the back, of Caracalla facing to left. He holds a ceremonial spear in his right hand and a shield on his left shoulder, the latter enriched with a relief of Nike driving a biga at full gallop to the left.
R/ Alexander hunting a boar. Inscribed ΒΑΣΙΛΕΩΣ ΑΛΕΞΑΝΔΡΟΥ (King Alexander).

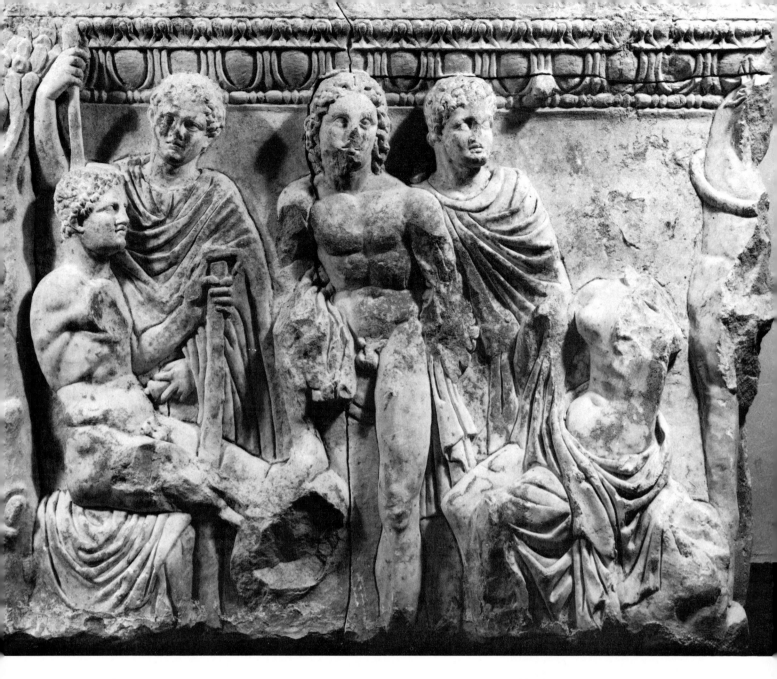

has a cameolike delicacy. The irises and pupils of the eyes are incised, as they regularly were in coins and gems, where the details could not be painted, long before the practice became usual in the large-scale sculpture of late Hadrianic times. The fizzy, spontaneous quality of the carving might be at home in late Hellenistic or as late as Neronian-Flavian times.

Probably first century B.C.–A.D.

Five Years of Collecting Egyptian Art (The Brooklyn Museum, 1956), no. 23, pls. 41, 42; K. Schefold, *Meisterwerke griechischer Kunst* (1960), no. 369; M. Bieber, *Alexander the Great in Greek and Roman Art* (1964), p. 86, figs. 80–85; G. M. A. Richter, *The Portraits of the Greeks* (1965), vol. 3, p. 256, 6, fig. 1740.

40

RELIEF WITH HERAKLES, ALEXANDER, HEPHAISTION, A COMPANION, AND A NYMPH

Height .95m. (37½ in.); length 1.20m. (47¼ in.)
Greek marble (Pentelic)
Alsdorf Foundation, Chicago
From an Attic sarcophagus or perhaps an architectural complex of about A.D. 200 in Roman Syria (the Antioch area)

Beneath a complex architectural molding of egg-and-dart and bead-and-reel, Herakles sits against a tree in a rocky landscape. A "companion" stands behind him, leaning on a spear or staff. In the center appears Alexander the Great in the pose of the famous statue in Munich (the Alexander Rondanini). Hephaistion looks off into the distance from a position behind Alexander's left shoulder, and the nymph, perhaps a geographical personification, sits facing Herakles. The horse (Bucephalus?) completes the scene at right.

The basis of this composition may be the myth of Meleager or a similar hunter, with Alexander assimilated to the ill-fated hero's role. The group is certainly intended to suggest the apotheosis of Alexander, Hephaistion, and perhaps Seleucus Nikator of Syria as they all would have been seen by Greeks and Romans of the time of Commodus (180 to 192), Septimius Severus (193 to 211), or Caracalla (sole ruler 212 to 217), who cherished the traditions and deeds of Herakles and Alexander.

C. Vermeule, in *Studies Presented to George M. A. Hanfmann* (1971), p. 176, pl. 45; G. Koch, *Archäologischer Anzeiger,* 1 (1978): 116–135.

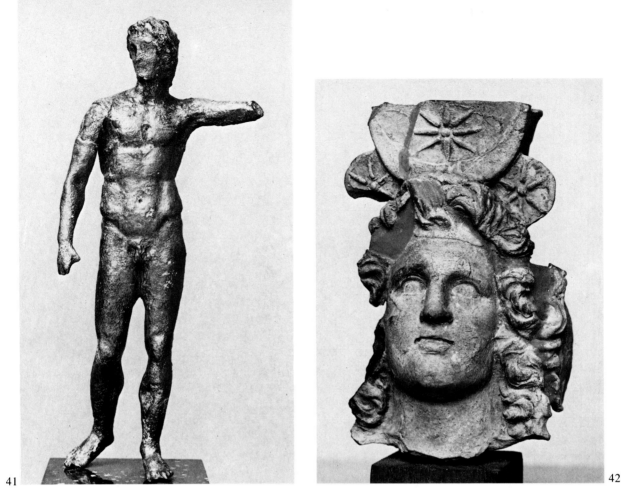

41

42

41

BRONZE STATUETTE
OF ALEXANDER WITH THE LANCE

Height .165m. (6½ in.)
Musée du Louvre, Paris, no. MN 1576, inv.
616
Said to be from Lower Egypt

Alexander is completely nude, his left arm
raised to grasp a lance. He strides forward,
his weight on the left leg, and turns his head
sharply toward his right. The statuette is
badly corroded all over. The left arm from
the elbow and part of the right hand are
missing.

Lysippos' most famous statue of Alexander
seems to have been an Alexander with the
Lance. A spear was the attribute par ex-
cellence of Achilles, the Homeric hero with
whom Alexander identified himself and from
whom he claimed descent. The Doryphoros
(Spear-Bearer) of Polykleitos probably repre-
sented Achilles; Lysippos' work would have
been at once an hommage and a challenge to
the earlier masterpiece. In turn, it was the
prototype for Hellenistic ruler statues. The
Louvre bronze is considered a possible re-
duced copy of Lysippos' Alexander. The
head, with its bony face, deep-set eyes, and
lank, not exaggeratedly long hair, does re-
semble the Azara herm. The pose, innovative
with respect to earlier fourth-century sculp-
ture, leads into the much more swaggering
and emphatic ruler portraits of Hellenistic
times. Lysippian traits are the indented waist,
the rotating rather than side-to-side movement

of the upper torso, the posture that reaches far
outside the body but retains its elasticity and
balance.

It is difficult, however, to accept the
Louvre bronze as the reflection of a famous
work when there are so few other echoes. A
partial explanation could be found in the pos-
sibility that the statue stood at Alexandria in
Egypt; the country had no marble, and made
very economical use of that imported, often
in small pieces, for local needs. Copyists'
workshops of the kind that flourished at
Athens and in the marble exporting centers of
Asia Minor could not have grown up there.
The Egyptian association, suggested by the
provenance of the Louvre bronze, is
confirmed by a late but vivid reflection of the
type. It is identifiable, reversed and wearing
the tall, horned Egyptian headdress of
Ammon, in the background of a magnificent
painted tondo portrait, on wood, of two
young men of the Roman period in Cairo.
The attachment hole in the head of the
Louvre bronze suggests it wore a similar
crown.

Hellenistic or Roman, after a prototype of the
late fourth century B.C.

S. Reinach, *Répertoire de la statuaire* II, p.
567, 1; A. de Ridder, *Les bronzes antiques
du Louvre* (1913), no. 370; F. P. Johnson,
Lysippos (1927), pp. 216–217; M. Bieber,
Alexander the Great in Greek and Roman Art
(1964), pp. 34–35, pl. X. See also *En-
ciclopedia dell' arte antica* 3 (1960): 605, fig.
732 for the statue in the background of a
painted double portrait in the Coptic Mu-
seum, Cairo.

42

FRAGMENT OF A PLASTIC VASE:
ALEXANDER AS KOSMOKRATOR

Height .16m. (6³/10 in.)
Terra-cotta
Musée de la Cinquantenaire, Brussels,
no. A 1938
From Amisos in Pontus

The face of Alexander, in very high relief, is
framed by long, wavy locks and crowned
with a divine headdress. A lunar crescent
supports a large disc with an eight-pointed
star; to either side of this is a smaller disc
with a six-pointed star.

The long, heavy-jawed face, the impas-
sioned look, and the richly upswept coiffure
recall high Hellenistic heads like the colossal
Dionysos in Leyden. The headdress implies
celestial dominions. The sun and moon are
clearly represented. Cumont traces the origin
of the three-star group back to the Babylonian
triad of sun, moon, and the planet Venus, but

120

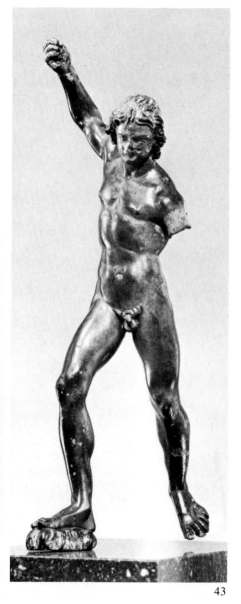

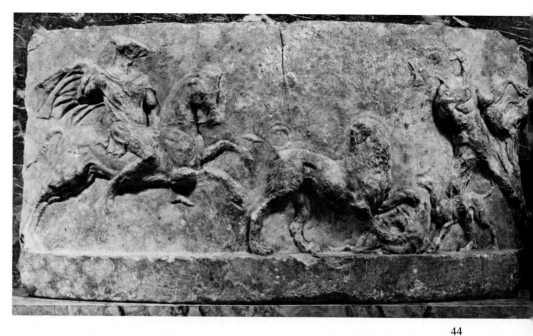

by now the original significance of the arrangement may have been forgotten, and the stars combined with additional solar and lunar symbols to stand for the heavens in general.

Probably second century B.C.

H. P. l'Orange, *Apotheosis in Ancient Portraiture* (1947), p. 25 and fig. 7; F. Cumont, *Le symbolisme funéraire des romains* (1966), p. 208, pl. XVI, 1. See S. Reinach, *Receuil de têtes antiques* (1903), pls. 244–245 for the head of Dionysos in Leyden.

43

ALEXANDER LANDING OR HUNTING

Height 0.141m. (5⁹/₁₆ in.)
Bronze with a rich olive-green patina
George Ortiz Collection
From a small group made in Alexander's later years or in the generation after his death

The youthful Alexander is shown as a mythological hero, his right arm raised and extended. The hand doubtless grasped a spear, and he appears to be stepping on a rock or a small mound of earth.

Alexander may be Achilles landing at Troy, a parallel very much in the conqueror's mind when he crossed the Hellespont. He might be shown at the moment when he reached Egypt, where he was remembered by later generations as the "landing Alexander." Alternatively, this sensitive creation in the attenuated, muscular style of the court sculptor Lysippos shows Alexander spearing an animal, perhaps as Meleager hunting the Calydonian boar.

K. Schefold, *Meisterwerke griechischer Kunst* (1960), pp. 255, 262, no. VII 346, illus.; *Ancient Art in American Private Collections,* Fogg Art Museum, Cambridge (Mass.) (1954), p. 31, no. 219, pl. 65.

44

STONE RELIEF: LION HUNT

Height .595m. (23⅜ in.); width 1.205m. (47⅜ in.)
Musée du Louvre, Paris, no. 858
From Messene

The relief, said by its discoverer to be of local Messenian stone, comes from the facing of a large curving or cylindrical base or altar. Though traces of clamps show that other blocks joined it, the scene on this one is complete in itself. Possibly the base, like that of Lysippos' Poulydamas statue at Olympia, had a series of self-contained scenes. At the center of the surviving segment, a lion crouches over a fallen hound while another hound continues to attack. A horseman dressed in Macedonian costume of chiton, chlamys, and broad-brimmed hat (*kausia*) charges in from the left to spear the lion. A second hunter attacks the lion on foot from the right. Nude except for the lion's skin wound as an improvised shield around his left arm, he wields a heavy axe.

The nonmythological lion hunt enters Greek art with Alexander the Great. He and his retinue must have practiced this dangerous pastime in the celebrated game parks of the former Persian Empire; the hunt with Krateros is referred to as taking place in Syria, and the Sidonian hunt of Alexander and King

45

Abdalonymos on the Alexander Sarcophagus is explicitly Oriental in accouterments as well as locale, with most participants in Persian dress. As a royal lion hunter, spearing the beasts from his horse, Alexander adopted the iconography along with the sport of ancient Near Eastern kings.

The Messene base is an apparently early Hellenistic monument which shows, in simplified form, many of the characteristic features of hunting scenes associated with Alexander's court. The principal hunter is mounted, and wears Macedonian dress. The lion is harried by lean, smooth-haired Laconian hounds, of the same breed as those in the Gnosis mosaic at Pella. As in the mosaic, a hunter on foot brandishes an axe. The Messene relief has been considered a possible echo of Lysippos' and Leochares' bronze lion hunt of Krateros and Alexander, with the heroic but endangered axe-wielder, wearing a Herakles-like lion skin, as Alexander, and the securely mounted rescuer as Krateros. Almost the same figures, clustered together instead of strung out, appear in an Arretine mold signed by M. Perennius, suggesting that the prototype was famous. Whether or not one accepts this interpretation of the rather modest and unspecific-seeming Messene relief, it remains an interesting echo of the Macedonian court iconography.

Early Hellenistic

O. M. von Stackelberg, *Annali,* Instituto di Corrispondenza Archeologica, I (1829), p. 131; idem, *Graeber der Hellenen* (1837), tailpiece, from a drawing made by von Stackelberg on the site, June 5, 1813; C. de Clarac, *Musée de sculpture* II, pl. 151 bis; G. Loeschke, *JdI* 3 (1888): 189ff., pl. 7; F. P. Johnson, *Lysippos* (1927), p. 227, with comparison of the relief to a related gem; T. Hölscher, *Griechische Historienbilder des 5. und 4. Jahrhunderts vor Christus* (1973), pp. 108ff., no. 1328; R. Vasić, *AK* 22 (1979): 106ff. See H. B. Walters, *Catalogue of the Roman Pottery . . . British Museum* (1908), no. L101, for the fragment of an Arretine mold.

45

BOWL WITH RELIEF SCENE OF ALEXANDER FIGHTING DARIUS

Height .073m. (2⅞ in.); diameter .116m. (4½ in.)
Light reddish-brown, rather porous clay
Museum of Fine Arts, Boston, no. 99.542.
Henry Pierce Fund

The body of the vessel is mold-made, with foot, lip, and handles added separately. The relief shows a many-figured battle scene of Greeks against Persians.

This piece is a signed production from the atelier of C. Popilius, who manufactured thin-walled "Italo-Megarian" cups, most of

them with ornamental patterns, at Ocriculum and Mevania in southern Umbria during late Hellenistic times. The battle scene has the same main figures and must derive from the same original as the famous Alexander Mosaic from Pompeii. At the center of one side is Darius's four-horse chariot. Around it, the elite Persian bodyguard falls before the irresistible Alexander, charging on Bucephalus from a rather inconspicuous spot under the vessel's handle. The Great King of Persia, as in the mosaic, turns back with a horrified, pitying gesture toward his defenders as his charioteer struggles to turn the heavy vehicle in retreat.

The prototype, often ascribed to Philoxenos of Eretria, must have been a famous work painted not long after Alexander's campaigns; it had close affinities with the facade painting of a hunt on the Royal Tomb at Vergina. The Battle of Alexander and Darius seems to have been especially influential in Italy. There are echoes in late Apulian vase painting and on Etruscan ash urns, perhaps to be explained by the use of a common artistic language all over the ancient world more than by the conscious transmission of models. In late Hellenistic times, however, the borrowings are more explicit. The appearance of the same main figures on the Popilius bowl and in a provincial relief from Isernia in the

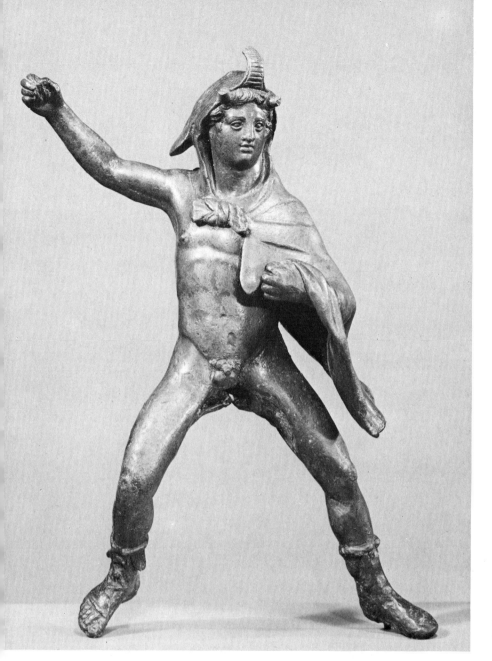

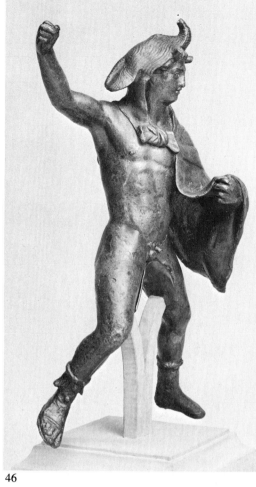

46

mountains of central Italy, as well as in the technically almost miraculous mosaic from the House of the Faun at Pompeii, suggests that the original had been brought to Rome, perhaps as booty after the defeat of Perseus of Macedon in 168 B.C.

Probably late second–early first century B.C.

M. Sieberg, *RM* 12 (1897): 41–45; P. Hartwig, *RM* 13 (1898): 399–408, Taf. XI; G. H. Chase, *Catalogue of Arretine Pottery* (1916), p. 8, n. 5; *Bulletin of the Museum of Fine Arts* 45 (1947):38–42; F. Jones, *Record of the Princeton Art Museum* 17 (1958):78ff.; G. Hafner, *Geschichte der griechischen Kunst* (1961), p. 438, figs. 454–5; M. Verzar, *Hellenismus in Mittelitalien* (Colloquium, Göttingen, 1974). See H. Comfort in *Enciclopedia dell' arte antica,* supplemento 1970, pp. 807–808 on the date of Popilius; L. Giuliani, *AK* 20 (1977): 26ff. on the Battle of Alexander motifs and their transmission to Italy. For the Isernia relief see *Enciclopedia dell' arte antica* 4 (1961):231.

46

RIDER WEARING AN ELEPHANT SKIN

Height .247m. (9¾ in.)
Bronze
The Metropolitan Museum of Art, New York, no. 55.11.11. Edith Perry Chapman Fund, 1955. From the J. Hirsch and Dattari collections
From Athribis in the Nile Delta

The figure, once mounted on a separately made horse, is nude except for an elephant skin of unrealistically small scale which covers his head and is wrapped around his left shoulder. The left hand is lowered as if to hold the reins, the right raised to brandish a now missing weapon.

The elephant skin can symbolize Asiatic or African conquests. Since the several small heads related to the Metropolitan piece have

all been found in Egypt, and since the Roman personification of the Provincia Africa wears a similar headgear, the Metropolitan statuette probably shows Alexander as ruler of Egypt. He appears wearing elephant spoils on the coins of Ptolemy I. It has been maintained that the Dattari statuette represents some other Hellenistic king, perhaps a Ptolemy or a ruler of Bactria, but the features, with their fleshy but regular contours and fiery expression, agree well enough with the coin portraits to represent Alexander himself. The deemphasized, rather short hair characterizes many early likenesses. The type seems early Hellenistic, and the precise, robust workmanship, though sometimes characterized as Roman, could be not far in time from the creation of the original.

Hellenistic

O. Rubensohn, *AA* 1905, p. 67; Sale of Lambros and Dattari collections, Paris, Hotel Drouot, June 17–19, 1912, lot 427, pls. XLVIII–IX; M. Bieber, *Sculpture of the Hellenistic Age* (1961), fig. 298; H. Sauer, in *Festschrift E. von Mercklin* (1964), pp. 152ff. on related heads with elephant skin, pp. 156ff., pl. 54 for Metropolitan statuette. See also M. Bieber, *Alexander the Great in Greek and Roman Art* (1964), figs. 40–42 for coin portraits with elephant skin; G. M. A. Richter, *Portraits of the Greeks* (1965), vol. 3, fig. 1972, for identification as Demetrios I of Bactria.

47 (*detail*)

48

49

47 (*Color plate 7*)

LEG OF A MARBLE COUCH

Height 1.26m. (49⅝ in.); width .31m. (12⅛ in.); thickness .24m. (9½ in.)
Kavalla Museum, no. 1206 *Lambda*
Found in 1974 in "Macedonian" Tomb A, Kerdyllia, Eastern Macedonia

The leg is from a marble funerary couch made in imitation of wooden furniture. On a wooden couch, the relief would have been inlaid or carved and decorated with glass, gold leaf, ivory, and other materials. The recent finds at Vergina, where remains from a wooden funerary couch were discovered, contribute much new information about the decoration of wooden couches. Full-sized funerary couches in marble were also used in such Macedonian tombs. The couches symbolized those used at symposia; life after death was thought of as a happy existence, filled with pleasures like consorting with the gods at symposia.

Fourth century B.C.

G. M. A. Richter, *The Furniture of the Greeks, Etruscans, and Romans* (1966), pp. 58–63; H. Kyrieleis, *Throne und Klinen* (1969), p. 171 with n. 590, pl. 21, no. 3; L. Heuzey and H. Daumet, *Mission archéologique de Macédoine. Les sépultures macédoniennes et les lits funèbres*, pp. 250ff.

48 (*Color plate 8*)

PAINTED MARBLE GRAVE STELE

Height .685m. (27 in.); width .31m. (12⅛ in.); thickness .06m. (2⅜ in.)
Volos Museum, no. *Lambda* 356
Found in a tower of the city wall, Demetrias

The stele, reassembled from two fragments, is preserved nearly complete. The lower edge and part of the left acroterion are broken. The colors — white, red, brown, yellow, green, and blue — are faded.

An oblong grave stele with crowning pediment and acroteria. An inscription carved above gives the name of the deceased: ΜΕΝΕΛΑΟΣ ΗΓΗΣΙΔΗΜΟΥ ΑΜΦΙΠΟΛΙΤΗΣ. In the central part of the stele is a painted representation in a rectangular field. It is the familiar type of banqueting hero composition, except that here only two figures are shown, the dead man and his servant. A young man, clad in chiton and himation, reclines on a couch, the upper part of his body to the right, resting his left elbow on a thick cushion. His cloak is wrapped around his left arm and he holds a kantharos in his

left hand. His right arm is comfortably stretched out along his thigh. In front of the couch, in the center of the composition, is a small round table with elegant legs ending in lion paws. On the left, a servant boy dressed in a short chiton and a cloak, and holding what is probably an oinochoë, advances toward a krater. In the pediment is a painted pomegranate, a well-known funerary symbol.

Third–second century B.C.

M. Theochares, *Guide to the Volos Museum* (in Greek) (1972), p. 35, *Lambda* 356.

49

GRAVE STELE

Height 1.28m. (50⅜ in.); width 1.00m. (39⅜ in.); maximum thickness .19m. (7½ in.)
Marble
Archaeological Museum of Thessalonike, no. 11375a
Found in 1970 at Makriyalos

Piece missing at bottom left. Breaks on the faces and on the framing band.

The stele is almost rectangular; the sides have a slight taper. The low relief is framed by a projecting band.

A young woman (most probably the deceased) is shown in three-quarter view to the right, seated on a stool. A cock (a common

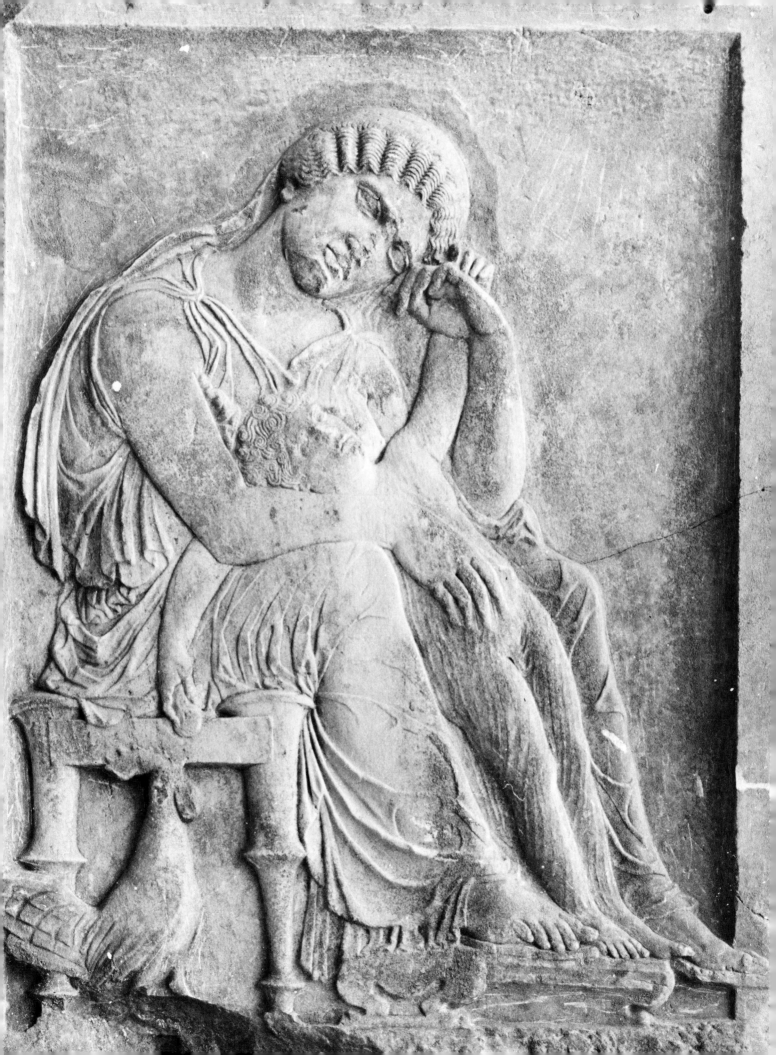

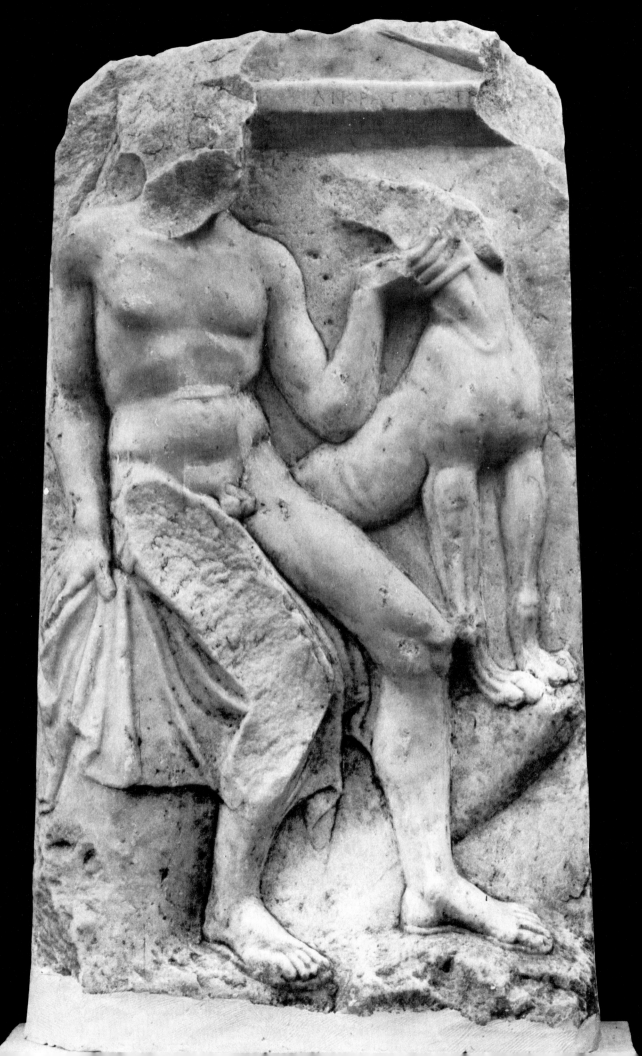

funerary symbol) is under the stool, facing right. The woman wears a peplos and a himation which covers the back of the head, the back, and legs. Her left elbow rests on her thigh and she bends her head down on her left hand in a pose of mourning and resignation. Her right forearm rests on her right thigh, her hand gently touching her small child. The trustful child leans back in his mother's arms, protectively encircled by her hands and legs in one of the most tightly composed and expressive representations of the deep inner relationship between mother and child in ancient art. His raised left hand touches her hand and his right arm hangs limply over her thigh; he holds something in his hand. The boy's head is bent back and his eyes turn upward as if to look into his mother's eyes, but their glances do not meet, for death keeps them apart.

Fourth century B.C.

50

GRAVE RELIEF

Preserved dimensions: height .90m. (35½ in.); maximum width .51m. (20 in.); maximum thickness .075m. (3 in.)
Local (?) marble
Dion Museum
Found at Kitros, Pieria (ancient Pydna)

The stele had a crowning pediment, most of which is lost. The name of the deceased is written on the horizontal band above the re-

lief: ΚΑΛΛΙΚΡΑΤΟΥΣ ΤΙ. The back of the stele is roughly dressed; the sides have been smoothed with the claw chisel.

On the left, a young naked man is seated on his himation spread out on rocks. He turns right toward the dog seated beside him, his body also facing right. The way the dog turns his head toward his master and the youth takes the dog's neck in his left hand with a tender gesture suggests their feeling for each other. The youth rests his right hand on the rock, the arm slightly bent. His feet, spread somewhat apart, also rest on the natural rock floor.

The subject of the young seated hunter is known from grave monuments of the large group of Ionic reliefs comprising the so-called Boeotian reliefs from Thespiai, the Thessalian reliefs, and the widespread group of Macedonian reliefs; this theme is absent in Attic iconography. Ionic, too, is the style, showing "eine gewisse Schwere und Weichlichkeit in der Ausführung" (G. Rodenwaldt, *Jahrbuch* 28 (1913): 332).

350–340 B.C.

G Bakalakis, *Reliefs* (in Greek) (1969). G. Despinis, "Kykladische Grabstelen des 5/4 Jhs. v. Chr.," *Antike Plastik,* Lieferung VII; *Bulletin of The Fogg Museum of Art,* Harvard University 10 (1947): 184; *AJA* 58 (1954): 227; G. Despinis, "Zum Motiv des Jünglings an dem Ilissos-relief," *Marburger Winckelmannsprogramm* (1962), pp. 44ff.

50A *(not reproduced)*

BRONZE HYDRIA (KALPIS)

Height .49m (19⅛ in.); diameter at body .32m (12½ in.)
National Museum, Athens,
no. 18775
From a tomb at Pharsala (Pharsalos) in Thessaly. It was set in a hollowed-out block.

The scene at the base of the vertical handle of this superlative vessel is the rape of Oreithyia by Boreas. Made as a ceremonial jug for water or other liquids, this hydria-kalpis contained the ashes of the deceased, as was so often the case in the archaeology and literature of northern Greece. The North Wind Boreas carried off Oreithyia, daughter of King Erechtheus, from the heart of Athens. Thus, a scene such as this could symbolize Athenian culture in the northlands of Greece or the carrying off of a delicate soul to eternal lands. Pharsala, or Pharsalos, had Athenian connections in the fifth century B.C. and supported Philip II of Macedon in the fourth.

350 to 340 B.C.

E. Diehl, *Die Hydria, Formgeschichte und Verwendung im Kult des Altertums* (1964), p. 222, no. B 201 (then in the Volos Museum). T. S. MacKay, in *The Princeton Encyclopedia of Classical Sites* (1976), p. 700.

52

51

51

GILDED BRONZE VOTIVE PLAQUE

Height .119m. (4⅝ in.); width .092m.
(3⅝ in.)
Archaeological Museum of Komotini,
no. 1589
Found at Mesemvria in Thrace

The plaque has a relief in repoussé technique
showing a group of divinities: the goddess
Kybele is seated on a throne holding a liba-
tion bowl in her right hand and a scepter in
her left. Three libation bowls (omphalos phi-
ales) hang on the wall; perhaps they are vo-
tive offerings. Artemis Hekate, holding
torches, stands beside Kybele, and Hermes
Kadmylos stands on her other side. The fig-
ures are framed by Ionic columns with a pedi-
ment above. In the pediment, a seated Pan is
playing the syrinx among sheep or goats.

Second half of the fourth century B.C.

Praktika (1973), pl. 82a; Th. Stephanidou,
"Votive relief from Potidaia"(in Greek),
Makedonika 13 (1973): 112–113.

52

SILVER VOTIVE PLAQUE

Height .065m. (2½ in.); width .16m.
(6¼ in.)
Archaeological Museum of Komotini,
no. 1610
Found at Mesemvria in Thrace

A family of worshippers is shown making
gestures of reverence to a seated female fig-
ure (the goddess Demeter?) who is holding a
poppy fruit in one hand and raising her gar-
ment with the other. The relief is executed in
the repoussé technique.

End of the fourth century B.C.

Praktika (1973), pl. 96a; *TAM*, no. 452, pl.
60. G. Neumann, *Probleme des griechischen
Weihreliefs* (1978), pl. 13C.

53 (*Color plate 6*)

SILVER RHYTON

Length (with handle) .29m. (11½ in.)
George Ortiz Collection

The rhyton, of hammered and chased silver,
has the form of a deer's head. Handle, ears,
and antlers are separately made. The antlers,
the inside of the ears, the beaded and ovolo
moldings of the vessel's rim, and details of
the frieze are gilded. There was apparently
an outlet for liquid in the muzzle of the deer.
The eyes are shallowly hollowed to receive
an inlay.

The horn of the rhyton has a frieze of six
warriors. All the figures carry large round
shields and are nude except for their baldrics
and headgear. Three wear pilos-shaped
helmets — one a petasos, or kausia, one a
Corinthian, and one a decorated Attic helmet.
All the warriors except one are beardless.

The deer's head is closely related to a
silver rhyton now in Trieste. A third member
of the group, of softer, broader, calf-like
form and with ears laid back instead of
pricked forward, was found at Rozovets in
Bulgaria. The Trieste and Rozovets rhyta are
usually dated in the early fourth century B.C.
The gold rhyton, also a deer's head, from
Panagyurishte in Bulgaria is a later, more
flamboyant member of the series, with an

53

elaborate, inorganically added handle and a rhyton horn that curves steeply upward.

While the deer of the Geneva rhyton is very like the Trieste and Rozovets examples, the style of the frieze is quite different. The relief is higher, more definite, the figures chunky and muscular. In large-scale sculpture, the best parallels are the battle reliefs of the Trysa Heroön and the Nereid Monument from Xanthos. The Atticizing East Greek works are datable in the eighties or seventies of the fourth century. Here one sees the high but rather simply modulated relief, the heavy rhythms, the interest in back views, the pairs of almost identically posed figures that stride forward to meet other pairs.

Though typology and composition of the frieze are Greek, the workmanship is typical of the metalwork circulated, perhaps from centers on the Propontis or the Black Sea, among the Thracians and their neighbors in what is today southern Russia. Especially comparable are the wonderful Dionysiac reliefs, with some local iconographic features, on the silver jug from Borovo in Bulgaria.

The rhyton form had a special significance for the Thracians, as attested by the many finds and by representations in art; clay imitations from southern Italy are often decorated with griffins and Arimasps evoking the fabled lands to the northeast of the Greek

world. This region was not nearly so remote from Alexander's Macedon. Many of Philip's campaigns, and Alexander's first, were against their warlike Thracian neighbors; Philip made political marriages with the daugher of a Getic chief and probably with a Scythian princess. A cultural continuity across broad areas of the ancient world, exemplified by works of art like the Greco-Thracian deer-head rhyton, already existed long before Alexander's conquests.

First half of fourth century B.C.

Unpublished. The owner's description, technical observations, dating, and attribution to the Thracian ambient are the basis of this catalogue entry. See I. Marazov, *Ritonite* (1978), in Bulgarian with summaries in English and other languages, for the fullest and most up-to-date presentation of the Thracian and related rhyta; P. Wuilleumier, *Tarente, des origines à la conquête romaine* (1968), pp. 336 ff., pl. XVIII, 2 for the Trieste rhyton, with attribution to a workshop on the Black Sea; E. Simon, *Enciclopedia dell' arte antica* 7 (1966): 935, fig. 1053, for an unconvincing attribution to Taras; I. Venedikov & T. Gerassimov, *Thracian Art Treasures* (1975), figs. 121–122 for the Rozovets rhyton, fig. 127 for the Panagyurishte treasure, fig. 130 for the Panagyurishte stag head rhyton; *Thracian Treasures from Bulgaria* (Metropolitan Museum of Art exhibition booklet, 1977), fig. 42 and Marazov, op. cit., figs. 135, 136 for the jug from Borovo; W. Childs, *The City Reliefs of Lycia* (1978), pp. 12–13 for the Nereid Monument, 13–14 for the Trysa Heroön, compare especially pls. 7.1, 15, 16; A. M. Snodgrass, *Arms and Armor of the Greeks* (1967), fig. 53 for a helmet like that of the bearded man on the rhyton, pp. 95–96 for a discussion of ancient terminology; H. Hoffmann, *Tarentine Rhyta* (1966), for the South Italian rhyta, which he considers derived from Thracian models in metal; N. G. L. Hammond, *Greek, Roman and Byzantine Studies,* Duke University, 19 (1978), p. 336 for Philip's Scythian and Getic queens.

54

55

56

54

GOLD BOW FIBULA

Length .045m. (1¾ in.)
Staatliche Museen Preussischer Kulturbesitz,
Antikenmuseum Berlin, no. 1960.1
Said to be from Derveni

On the tubular bow of the fibula are threaded
four large biconical beads, each decorated
with filigreed petal ornament and flanked by
spacers of flattened spool shape. The rectan-
gular hinge plate, from which the bronze pin
is missing, has a frontal female head wearing
a lion skin, probably Herakles' consort Om-
phale, in low relief on each side. The catch
plate is T-shaped, with outlining and central
rib of spool wire. On it perches a sphinx,
made in the round from two joined halves.
She is flanked by large, smooth gold beads on
filigreed cylindrical bases; between her paws
emerges a horse head.

Such fibulas, commonly found in the
northeastern part of the Greek world, must,
like the closely related mill-wheel type, have
secured the shoulders of bulky garments. The
culminating phase of a fashion important
since the fifth century, they were worn in
sets, sometimes with dangling ornaments or
with chains festooned from one fibula to the
next.

Fourth century B.C.

K. Schefold, *Meisterwerke griechischer
Kunst* (1960), no. 577; P. Amandry, *Collec-
tion Hélène Stathatos* III (1963), p. 203, figs.

111 a–d for the Berlin fibula, and pp. 203ff.
for the type and its function, p. 209 for a list
of sets; *Greek Gold,* no. 77; Greifenhagen,
Schmuckarbeiten II, p. 89, pl. 65, 4–6. See
also I. Venedikov & T. Gerassimov, *Thra-
cian Art Treasures* (1975), pl. 210 for a set of
millwheel fibulas, pendants and festoons,
from Boukyovtsi in Bulgaria, whose original
arrangement is especially clear.

55 (Color plate 12)

PAIR OF GOLD BOW FIBULAE

Widths .025m. and .028m. (1 in.)
Veroia Museum, nos. 991 a–b
Found in a double "Macedonian" tomb at
Veroia

The hinge-plate on each of the fibulae is a
plaque in repoussé technique applied to a
smooth, flat piece of gold; it shows Omphale,
the spouse of Herakles, ancestral hero of the
Macedonians. The catch-plate has a protome
of Pegasus, the winged horse, in relief. The

pins themselves, which were of bronze, are
missing, but traces of them remain on the
gold plaque where·they were attached. A
fibula of the same type in Berlin (Staatliche
Museen, inv. no. 30219.453) also comes
from northern Greece.

End of fourth into the third century B.C.

TAM, no. 63, pl. 12. See also *Greek Gold,*
pp. 197–198, no. 75. Greifenhagen,
Schmuckarbeiten II, p. 89, pl. 65, nos. 1, 3, 7.

56

GOLD NECKLACE

Length as restrung .377m. (14⅞ in.)
Indiana University Art Museum, Blooming-
ton, Indiana, no. 70.105.4. From the Burton
Y. Berry collection

The necklace has finials in the form of ribbed
Herakles clubs, whose tips are decorated with
filigree work and granules. All the beads,
hollow, are made in two halves. Near the
ends, smooth beads alternate with lobed, bi-
conical ones. The central portion is made up
of sixteen smooth beads, each decorated with
a rosette and supporting a lobed, amphora-
shaped pendant decorated with granules. The
smooth beads alternate with beads of similar
size that are decorated with filigree work and
granules; from sixteen of the seventeen hang
smooth, bud-shaped pendants. The join of
each pendant to its bead was masked by a
small disc.

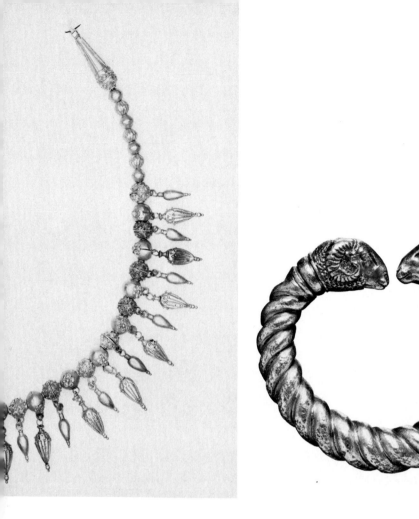

58

57

This is a uniquely rich combination of familiar fourth-century bead, pendant, and finial types. A necklace from the Third Lady's Tomb in the Great Bliznitsa (Taman peninsula, southern Russia) seems closest, with parallels for both kinds of pendants as well as for the finials and two of the bead types. Similar Herakles club finials are seen with smooth and filigreed beads in a necklace from Abdera (catalogue no. 59), and with filigreed beads only in one from a late-fourth-century burial in the Maltepe mound at Mezek in Bulgaria.

Second half of fourth century B.C.

Indiana Art Museum Bulletin I, I (1977), cover and p. 62. See also M. I. Artamanov, *Treasures from the Scythian Tombs* (1969), fig. 309 for the necklace from the Great Bliznitsa; *TAM,* no. 423 for the neckace from Abdera; I. Venedikov & T. Gerassimov, *Thracian Art Treasures* (1975), pl. 198 for the Mezek necklace.

57
BRACELET WITH RAM'S HEAD FINIALS

Diameter .055m. (2⅛ in.)
Silver
Norbert Schimmel collection, New York
Probably from Macedonia

The hoop of the bracelet is formed by two thick silver wires twisted together, originally with a row of granulation in the groove between them. The finials are rams' heads, rather plainly and robustly modeled; details of the fleece are indicated with a punch. Instead of the ornate collars usual in late-fourth-century gold examples, the silver bracelet has simple, heavy convex moldings.

The austere workmanship, dictated partly by the material less ductile than the gold, has a forerunner in a pair of twisted, snake-headed bracelets from Nea Triglia in the Chalkidike, attributed to the fifth century B.C. Also ascribed to the fifth century are a pair of gilded copper ram's head bracelets from Kourion on Cyprus, which suggest the Schimmel piece in the style of the rams' heads as well as the treatment of the hoop. Later, but still related in style as well as typology, is the rock crystal and gold example in the Metropolitan from the Ganymede treasure, datable in the second half of the fourth century.

Fourth century B.C.

H. Hoffmann, *The Norbert Schimmel Collection* (1964), no. 34; *Greek Gold,* no. 58; H. Hoffmann in *The Norbert Schimmel Collection* (O. Muscarella ed., 1974), no. 70. See C. Alexander, *Greek and Etruscan Jewelry,* Metropolitan Museum of Art (1940), fig. 3 for the gold and rock crystal bracelet in the Metropolitan.

58
GOLD RING WITH NEREID RIDING A HIPPOCAMP

Height of bezel .017m. (⅝ in.) (Reproduced three times actual size)
Museum of Fine Arts, Boston no. 95.92.
Catherine Page Perkins Fund

The ring belongs to Boardman's Type III. It is carved in intaglio with the figure of a Nereid, dressed in chiton, himation, and necklace, riding on a bridled sea horse.

The Nereid is probably Achilles' mother Thetis, a subject especially popular in the northern Greek regions close to Achilles' Thessalian homeland. The Epirote royal house claimed descent from Achilles, as did Alexander through his mother, the Epirote princess Olympias. The procession of Nereids bringing the armor in which Achilles will meet his glorious death, or accompanying souls to the

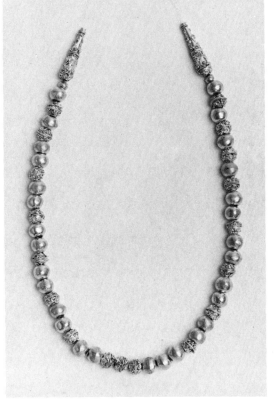

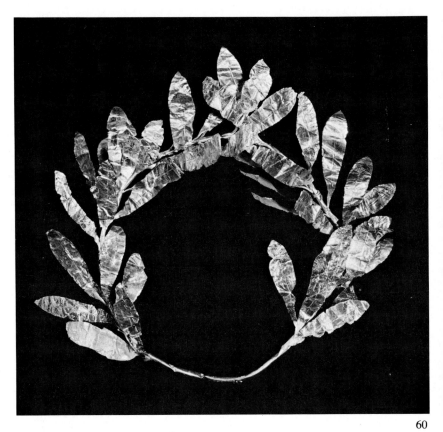

59

60

Isles of the Blessed, is a frequent subject in early Hellenistic funerary art.

The scheme of the ring engraving, with a decorously clothed Nereid seated upright on her proportionately small mount, probably predates Skopas' famous sculptural group of the Sea Thiasos. It is seen throughout the fourth century, in versions ranging from the exquisite gold cutouts under rock crystal, found at Homolion and reportedly at Taranto, to the ornate pendants from south Russia, the versions from Derveni and the Vale of Tempe, the wholly Thracian interpretation on a harness ornament from Letnitsa in Bulgaria. Skopas' innovations are perhaps first reflected in the terra-cotta appliqués of the sarcophagus from Anapa on the Taman Peninsula. Here the interest shifts to the larger and more varied sea monsters, some of them part human. The Nereids' poses are more abandoned, their garments stirred by the wind. The matronly elegance of the Boston Thetis has given way to a Hellenistic sense of nature's uncontrollable forces.

Probably first half of the fourth century B.C.

Annual Report (Museum of Fine Arts, Boston, 1895), p. 24; A. Furtwaengler, *Die antiken Gemmen* I (1900), Taf. IX,42; *Greek Gold,* no. 111; J. Boardman, *Greek Gems and Finger Rings* (1970), pp. 220, 297, pl. 686; S. Miller, *Two Groups of Thessalian Gold* (1979), p. 19 for Thetis in Thessaly; C. Kraay, *Greek Coins* (1966), pl. 150, no.

473 for coins of Pyrrhos of Epiros, 297–272 B.C.; P. Gardner, *BM Coins, Thessaly to Aetolia* (1883), pl. 7,1 for coin of Larissa Kremaste in Thessaly, datable 302–286 B.C.; *TAM,* no. 4 for the ring from Homolion; *Greek Gold,* no. 99 for the related piece of reportedly Tarentine provenance; M. I. Artamanov, *Treasures from the Scythian Tombs* (1969), fig. 296 for the Great Bliznitsa pendants; *Catalogue of the Jewellery . . . British Museum,* nos. 3046–7, for discs found with fibulas and chain; *TAM,* no. 181 for Derveni examples; I. Venedikov & T. Gerassimov, *Thracian Art Treasures* (1975), pl. 287 for the Letnitsa ornament; A. F. N. Stewart, *Skopas of Paros* (1977), pp. 99–101 on Skopas' Sea Thiasos; M. Vaulina & A. Wąsowicz, *Bois grecs et romains de l'Eremitage* (1974), no. 12 for the Anapa sarcophagus.

59

GOLD NECKLACE

Preserved length .25m. (9⅞ in.)
Archaeological Museum of Komotini, no. 1570
Found in a cist grave, Abdera

Gold necklace with round beads, most of which are plain; the others are made of two hemispheres with double spirals in fine filigree. The two large conical terminals repeat the filigree patterns in three zones.

Fourth century B.C.

TAM, no. 423, pl. 59; *Deltion* 29 (1973-74): Chronika. For similar examples see *Catalogue of the Jewellery . . . British Museum,* nos. 2036–2039, 2044.

60 *(Color plate 11)*

GOLD OLIVE WREATH

Diameter .14m (5½ in.)
Archaeological Museum of Thessalonike, no. 5408
Found in 1938 in Grave *Alpha,* Sedes, Thessalonike

The wreath is made of gold tubing with holes at regular intervals for attaching the gold olive leaves. There are forty-seven leaves.

Fourth century B.C.

AE (1937), pp. 866ff., fig. 2; H. Hoffmann & V. von Claer, *Antiker Gold-und-Silber-*

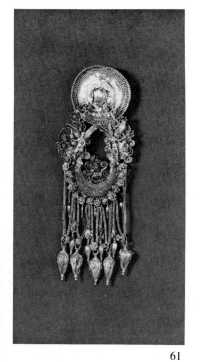

61

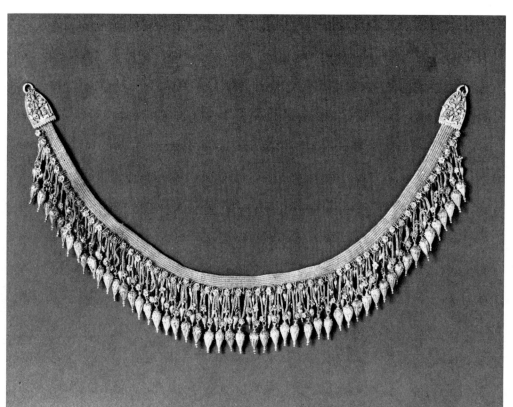

62

schmuck (Museum für Kunst und Gewerbe Hamburg) (1968), pp. 43ff., no. 29 (with bibliography for wreaths used in burials).

61 (*Color plate 14*)

GOLD EARRING

Height .083m. (3¼ in.)
On loan to the Dallas Museum of Fine Arts from the Schimmel Foundation
Said to be from Trebizond

The upper disc, which masks an ear hook in the form of a snake, has lost its originally very rich central ornament. The rim is of corrugated gold ribbon, the tip of each fold enhanced by a granule. From the disc, attached at either end, hangs a boat-shaped pendant covered with an all-over diamond pattern in minute granulation and "ribbed" with spool wire. Tiny double rosettes cluster thickly along its lower edge. From them hang tiers of pendants on chains: "spear points" on short chains; smooth bud pendants, topped by honeysuckle palmettes with granulated centers, on longer chains; and handleless, decorated "amphora" pendants on V-shaped festoons of chain, the join of each amphora to its chain masked by a small cylindrical element with rosette ends. From the center of the boat pendant rises an acroterionlike formation of

ribbon-scrolls, rosettes, and tendrils. At either side, another mass of plant ornament masks the attachment of pendant to disc. Figures of nude, slender Erotes with long wings hover before the arrangements of tendrils and honeysuckle palmettes, attached by wires at shoulder level so that they are levitated above, rather than touching, their miniature pedestals.

Other earrings of this type, all of the most fanciful richness and elaboration, have been found in southern Russia, northern Greece (see catalogue no. 138), and Asia Minor. One version, in the British Museum, is said to come from Crete, and a locally made variant is in the Taranto Museum, but the great majority of examples come from the northeastern part of the Greek world. Particularly close to the Schimmel piece is one from Madytos, on the Hellespont, in the Metropolitan. These pieces, with their deeply curved "boat hulls" and acroterionlike arrangements of plant ornament, have a clearer articulation than most members of the group. The boat earrings seem connected, by the style of their figural elements and by such ornamental details as the honeysuckle palmettes with granulated centers, with the ateliers that produced the Boston Nike earring and other exquisite sculptural earrings (cf. catalogue no. 63).

Second half of fourth century B.C.

J. Settgast *et al., Von Troja bis Amarna* (1978) Suppl. no. 93a (H. Hoffmann). See M. I. Artamanov, *Treasures from the Scythian Tombs* (1969), figs. 304 for a parallel from the Great Bliznitsa, 326–328 for a pair from Theodosia; I. Venedikov & T. Gerassimov, *Thracian Art Treasures* (1975), fig. 196 for a rather simpler version from a fourth-century burial at Vratsa in Bulgaria; A. Oliver, *Bulletin,* Metropolitan Museum of Art, N.S. XXIV (1966), figs. 8–9 for a pair from Asia Minor; C. Alexander, *Jewelry* (1928), fig. 55 for the version from Madytos in the Metropolitan; *Catalogue of the Jewellery . . . British Museum,* no. 1655 for an example from Crete; C. Belli, *Il Tesoro di Taras* (1970), pp. 182–183 for a Tarentine derivative.

62 (*Color plate 14*)

GOLD NECKLACE

Length .343m. (13½ in.)
On loan to the Dallas Museum of Fine Arts from the Schimmel Foundation
Said to be from Trebizond

The strap of the necklace is made from interlocking rows of loop-in-loop chain. Its terminals are tongue-shaped; each has an acroterionlike plant ornament of scrolls, rosette, and honeysuckle palmette rising from

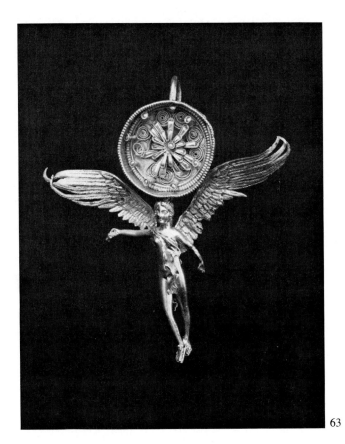

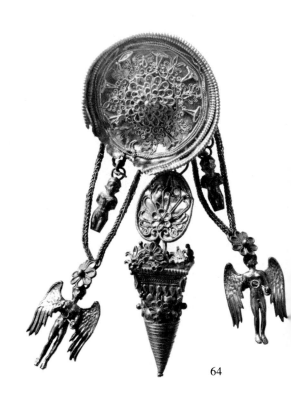

64

63

an acanthus chalice. This decoration is partly in filigree work, with the rosette and the palmette applied in sheet gold. Granulation of sandlike fineness covers the petals of the rosette and the palmette center. From the strap hang plain bud pendants on short chains and decorated handleless amphora pendants on longer, V-shaped festoons of chain. All joins are masked by double rosettes; along the edge of the strap, these alternate with minute budpendants.

This necklace is an extremely ornate but sensitively proportioned and detailed version of a widespread early Hellenistic type. The decoration of its finials is richer yet lighter and more clearly composed than that seen on the well-known Thessalian versions of the same type. In its delicacy and its expert use of granulation it represents a different, highly sophisticated workshop tradition. The piece forms a set with catalogue no. 61; wherever they were produced, the center must have supplied both eastern and north Greek markets.

Second half of fourth century B.C.

J. Settgast *et al.*, *Von Troja bis Amarna* (1978) Suppl. no. 93a (H. Hoffmann).

63 (*Color plate 10*)

EARRING WITH NIKE PENDANT

Height .053m. (2 in.)
Gold
Virginia Museum, Richmond, no. 64.12.1, The Williams Fund, 1964

On the richly ornamented disc, a two-tiered rosette, its petals outlined in filigree, is surrounded by coils of spiral-spool wire and tiny, filigree-outlined discs on stems. The pendant Nike hangs directly from a loop on the edge of the main disc. Nude and of a boyish slimness, she steps forward into the air, supported on long, upward-sweeping wings with engraved feathers. Her left arm is outstretched, her right lowered; each held some now unidentifiable attribute. A long mantle once fluttered behind her; only the end, pulled diagonally across the front of her body, survives. Her hair is gathered up in a topknot; she wears sandals and earrings. The figure is solid cast, with details engraved and elements such as wings and drapery added separately.

The girl's hairdo and her dainty but sharp and severe profile recall the Nike-charioteer of the Boston earring. Once suspected of being a forgery, the exquisite Richmond earring has been vindicated by recently found parallels. A single earring from Izmit is a mirror image and corresponds almost exactly except that it has a biconical spacer bead between disc and pendant. A magnificent pair in the Varna Archaeological Museum have very similarly ornamented discs from which the figure hangs directly; the free-floating drapery survives, framing the nude figures. Each of the Varna Nikai pours a libation from a rhyton into a miniature phiale. The attributes are interesting because clearly chosen to suit the preferences of the Thracian market. The Richmond, Izmit, and Varna earrings are so much alike that all must have been produced in the same ambient.

The nude female sprites are conventionally known as Nikai, but it has been pointed out that they can have little to do with military victory. They are, rather, the girl counterparts of male Erotes. Greifenhagen suggested that they might be thought of as Charites, the Graces attendant on Aphrodite.

Second half of fourth century B.C.

Greek Gold, no. 13; A.Greifenhagen, *Gnomon* 40 (1968): 697 for doubts on au-

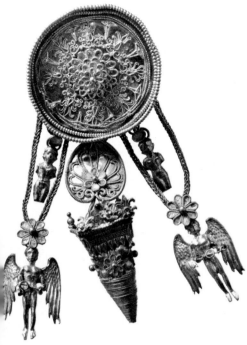

65

thenticity; H. Hoffmann, *AJA* 73 (1969), p. 448, n. 7 for reaffirmation. See N. Fıratlı, *Annual of the Archaeological Museums of Istanbul* 11–12 (1964): cover, pp. 212ff., and pl. 43 for the Izmit earring; A. Greifenhagen, *Schmuck der alten Welt* (1974), p. 38 for the Charites interpretation in connection with a related but much more loosely modeled pair of Nike earrings.

64

PAIR OF GOLD EARRINGS

Height .06m. (2⅜ in.), .064m. (2½ in.)
Staatliche Museen Preussischer Kulturbesitz, Antikenmuseum Berlin, no. GI 165/6
Said to be from Kyme in Aeolis

The earrings are particularly ornate but clearly structured elaborations of the disc-and-pendant type. On the disc, a four-tiered, applied rosette is surrounded by a palmette-and-bellflower design, outlined in filigree wire, and by borders of countertwisted and beaded wire. Below the disc hangs a palmette-shaped plaque, its details outlined in filigree. From this is suspended the main pendant. Its top, of pier-capital form, supports small, acroterionlike palmette and granule ornaments. Below, it rests on a double layer of globules, decorated with rosettes, which terminates in a large inverted cone formed of

coiling wire. From the large disc, at either side of the cone pendant, hang small solid-cast figures of nude Erotes on V-shaped chain festoons. Each Eros carries the *iunx,* a magic wheel associated with love spells, and is joined to his chain loop by a tiny rosette. Between the arms of each V hangs a nude, truncated female figure, the Greek doll; it stands for the childish pastimes a girl set aside with marriage.

The earrings are associated with a treasure, most of which is in the British Museum, and which is given an approximate date by a coin of Alexander the Great found with it.

Second half of fourth century B.C.

K. Hadaczek, *Der Ohrschmuck der Griechen und Etrusker* (1903), p. 31, fig. 53; R. Zahn, *Ausstellung von Schmuckarbeiten aus Edelmetall* (1932), p. 58, no. 15 a–b; *Greek Gold,* no. 19; Greifenhagen, *Schmuckarbeiten* II, p. 49, pl. 40, I. See also *Catalogue of the Jewellery . . . British Museum,* nos. 1672–1673 for a very similar pair of earrings, no. 1946 for the matching necklace, p. XXXVIII and no. 1611 for the find as a whole.

65 (*Color plate 9*)

THREE EARS OF WHEAT

Height .30m. (11⁴/5 in.)
Gold
Norbert Schimmel collection, New York.
From the Hambeuchen, Hirsch, and Loeb collections.
Said to have been found at Syracuse

The kernels, hollow and unbacked, are wired in tiers to the central stems; a fine, rolled gold

66

wire emerges from the tip of each grain to represent the "silk." The leaves are made of sheet gold, delicately striated to suggest the fibers, and are grooved at the base to fit around the stems. The stalks are fastened together at the bottom, forming a spray.

This piece, reportedly found at Syracuse in 1900, is the most famous and, along with an example found in a Hellenistic burial on the Taman Peninsula, the most securely ancient of a by now quite large group of which some examples are questionable. It must have been a votive or a funerary offering, invoking Demeter as a goddess of regeneration. The wheat ears from the Great Bliznitsa on the Taman peninsula were held in the hand of a female corpse, perhaps as a badge of sacred office. The wonderful preservation of the Schimmel piece suggests that it must have been preserved inside a sarcophagus or a chamber tomb. Its sensitive but ordered naturalism relates it to late Classical and early Hellenistic funerary wreaths.

Fourth–third century B.C.

S. P. Noe, *The Coinage of Metapontum, Numismatic Notes and Monographs* 32 (1927):

9, illus.; P. Wolters, *Festschrift James Loeb* (1930), pp. 111ff., figs. 1–15, pl. XVI; *Die Antike* 6 (1930): 301; D. von Bothmer, *Ancient Art in American Private Collections* (1954), no. 310, pl. LXXXVII; K. Schauenburg, *RM* 64 (1957): 198, and *Jdl* 78 (1963): 317, n. 106; *Greek Gold*, no. 137; P. Amandry, *AJA* 71 (1967), p. 205; E. Simon, *Die Götter der Griechen* (1969), pp. 115ff.; H. Hoffmann, *The Norbert Schimmel Collection* (1974), no. 74. See A. Peredolskaja, *AK*, Beiheft II (1964), p. 22, cover and pl. 16, 4 for the wheat ears from the Great Bliznitsa.

66 *(Color plate 10)*

DOUBLE-SNAKE BRACELET

Diameter .095m. (3¾ in.)
Gold with garnet
Schmuckmuseum Pforzheim im Reuchlinhaus, no. 1957.12. From the J. Hirsch collection
Said to be from Egypt or from Eretria

The tails of two snakes are twisted together in a Herakles knot around a large, oval cabochon garnet; the tail tips emerge in thin loops and ripples. Each of the head ends of the snakes takes a turn and a half around the arm, then wriggles upward or downward along it. Flattened and plain as they wind around the arm, the snakes are powerfully modeled at the ends. Scales were indicated by stippling,

the backbones by ridges; details of the head were defined by chasing, and the eyes were once inlaid.

The Pforzheim bracelet is the most elaborate and at the same time one of the most naturalistically sculptured of all Hellenistic snake bracelets. Related pieces are the pair of single-snake bracelets, also twisting around garnet cabochons, in the Stathatos collection. A thin hoop bracelet made up of two snakes, naturalistically modeled and with their tails joined in a Herakles knot, comes from a probably early-second-century burial at Pelinna. It seems to be a more mannered and attenuated adaptation of the motive of the Pforzheim bracelet.

Early Hellenistic

Nachlass Dr. J. Hirsch, Hess-Schab auction catalogue, Lucerne, December 7, 1957, no. 97, pl. 47; K. Schefold, *Meisterwerke griechischer Kunst* (1960), no. 599; P. Amandry, *Collection Hélène Stathatos* III (1963), pp. 253ff., n. 7, fig. 152 for Pforzheim bracelet, and nos. 256–257 for the pair of single-snake bracelets; *Greek Gold*, no. 67 for Pforzheim snake bracelet, and no. 68 for a spiral child's bracelet in the form of a *ketos,* reportedly found with it and also acquired by Pforzheim. See S. Miller, *Two Groups of Thessalian Gold* (1979), pl. 24a for the Pelinna bracelet, pp. 47–48 for the dating.

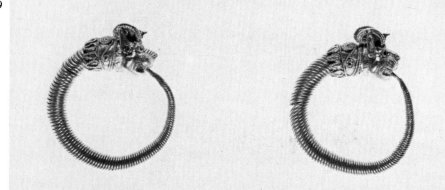

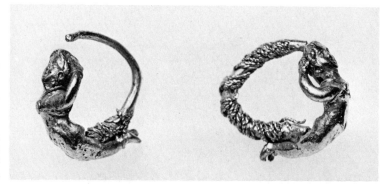

67

GOLD PIN

Length .075m. (3 in.); length of chain
.055m. (2⅛ in.)
Kozani Museum, no. 69
Found at Tsotyli, western Macedonia

This gold pin, which is without its sheath, is
of the type most widely known in the north-
ern Greek area. Braided chains are attached
to the pinheads by golden wire; at the ends of
the chains are dark red stones shaped like
spools.

Fourth century B.C.

P. Jacobsthal, *Greek Pins* (1956), p. 137, fig.
393; *TAM*, no. 39, pl. 9.

68

PAIR OF GOLD EARRINGS

Diameter .012m. (½ in.)
Veroia Museum, no. 114 a–b
Found in Grave *Iota Delta,* Sid. Stathmou
St., Veroia

The earrings are formed of rope braid wound
around a hoop attached to a naked figure of
Aphrodite(?) wearing earrings, bracelets, an-
klets, and breast ornaments (periammai).
Earrings were made in this technique in the
fourth and third centuries B.C.

Second half of the fourth century B.C.

TAM, no. 69, pl. 12. For similar earrings
with Erotes, see T. Hackens, *Catalogue of
the Classical Collection, Classical Jewelry*
(Museum of the Rhode Island School of De-
sign, Providence, 1976), p. 89, no. 32.

69

GOLD HOOP EARRINGS
WITH HEADS OF LION-GRIFFINS

Height .03m. (1¹/₅ in.)
Museum of Fine Arts, Boston,
nos. 01.8159-60. Purchased by Contribution

The sharply tapering hoop is made of plain
wire, wound spirally around a gold core. The
finial is the head of a fabulous beast, the lion-
griffin, made in two halves and with details
added separately. A collar with filigreed
scrolls and toothed ornament joins each head
to its hoop.

The lion-griffins are one of the many Greek
borrowings from Achaemenid Persian art,
beginning even before Alexander's conquests
but gaining momentum in the early Hellenis-
tic period. Many examples of this earring
type are known, most of them from southern
Russia or from Cyprus. A version found in
Egypt with a coin of Ptolemy I or II and one
found on Cyprus with a coin of Alexander
confirm an early Hellenistic dating for the
category; Higgins ascribes the creation of the
type to Cyprus.

Early Hellenistic

Greek Gold, no. 25. For comparison, see
R. Higgins, *Greek and Roman Jewellery*
(1961), p. 162 (ii) for the type; T. Hackens,
Classical Jewelry (1976), no. 26 for two ex-
amples in Providence and an up-to-date list of
comparable pieces.

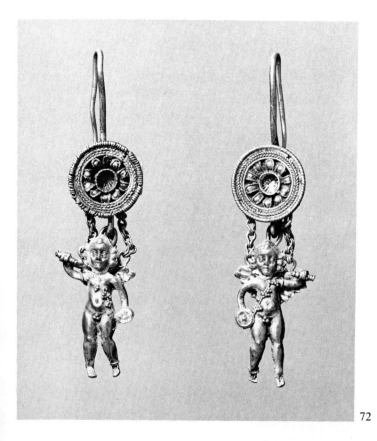

72

72

GOLD EARRINGS WITH EROS PENDANTS

Height .035m. without hook (1⅜ in.)
Museum of Fine Arts, Houston, no. 37.42,
the Annette Finnigan Collection

The earrings are of disc-and-pendant type.
Each has a disc with a rosette, its center once
inlaid, surrounded by rows of plain, coun-
tertwisted, and spiral-spool wire. From each
disc, suspended by a loop at the center and a
short chain at each side, hangs a figure of
Eros. The two are mirror images, as is usual
in Greek earring pairs. They are cast flat in
open molds and have been bent into position,
with details added afterward. Each holds an
alabastron(?) in his raised hand, a phiale in
his lowered hand. They are nude except for a
diagonally worn garland, an armband, and an
ankle bracelet each. Granules decorate the
garlands and, in groups of three, indicate the
genitals of the plump little figures.

The type is of early Hellenistic origin. The
unusual side chains are paralleled in an ex-
ample, presumably of Italian provenance, in
the British Museum from the Castellani col-
lection. North Greek versions include exam-
ples from Abdera, Neapolis, Amphipolis, and
Pella.

Hellenistic

H. Hoffmann, *Ten Centuries That Shaped the
West* (1971), no. 216. See R. Higgins, *Greek
and Roman Jewellery* (1961), p. 166 (ii) on
the type; *Catalogue of the Jewellery . . .*

British Museum, no. 1876 for the side chains;
TAM, no. 424 for the Abdera earrings, no.
311 for a pair from Neapolis, no. 380 for ex-
ample from Amphipolis, no. 81 for example
from the East Cemetery at Pella; G. Becatti,
Oreficerie antiche (1955), nos. 402–403 for
earrings of Tarentine provenance very close
to those in Houston.

72A *(not reproduced)*

PAIR OF EARRINGS WITH NIKE DRIVING A CHARIOT

Height .086m (3⅜ in.); width .055m (2⅛ in.)
Gold, set at the top with two red stones
(garnets)
Volos Museum, nos. M194, M195
From Pelinna in Thessaly

Nike drives a two-horsed chariot (a biga).
The animals are supported by a ship's prow
set just behind their forelegs, and the ensem-
ble stands on a decorated, rectangular pedes-
tal. Although the Nike, horses, chariot, and
supports have a somewhat awkward air to
their proportions and relationships, they
abound in little details, such as granulation,
wire, and chasing for the animal's skin. The

device rising above the horses' heads and set
with stones is fairly complex, leading to the
fastening hoop which runs from a loop at the
top back down behind the chariot to the base.
S. G. Miller has suggested these large ear-
rings might reflect a monumental sculptural
group, which would have stood on a pedestal
and needed a support such as a ship's prow.
Speculatively speaking, the Macedonian
kings Demetrios Poliorketes or Philip V
could have erected such a monument in Thes-
saly early or late in the third century, but
such a hypothetical work of art may have
been commissioned elsewhere.

Third century B.C.

S. G. Miller, "Two Groups of Thessalian
Gold. Hellenistic Jewelry from Pelinna,"
*University of California Publications, Clas-
sical Studies,* vol. 18, pp. 42–44, 61–62, pls.
24, 25 (a full and detailed interpretation and
catalogue); *TAM,* no. 9, pl. 3.

74

75

73

73

NECKLACE WITH LION'S HEAD FINIALS

Length .445m. (17½ in.)
Gold with amethyst and beryl(?)
Virginia Museum, Richmond, no. 64.28

The lion's head finials, ending in a hook-and-eye clasp, have collars formed by semiprecious stone beads of irregular truncated-conical form, held in gold capsule settings. The chain alternates small spool-shaped gold beads with large cylindrical openwork ones. The netlike effect of the large beads was produced by joining, at the points, strips of gold wire bent into zigzags, then applying a granule over each point of contact.

The piece, with its colored stones, its heavy and naturalistically modeled lions' heads, and its complex decorative elements, is a magnificent example of the favorite Hellenistic chain necklace. The netting technique is paralleled on the famous animal-headed torque sections(?) from Thessaly and on a dome-shaped "hair net" of reportedly Tarentine provenance. The openwork, or cage beads appear in a necklace from a third-century grave at Neapolis (catalogue no. 102); another(?) from the Thessalonike necropolis is cited by Hoffmann. A related necklace was found in Artjukhov's Barrow, perhaps datable in the early second century

B.C. A necklace alternating openwork beads with emerald beads was once in the von Gans collection, and a single cage bead is in the Walters Art Gallery, Baltimore. Spool-shaped beads like the small ones of the Richmond necklace are considered by Amandry a mainly third-century form.

Third century B.C.

Greek Gold, no. 43, with reference to unpublished parallel in Thessalonike. See B. Pfeiler-Lippitz, *AK* 15 (1972): 109 and Taf. 32, 1; *Compte-rendu de la Commission impériale archéologique* (1880), pl. 2, 1 for the example from Artjukhov's Barrow; K. Schefold, *Meisterwerke griechischer Kunst* (1960), no. 601 for the von Gans piece; D. Buitron in *Jewelry* (1979), no. 263 for the Walters bead.

74

NECKLACE
WITH GAZELLE-HEAD FINIALS

Length .388m. (15¼ in.)
Gold with sard
Museum of Fine Arts, Boston, no. 99.376.
Henry Pierce Fund

A gold loop-in-loop chain is punctuated between every three links with a link-set sard bead. The finials are naturalistically modeled gold gazelles' heads. One preserves its collar, a capsule-set cylinder of some grayish-white material.

The piece, finely executed, is one of the many variants on a standard Hellenistic type.

Third century B.C.

Greek Gold, fig. 47c. See B. Segall, *Katalog der Goldschmiede-Arbeiten* (1938), no. 50 for an example in the Benaki Museum with comparable finials.

75

NECKLACE
WITH GAZELLE-HEAD FINIALS

Length .383m. (15⅛ in.)
Gold with brown glass(?) beads
Museum of Fine Arts, Boston, no. 98.787.
Henry Pierce Fund

The chain consists of beads joined by gold links; transparent brown beads, held in filigree-outlined rosette-cup settings, alternate with spherical gold beads, smooth except for

filigree ornament around their openings. The finials are schematized gazelles' heads with inlaid eyes and small, once-inlaid discs arranged like bridle ornaments. A bead in a capsule setting forms the collar of each.

In this version, the favorite Hellenistic necklace type becomes rather colorful and showy. A similar bead-chain was found in Grave I of Artjukhov's Barrow; a lynx-head necklace in a private collection is also related. The parallels for the very stylized gazelle heads are very numerous. (Compare catalogue no. 70.)

Probably third to second century B.C.

Greek Gold, fig. 47d (incorrectly as 01.8154). See also *Greek Gold,* no. 46 for the necklace with lynx heads in a German private collection; E. H. Minns, *Scythians and Greeks* (1913), fig. 321 for the necklace from Artjukhov's Barrow, dated in the early second century by R. Higgins, *Greek and Roman Jewellery* (1961), p. 157.

76

NECKLACE
WITH HEADS OF AFRICANS

Length .428m. (16⅞ in.)
Gold with carnelian
Museum of Fine Arts, Houston,
no. 37.41, the Annette Finnigan collection

The loop-in-loop chain alternates one link carved from carnelian with two of spirally twisted, flat gold wire. The finials are heads of Africans carved from carnelian; they are set in gold capsules and threaded on wires which emerge at the top to form the hook-and-eye clasp. The hair is rendered with wire curls attached to a cap of sheet gold.

The type is an exotic variant on the most popular Hellenistic necklace form; three necklaces with similar finials are in the British Museum, and many earrings, including a pair in Thessalonike from a third-century grave, have hoops terminating in carved stone heads of Ethiopians. The fragile but colorful carved stone links are a Hellenistic fashion (see catalogue no. 91).

Third–second century B.C.

H. Hoffmann, *Ten Centuries That Shaped the West* (1971), no. 213. See *Catalogue of the Jewellery . . . British Museum,* nos. 1961, 1962, 1963 for necklaces with similar terminals, all ascribed to the third century B.C.; P. Amandry, *Collection Hélène Stathatos* I (1953), nos. 249, 277 for related pieces; G. Becatti, *Oreficerie antiche* (1955), nos. 405, 406 for earrings with heads of Africans; *TAM,* no. 329 for a pair datable in the third century B.C.

79

77

77

NECKLACE
WITH PENDANT AMPHORAS

Length .385m. (15⅛ in.)
Gold with garnets
Museum of Fine Arts, Boston, no. 1971.212.
Edward J. and Mary S. Holmes Fund

A broad strap, made up of extraordinarily
fine links by the multiple, interlocking loop-
in-loop technique, ends in ivy-leaf-shaped
finials, each set with a garnet and decorated
in filigree work and granules. One garnet is a
cabochon, the other, like some set into the
pendants, a naturally faceted crystal. Both
finials end in loops; to one is attached an
extra, ivy-leaf-shaped element, set with a gar-
net and ending in a closure hook. From the
strap, each join masked by a tiny disc, are
suspended rows of pendants: plain gold
"spear points"; gold leaf shapes, each set
with a garnet, on short chains; and finally, on
long, V-shaped festoons of chain, pointed
amphoras with high, scrolling handles.

This necklace is a slightly simplified ver-
sion of the sumptuous example, inscribed
"Zoilas," in the Benaki Museum, Athens.

Probably third century B.C.

Sotheby's sale catalogue, July 13, 1970, lot
149; C. Vermeule, *Annual Report,* Museum
of Fine Arts, Boston (1970–71), p. 35. See
B. Segall, *Katalog der Goldschmiede-Arbei-
ten* (1938), no. 4 for the Zoilas necklace in
the Benaki Museum.

78 *(Color plate 13)*

ROUNDEL WITH BUST OF ARTEMIS

Diameter .079 m. (3⅛ in.)
Gold with garnet
The Art Museum, Princeton University,
Princeton, New Jersey, no. 38.50
Said to be from Thessaly

The central part of the medallion, with a bust
of Artemis in very high relief, is separately
made, probably by hammering over a model.
It is surrounded by a wreath of garnet seg-
ments, of which two survive, held in place
by, originally, eight ribbonlike gold bands.
Around this is a Lesbian cymation with fi-
ligree-outlined leaf and tongue decoration,
preserving traces of enamel. The outermost
zone has a filigree-outlined ivy-leaf chain. On
the edge are four pairs of attachment loops;
the backing is a disc of sheet gold. The me-
dallion forms a pair with another of Athena,
also in Princeton. The reported provenance
from the "Carpenisi lot" of Thessalian jew-
elry has been questioned.

The function of these Hellenistic relief me-
dallions is uncertain. It has been suggested
that those with four sets of loops, like the
Princeton pieces, marked the crossing of two
ornamental chains worn diagonally across the
chest; this would explain the existence of
pairs if the back crossing, too, had a medal-
lion. Similar pieces with many evenly spaced
attachment loops have been explained as
pyxis lids or as hair net decorations. Since a
chignon-like arrangement would require only

one such adornment, the appearance of
groups remains difficult to account for by this
theory.

The full, fleshy face of the Princeton Ar-
temis, her ample bosom and loose, high-piled
coiffure have an incipiently baroque feeling.
Such trends can, however, be paralleled in
the art of the mid third century; as Amandry
pointed out, the Princeton medallions, while
unlike the "Carpenisi lot" examples in com-
position, are closely related in the style of
their ornament and should not be far from
them in time. The type of object, too, is one
that may not have continued in use for very
long.

Probably third–early second century B.C.

B. Segall, *Record of the Museum of Historic
Art, Princeton* 4, no. 2 (1945), pp. 3ff.;
D. M. Robinson, *AJA* 57 (1953): pl. 10; R.
Higgins, *Greek and Roman Jewellery* (1961),
p. 170. See also T. Hackens, *Classical Jew-
elry* (1976), no. 22, for a new discussion of
the medallion series in connection with an ex-
ample in Providence; D. B. Thompson, *Troy,*
Supplementary Monograph 3 (1963), pp.
41–42 on Artemis' coiffure, a variant of the
"lampadion knot."

78

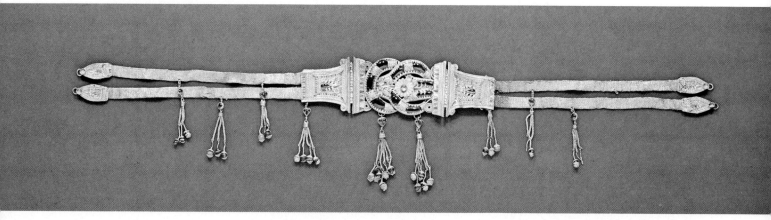

79A

79

GOLD DIADEM WITH GARNETS

Length .475m. (18¾ in.)
Museum of Fine Arts, Boston, no. 1971.211.
Edward J. and Mary S. Holmes Fund

The central element is a Herakles knot whose strands are garlands of pointed leaves; a rosette, once inlaid with a stone, marks the center of the knot. The Herakles knot is hinged to capital-shaped plates, each set with a cabochon garnet in a toothed mounting and surrounded with repeating "plaited" borders of countertwisted wire. A double band of toothed ornament runs across the lower parts of the capitals. Three bunches, each originally of three garnet beads held above and below by rosette-cups and attached to chains, hang down, one from the Herakles knot and one from a lower corner of each capital. The straps, two at each side, are made by the interlocking loop-in-loop technique with links of hairlike fineness; each ends in a tongue-shaped finial with filigree ornament and a hook or eye for fastening.

The diadem is an apparently somewhat misunderstood variant of famous examples like the Thessalian masterpiece of the Benaki Museum (catalogue no. 79A). The Herakles knot is bordered with the teeth used to hold stone or glass inlays, but the strands are made up of pointed gold leaves. The volutes, of loosely coiled wire, are reduced to vestigial form. By contrast, the decoration of the capitals is overt and repetitious, with no attempt at transition between the round garnet cabochons and the angular surrounding elements. Most

comparable in its simplification, though more logically organized and entirely different in construction, is an example in Cairo for which a mid-third-century date has been suggested.

Probably third century B.C.

Sotheby's sale catalogue, July 13, 1970, lot 150; C. Vermeule, *Annual Report,* Museum of Fine Arts, Boston (1970–71), pp. 35–36. See *Greek Gold,* figs. 2a, b, c, d etc. for Herakles knots with inlays held by toothed borders; P. Amandry, *Collection Hélène Stathatos* I (1953), fig. 72 for the Cairo diadem.

79A *(Color plate 15)*

DIADEM

Overall length 0.51m.(20 in.)
Gold, garnet, and enamel
Benaki Museum, Athens, no. 1548

Plaques and bands, themselves richly inlaid, flank a sumptuous Herakles knot, all leading to double strands of loop-in-loop chains. The garnets stand out everywhere. This diadem was the work of a master to whom a related object in a private collection in Germany has been attributed (*Greek Gold,* no. 2). Others come from northern Greece and as far afield as a tomb near Kerch (Panticapeum) on the eastern tip of the Crimea. Ladies fastened such luxurious objects by ribbons over a high

coiffure, the little chains with pendants falling over the forehead and the temples. The popular Herakles knot had all sorts of implications for the female wearer: a royal woman (Omphale) dominated the hero, and he was otherwise the embodiment of a strength symbolized by the knot of power and love.

Late fourth, early third century B.C.

B. Segall, *Museum Benaki. Katalog der Goldschmiede-Arbeiten* (1938), pp. 32–36, no. 28, pls. 8, 9; *Greek Gold,* p. 57, fig. 2c.

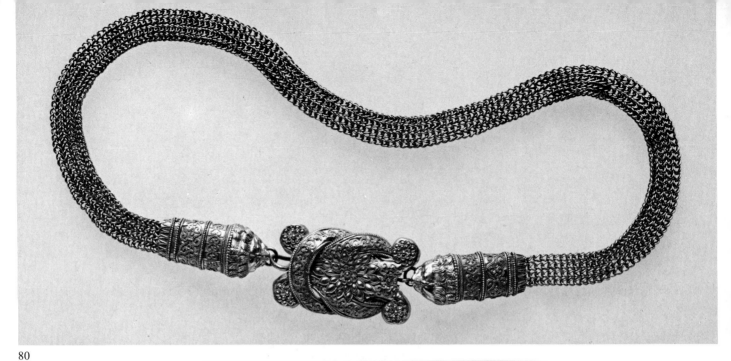

80

80

GOLD THIGH BAND (?)

Length .417m. (16²/₅ in.)
Staatliche Antikensammlungen, Munich, no.
SL 653. From the Loeb and Branteghem
collections

The five interwoven loop-in-loop chains, un-
usually robust, which make up the flat strap,
end in lion's head finials. The flattened col-
lars of these are decorated in filigree work
with a toothed border. The convex, tapering
strands of the Herakles knot end in two-tier
rosettes; a large rosette with one tier of
rounded and two of pointed petals marks the
center of the knot. A filigreed heart-chain
decorates the surface of the strands.

This complex but solid and well-orches-
trated elaboration of a traditional design is
ascribed by Hoffmann to the same workshop
as the "Carpenisi lot" of Thessalian jewelry.
For the function of the type, see below,
catalogue no. 82.

Late fourth century B.C.

Greek Gold, no. 83.

81

GOLD NECKLACE

Length .34m. (13⅜ in.)
Staatliche Museen Preussischer Kulturbesitz,
Antikenmuseum Berlin, no. 26
From Smyrna, acquired in 1854 from the
English consul Borrel

The necklace is a strap of interwoven loop-in-
loop chains, ending in rectangular finials each
with a facing female head, wearing a polos,
in low relief. The center of the necklace is a
flattened Herakles knot whose strands, not
tapered, are the same width as the main strap,
giving the illusion that it actually has been
knotted. Nine rows of countertwisted wire
texture the surface of the loop in an effect
mimicking that of the strap's interwoven
links. A thunderbolt ornament, outlined in fil-
igree and with a rosette at its center, is super-
imposed on the Herakles knot. Rosettes with
palmettes emerging from them cover the joins
of the strap to the upper ends of the Herakles
knot. Each of the two lower ends of the knot
connects to a large biconical bead, from
which hangs a tassel of short chains ending in
filigreed and granule-decorated pendants with
the form of stylized lotus pods.

This variant on the Herakles-knot-and-band
jewelry is ascribed by Hoffmann to Ionia and
probably to the Kyme group (see catalogue
no. 64). The Kyme treasure contained two
necklaces, now in the British Museum, with
similar tassel pendants hanging from large
biconical beads, though without the Herakles

knot. A related example is in the Metropoli-
tan Museum.

Fourth century B.C.

Archaeologia 35 (1853): 190, pl. VIII, 4; R.
Zahn, *Ausstellung von Schmuckarbeiten aus
Edelmetall* (1932), p. 20; Greifenhagen,
Schmuckarbeiten II, pp. 16–17, pl. 6; *Greek
Gold,* no. 40. See also *Catalogue of the
Jewellery . . . British Museum,* no. 1954,
1955 for the related necklaces from the Kyme
Treasure, p. XXXVIII and no. 1611 for the
treasure as a whole, no. 1949 for a piece with
a similar terminal, from Smyrna; C. Alexan-
der, *Jewelry* (1928), fig. 17 for a version in
the Metropolitan.

(About one-half of the necklace is reproduced.)

82

THIGH BAND (?)

Length .306 m. (12¹/₁₆ in.)
Gold
The St. Louis Art Museum, no. 382.1923
Said to be from Olbia (Black Sea)

The "upset" chain ends in rather indis-
tinctly modeled lions' heads whose collars are
worked in filigree with one row of very long
and one of shorter rays. The central element
is a Herakles knot with rather thin strands
which taper sharply and whose ends roll
themselves into spirals around small, slightly
convex discs. The knot is decorated on its
surface with a scrolling filigree pattern; its

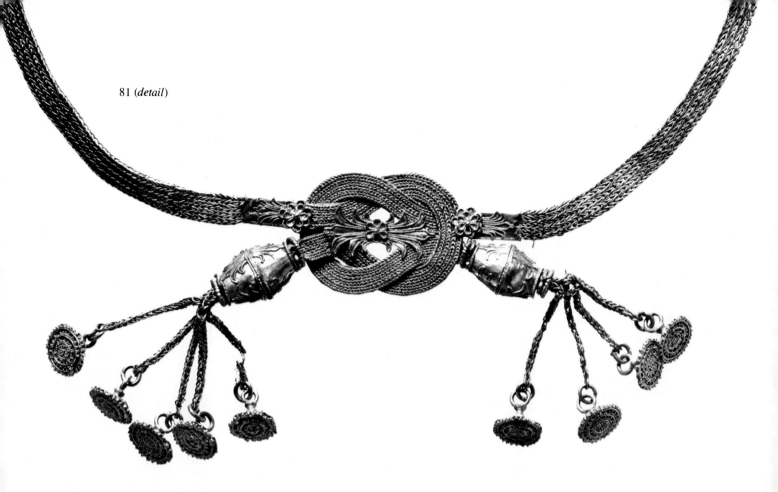

81 *(detail)*

center is marked by a large, filigree-outlined honeysuckle palmette with a rosette at its heart.

The pendant, unprecedented in comparable chains, is composed of a cast hippocamp with a gorgon mask between his wings and a suspension ring with granulation. The function of such chains has been disputed. On the analogy of ornaments worn by Erotes and Aphrodite figures in the minor arts, they have been identified as thigh bands. The length of some, indeed, is approximately the circumference of a healthy but not overdeveloped female thigh; others seem too short. Another problem is the weight of most examples; they would certainly slip out of place, especially as there seems to be no way of tightening or loosening them. The clasps are normally of hook-and-eye type, which would dig into the flesh. It seems implausible, too, that so precious an ornament would be worn out of view, underneath any normal clothes worn by a respectable Greek woman.

Early Hellenistic

[R. Zahn] *Galerie Bachstitz,* vol. II (1921) no. 22, Taf. 4; *Annual Report of the City Art Museum* 15 (1924), p. 16; *Bulletin of the City Art Museum* 9, no. 2 (1924), pp. 25–26, with a misunderstood provenance; *Greek Gold,* fig. 84b, questioning the pendant. See P. Amandry, *AJA* 71 (1967): 205, for skepticism about thigh band function; *TAM* 365, 390 for examples from Amphipolis, 5 for example from Homolion, 319 for a more massive piece from Sedes.

83

BRACELET
WITH LION'S HEAD FINIALS

Diameter .08m. (3¹/₁₆ in.)
Gold with enamel
Metropolitan Museum of Art, New York, no.
45.11.10. Joseph Pulitzer Bequest Fund, 1945

Two thick gold wires are twisted together to
form the hoop; in the channel between them
is laid a row of beaded ornament. The termi-
nals are lions' heads with ornamental collars.
The main band of decoration has filigree-
outlined palmettes with traces of enamel; in
the spaces between were enameled rosettes
and filigree coils with granules at their cen-
ters. Where it joins the hoop the collar has a
scalloped border made up of pelta-shaped ele-
ments placed side by side.

Filigree collars were a fashion of the sec-
ond half of the fourth century B.C., though
the thick hoop with its beaded ornament in
the channel has earlier precedents.

The bracelet has been wrongly ascribed. It
appears in a photograph, once in possession
of R. Zahn, with a group of forged ancient
jewelry probably for sale in Istanbul before
World War I.

Second half of fourth century B.C.(?)

G. M. A. Richter, *AJA* 50 (1946): 361ff.
with discussion of the find group; *Handbook
of the Greek Collection,* Metropolitan Mu-
seum of Art (1953), pp. 157ff., pl. 129ff.;
Greek Gold, fig. 61b (no. 61 for a very simi-
lar bracelet in a German private collection.)
P. Amandry, *Collection Hélène Stathatos*
III, 247–249, no. 6. Greifenhagen,
Schmuckarbeiten II, p. 50, fig. 46.

84

SNAKE RING

Height .04–.05m. (1⅝–2 in.)
Gold
Virginia Museum, Richmond, no. 65.43.3/7.
The Williams Fund, 1965
Said to be from Amphipolis

The snake's body is a flat strip making three
turns around the finger. Head and tail are
hammered into shape. The head is incised
with a coarse herringbone pattern, the neck
and tail with a few diagonal strokes.

The piece is a modest, schematized version
of a form that runs from the fourth century
down into Roman times.

Hellenistic

Greek Gold, no. 122. See *BCH* 85 (1961):
818, fig. 3 for a related serpent ring from
Amphipolis.

85

NECKLACE
WITH GAZELLE-HEAD FINIALS

Length .364m. (14⅓ in.)
Gold and carnelian
Virginia Museum, Richmond, no. 65.43.6/7.
The Williams Fund, 1965
Said to be from Amphipolis

The necklace is a very fine loop-in-loop chain
ending in carnelian gazelles' heads. Only one
of these finials survives, with the empty cap-
sule setting of the other. The collar element
and the head itself, both carved from carne-
lian, were threaded, along with gold divider
elements, on the wire that emerged to form
the clasp.

Early Hellenistic

Greek Gold, no. 121. See *BCH* 85 (1961):
818, fig. 5 for a related necklace from Am-
phipolis with garnet lynx heads.

86

GOLD EARRINGS
WITH CARNELIAN DUCK
PENDANTS

Height .026m. (1 in.)
Virginia Museum, Richmond, nos.
65.43.4&5/7
Said to be from Amphipolis

The centers of the rosettes once held an
inlay, perhaps of paste or of glass se-
cured only with an adhesive, since the
rim of the setting was never hammered
inward to contain a stone. Carnelian
beads, carved in the shape of ducks with
turned-back heads, form the pendants.
Each is threaded, below a spherical burnt
carnelian spacer bead and a spool-

86

Greek Gold, no. 120. See D. von Both-mer, *Ancient Art from New York Private Collections* (1961), no. 284 for the necklace with pendant of gold Eros riding a car-nelian duck in the collection of Joseph V. Noble; *Catalogue of the Jewellery . . . British Museum,* no. 1917 for a plasma earring pendant in the form of a dove; B. Segall, *Katalog der Goldschmiede-Ar-beiten* (1938), no. 56 for carnelian doves in the Benaki Museum.

87

EARRING
IN THE SHAPE OF AN ISIS CROWN

Height .033m. (1³/₁₀ in.)
Gold with garnet, agate, and glass
Virginia Museum, Richmond, no. 65.43.7/7.
The Williams Fund, 1965
Said to be from Amphipolis

The lower disc of the crown is indicated by a cabochon garnet in a broad, heavy box set-ting. Above, a horizontally striped agate bead, topped by a small spherical one of green glass, is framed by a lyre shape of gold wire, suggesting Isis's horns. Flanking this arrangement are four pairs of wire scrolls, at the center of which are knobbed pins of the type used to fasten pearls or small beads. The heavy, decorated ear wire is a complete hoop, whose end has been pulled through the upper eyelet, bent back and twisted to secure it.

shaped gold one, on a double strip-twisted wire that runs through a vertical hole in the body and is spread apart, holding the elements together, under-neath. Addorsed sheet-gold palmettes, outlined in filigree wire, clasp the ducks' bodies over the wings. The eyes are marked by a hole, perhaps originally filled with another material, drilled from side to side through the heads.

A carnelian duck pendant, in this case the duck ridden by a gold Eros, is in a New York private collection; earrings with carved semiprecious stone birds, less elaborately mounted, are in the Brit-ish and the Benaki museums. The un-usual Richmond earrings are probably of early Hellenistic date, like the necklace (catalogue no. 85) and the gold funerary wreaths with which they were reportedly found.

Early Hellenistic

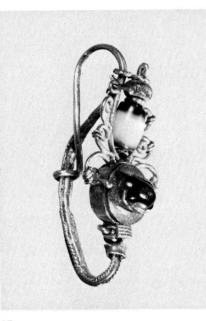

87

88 *(detail)*

Though allegedly found with the early Hellenistic elements of the Amphipolis treasure (see catalogue nos. 86, 85), this earring seems not to be contemporary with them. Its banded agate bead, its broad box setting, its wire scrolls recall the late Hellenistic jewelry from Olbia in South Russia, now in the Kofler-Truniger collection and the Walters Art Gallery. Related in form more than in style are the Isis-crown tops of the Walters sphinx earring and of the chariot earrings from Pelinna, both probably datable in the second century B.C. The Richmond earring should be, if anything, later. A pair of earrings from Kertch in the form of plain Isis crowns seems related and is probably misdated in the fourth century.

Second–first century B.C.

Greek Gold, no. 123, and see no. 51 for the Kofler pendant. See also A. Oliver in *Jewelry* (1979), nos. 281ff. for the Olbia treasure; D. Buitron in *Jewelry* (1979), no. 245 for the Walters sphinx earring; *TAM,* no. 9 for the Pelinna chariot earrings; I. Ondrejova, *Les bijoux antiques du Pont Euxin septentrional* (1975), pl. III, 4a–b for a pair of Isis-crown hoop earrings from Kertch; Greifenhagen, *Schmuckarbeiten* II, p. 45, pl. 22, 15/20, 16/21, for simpler versions dated in late antiquity.

88 *(Color plate 12)*

GOLD DIADEM

Length .35m. (13¾ in.); width at center .016m. (⅝ in.)
Kavalla Museum, no. M 185
Found in Grave 4, Amphipolis

A simple gold band, plain except for the Herakles knot in the center. The motif of the Herakles knot probably derives from Egypt and appears early in Greek art (for example in the headbands of kouroi); it had a symbolic and mystical significance associated with fertility, healing, and so forth. The knot was frequently used in Greek jewelry in archaic times, and from the fourth century B.C. into the Roman period it often appears as the central ornament on bracelets, thigh bands, diadems, rings.

On the diadem of Amphipolis the Herakles knot is of the tubular type, consisting of two interlocking loops, each made of two convex bands of sheet gold edged with filigree; the ends are joined by six-petal rosettes. A third, similar rosette fills the gap left in the middle of the knot, thus emphasizing the center of the closed composition.

Traces of a blue vitreous mass are visible in the rosette petals.

Through Alexander's conquests in Persia the Achaemenid technique of polychromy became known to the Greeks, and it was a typical feature of Greek jewelry from the fourth century onward. Most of the inlay has disintegrated over the centuries, however.

In later Hellenistic times jewelry was lavishly embellished with precious stones of various colors. But in the Amphipolis diadem the various refinements of gold-working technique predominate, with color used very discreetly, as is characteristic of works of the fourth century B.C.

Last quarter of the fourth century B.C.

D. Lazarides, *Praktika* (1956), p. 142, pl. 48; *TAM,* no. 388, pl. 53. For the Herakles knot, see Daremberg-Saglio, s.v. Nodus; R. A. Higgins, *Greek and Roman Jewellery* (1961), p. 155; *Greek Gold,* pp. 30–31.

89 *(Color plate 12)*

GOLD EARRINGS

Height .023m. (⅞ in.)
Kavalla Museum, no. M 190
Found in Grave 70, Amphipolis

A pair of richly decorated gold earrings combining filigree and added plastic ornamental features. A pendant in the form of an inverted pyramid is suspended from a separately wrought attached loop. The minute, architectonic treatment is emphasized by two miniature pediments at the base of the inverted pyramid, the division into zones, and the rope-like bands that wind around the peak of the pyramid and terminate in globules.

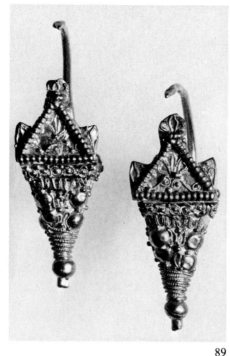

89

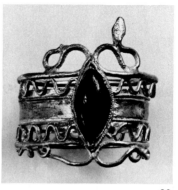

90

The various decorative elements — palmettes, spirals, lotus, wave-pattern, bead-pattern — are rendered with clear outlines; the craftsman who lavished his skill and love of detail on these earrings must have been a specialist in filigree.

This type of pyramidal or conical pendant has a long tradition in Greek lands, going back to the classical and archaic periods, and probably to Mycenaean times.

At the end of the fourth century B.C. still more elaborately designed earrings were made in which the pyramidal pendant is combined with other pendants in a great variety of forms, all suspended from a central disc (compare the group from Kyme). The earrings from Amphipolis must be somewhat earlier than the end of the fourth century B.C. because a red-figure vase (pelike) belonging to Group G, datable 350 B.C., was found in the same tomb.

Circa 350 B.C.

D. Lazarides, *Praktika* (1956), p. 142, pl. 48a. For the red-figure pelike from the same grave, see K. Rhomiopoulou, *AE* (1964), pp. 91–92, pl. 21a.

For earrings of the same type, see P. Amandry, *Collection Hélène Stathatos* I, (1953), pl. 250. For earrings from Ionic workshops, see *Catalogue of the Jewellery . . . British Museum,* nos. 1666–7, from Cyprus, fifth–fourth century B.C.; nos. 1668–9, fifth–fourth century B.C., and 1670–1, 1672–3 from Kyme in Asia Minor, fourth–third century B.C.

90 (*Color plate 13*)

GOLD RING

Diameter .02m. (¾ in.)
Kavalla Museum, no. M 213
Found in Grave 289, Amphipolis

The ring is a band hoop with a pointed oval bezel set with a red garnet. Two wire snakes coil around the hoop; above and below, flanking the points of the bezel, the heads and the tails of the snakes meet.

Second century B.C.

D. Lazarides, *Praktika* (1958), p. 81, fig. 57a; *TAM,* no. 393, pl. 53. For comparisons, see *Oreficerie antiche,* p. 93; P. Amandry, *Collection Hélène Stathatos* I (1953), pp. 116–118; R. A. Higgins, *Greek and Roman Jewellery* (1961), pp. 172, 175; B. Pfeiler-Lippitz, *AK* 15 (1975): 114, fig. 36, no. 13 (as second century B.C.); S. Miller, *Two Groups of Thessalian Gold* (University of California Publications in Classical Studies, vol. 18, 1979), pl. 24 a-b.

91

GOLD NECKLACE WITH GARNETS

Length .32m. (12³/₅ in.); height of Eros figure .02m. (⁴/₅ in.)
Museum of Fine Arts, Boston, no. 98.794.
Henry Pierce Fund
From the Tomb of the Erotes at Eretria

The necklace is a link-in-link chain that alternates gold with carved garnet links. Part of its original length has apparently been lost and there are some repairs. The clasp is a solid-cast gold figure of Eros, suspended from a capsule-set element, now missing, probably a long garnet bead. When the necklace was fastened, the Eros sat on a cylindrical gold base, minutely cut out to form an openwork design of addorsed protomes of winged and horned lions, which was the finial at the other end of the chain. Two parallel loops under the Eros join one atop the cylindrical base; the gold pin holding them together has been permanently bent into place, perhaps for burial.

A necklace from S. Agata dei Goti in southern Italy resembles this one both in its use of alternating gold and garnet links and in

91b

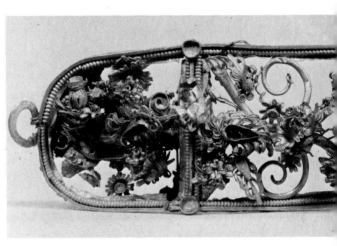

92

91a

the way its clasp, which fastens in the same way as that of the Eros necklace rather than by the more usual hook-and-eye system, seems designed to·be seen in an upright position. The clasp of the S. Agata necklace is a miniature column whose capital suggests those used in Tarentine limestone architecture of the late fourth and early third centuries B.C. The dainty but firm modeling of the Eros and the orientalizing detail of his base would be at home in the same period.

The small scale and exquisite conceit of the Eros necklace link it to other jewelry from the Tomb of the Erotes find, a collection of apparently early Hellenistic adornments that were surely worn by the owner in life.

Early Hellenistic

Annual Report, Museum of Fine Arts, Boston (1898): 50; *Greek Gold,* no. 50. See below, catalogue no. 92, for references on the Tomb of the Erotes; R. Siviero, *Gli ori e le ambre* (1954), no. 84, for the S. Agata dei Goti necklace in the Naples Archaeological Museum, no. 24887.

92 (*Color plate 13*)

FRAGMENTARY DIADEM

Height .025m. (1 in.); preserved length .185m. (7¼ in.)
Gold with glass and carnelian
Museum of Fine Arts, Boston, no. 98.798.
Henry Pierce Fund
From the Tomb of the Erotes at Eretria

The surviving piece is less than half the diadem, broken away at the front where it probably had some central ornament, and preserving the terminal section at the back. The diadem is composed of lyre-shaped elements, made from gold tubing and joined to an outer frame. The border, of spool wire reinforced by a strip of folded sheet gold, is punctuated at its corners by tiny disc-cups once containing glass inlays. The terminal section originally had a sheet gold backing. To the trellis of lyre-shaped supports is wired a profusion of fragile and richly varied gold vegetation: many-tiered blossoms, tendrils, acanthus leaves, a bursting pomegranate, single and double honeysuckle palmettes. Petals are outlined in filigree, centers made of coiled spiral-spool wire or inlaid with carnelian or now-opalescent glass (two of the glass elements have been replaced in modern times). The large, double honeysuckle palmettes are spaced along the center of the band and are all oriented the same way, toward the front. A fragment seemingly of the other end of the same diadem, found at the tomb, was published by Kourouniotis.

The decoration is attached to a solid supporting framework, showing that this piece, unlike equally sensitive but much simpler funerary jewelry, was made for wear by the living. As in the sumptuously ornate boat earrings (see catalogue no. 61), the underlying arrangment is orderly; the look of chaotic profusion comes from the way plant forms

mask and overlap all structural elements. Details observed from nature are combined in fanciful, unrealistic ways; these vines grow by their own nonterrestrial rules.

The Eretria diadem has been dated in middle Hellenistic times. In its delicate workmanship and feverishly overgrown look, however, it seems connected with fourth-century jewelry like the boat earring category and the "queen's diadem" from the Royal Tomb at Vergina, as well as the trellis diadem from Demetrias. Belt elements in the Stathatos collection from the "Carpenisi lot" seem to mimic its composition but are actually quite differently constructed as well as showing a more truly baroque sensibility; the Eretria diadem should belong to a considerably earlier phase of the same development.

Early Hellenistic

Annual Report, Museum of Fine Arts, Boston (1898): 50–51; P. Amandry, *Collection Hélène Stathatos* III (1963), p. 244, n. 5; *Greek Gold,* no. 3; P. Amandry, *AJA* 71 (1967): 203; R. Higgins, *JHS* 88 (1968): 243; K. Kourouniotis, *AE* (1899) and K. G. Vollmoeller, *AM* 26 (1901): 333ff., Abb. 1–9, Taf. XIII–XVII for the Tomb of the Erotes. See *TAM* no. 12, pl. 7, for the Demetrias diadem; P. Amandry, *Collection Hélène Stathatos* I (1953), no. 265 and especially no. 266, dated mid third century, for comparable but later-seeming arrangements.

93 94

93, 94

TWO TERRA-COTTA EROTES

Height .10m. (4 in.) each
Museum of Fine Arts, Boston, nos. 97.300,
97.301. Catharine Page Perkins Fund
From the Tomb of the Erotes at Eretria

One Eros is muffled in a long himation,
drawn up over his head and around his torso
but leaving his thighs childishly bare. The
high, pointed outline of his head suggests that
his hair is worn in a topknot under the drap-
ery. He has the short and fluffy wings of a
fledgling bird. Hovering in midair, he holds
up a large kithara against his left shoulder, an
instrument which, with his swathed hands, he
cannot really be playing. Rose color survives
on the drapery.

The other Eros is dressed in oriental cos-
tume: a Phrygian cap, a belted chiton with
overfall over trousers, and a sleeved un-
dergarment. His wings end in stylized vo-
lutes. He dances forward, both hands raised
to support the ends of the now missing double
flute he was playing. A rose color is pre-
served on his chiton, purplish-gray borders on
the trouser legs, red-brown on the hair, and
white, rose, and gold on the wings. Both fig-
ures, like the other terra-cottas from the same
find, are made of a fairly fine, porous
pinkish-buff clay, and are coated with a white
engobe as a base for the bright surface colors.
The backs have small vent holes between the
wings.

The two Erotes belong to a swarm of
twenty-eight in Boston. The figures are mold-
made but have many details separately cast or
added freehand. Each one is different and
carries some attribute suggesting amusement
or personal adornment. The figures give their
name to the early Hellenistic "Macedonian"
tomb near Eretria where they, other terra-
cottas, and jewelry were found.

The monument is a tumulus, with a foun-
dation at its center for some sort of crowning
element. It has a dromos and a barrel-vaulted
tomb chamber, fitted out with two stone
couches which contained the remains of the
dead men, two stone seats and a larnax-shaped
chest for female dead. The tomb continued in
use over a considerable time span; inscrip-
tions show that the dead belonged to at least
three generations. The decoration of the walls
has three distinct periods: a first phase with
metal hooks on the wall to hold real objects
such as wreaths and shields; a second phase
where the original offerings had been taken
away and similar objects painted on the wall;
and a third phase when the second was
painted over. While these renovations might
all have been carried out during the course of
the third century B.C. by descendants of the
first generation buried there, one inscription
was dated by Rehm to around 60 B.C. and
would imply that the tomb was reused much
later. The burial in the larnax-shaped stone
container, which carries the late inscription,
was the only one excavated officially and
proved to contain no grave gifts. The finds

from the tomb all appear to be of the third
century B.C. Within that period, however,
they can only be dated tentatively on stylistic
grounds, since there is little information on
their disposition within the chamber. Most of
the terra-cottas are thought to have been
found in a wall niche opposite the entrance.
The elegant style of the statuettes suggests
Boeotian influence, though the Erotes have
recently found parallels from Pella. One
piece, a large standing female figure, was
dated by Kleiner in the second quarter of the
third century B.C.; he placed the Erotes in the
third quarter of the century.

Probably third quarter of the third
century B.C.

Bibliography for catalogue nos. 93–98: *AJA*
2 (1898): 147; K. Kourouniotis, *AE* (1899),
cols. 221–234; K. Vollmoeller, *AM* 26 (1901):
333–376; G. Kleiner, *Tanagrafiguren* (*JdI*
Ergänzungsheft 15, 1942), pp. 19–20;
R. Higgins, *Greek Terracottas* (1967), p. 101
for the find, pl. 46B for Eros 97.301; B.
Segall, *Winckelmannsprogramm der ar-
chäologischen Gesellschaft zu Berlin* 119/120
(1966): 22; U. Wintermeyer, *JdI* 90 (1975):
138. See also *TAM*, nos. 180, 182, 231 for
miniature shields from Derveni; H. Her-
dejurgen, *Götter, Menschen und Dämonen*
(1978), no. A69 for a Tarentine terra-cotta
disc with a gorgoneion.

95–98

FOUR MINIATURE TERRA-COTTA SHIELDS

Diameter of round shields .088m. (3½ in.)
and .09m. (3½ in.); height of oval shields .093
(3¾ in.) and .095 (3¾ in.)
Museum of Fine Arts, Boston, nos. 97.323,
97.327, 97.334, 97.345.
Catharine Page Perkins Fund
From the Tomb of the Erotes at Eretria

Two shields are of the round, convex,
"Argive" type. The first of these has a radi-
ate head of Alexander-Helios. The shield is
rose-colored, with a gilded border. The rays
and Helios' hair are gilded; his face is white.
The second round shield is decorated with a
head of Medusa, of the "beautiful" type,
surrounded by a scaly aegis. Again the border
is gilded, the ground color of the shield rose.
The scales of the aegis are sky blue, while
Medusa's flesh is white and her hair gilded
over ocher underpainting.

Two other shields are of the pointed-oval,
"Gallic" form. One of these is decorated
with a thunderbolt whose center is a face of
Medusa. The rim, the thunderbolt, and Me-
dusa's hair were gilded, her face white. The
background color is a grayish-mauve. The
other Gallic shield has a small, scaly aegis
with a head of Medusa. The rim and Me-
dusa's hair are gilded, the scales sky blue, the
background rose. All the shields are made of
medium-fine, rather porous pinkish-buff clay,
covered with an engobe as a base for the col-
ors. Mold-made, they are hollow behind.

Twenty-eight shields from the Tomb of the
Erotes, of six different kinds, are in Boston.
Besides the types represented here, there are
"Gallic" shields with a head of a Molossian
hound and round ones with a youthful male
head flanked by stars. Another piece from the
tomb, seen by Vollmoeller in Chalkis, had
the form of a Macedonian shield with a star at
its center. Their use remains problematical.
None have any kind of provision for attach-
ment, though they seem designed to be dis-
played vertically. If they were attached to
funerary furniture, it must have been with
adhesives.

Kleiner dated the shields, with the Erotes
from the same tomb, in the third quarter of
the third century B.C. Closely related minia-
ture shields, both in metal and terra-cotta,
have since been found in the fourth-century
burials at Derveni. Tarentine versions, more
baroque and at least generically later than the
examples from Eretria, are thought to date
from the years around 280. Those from Ere-
tria could well belong to the early phase of
the tomb, and are further evidence of its
Macedonian connections.

Probably early third century B.C.

See bibliography for catalogue nos. 93, 94

99

GOLD RING WITH GARNET INTAGLIO OF APHRODITE ARMING

Height of bezel .031m. (1¼ in.)
Museum of Fine Arts, Boston, no. 21.1213.
From the Warren and Evans Collections.
Francis Bartlett Donation.
Found in the Tomb of the Erotes at Eretria

The thick hoop of the ring swells without
demarcation into a high bezel. Into this is set
a convex garnet of broad oval form. Its in-
taglio carving shows Aphrodite in three-
quarter back view, her drapery falling about
her thighs as she bends forward to arm herself
with the heavy shield and the spear of her
lover Ares. Behind the figure is the signature
"Γέλων ἐπόει," (Gelon made it). Inside the
ring there is a faintly and irregularly
scratched "Χαῖρε," (farewell).

Recent north Greek finds are yielding im-
portant evidence as to the date and original
context of ancient gems, until now known
most often as collection pieces. The massive
setting of the Aphrodite intaglio has good
third-century parallels, as does the convex
form of the stone. A heavy finger ring is
worn by the large terra-cotta female figure
also found in the Tomb of the Erotes and
dated by Kleiner in the second quarter of the
third century B.C. The carving, with its view
of Aphrodite's nude back, is a forerunner of
the elongated, boneless back views familiar
in late Hellenistic and Roman art, but has a
much more robust, substantially fleshed, and
articulated quality. The goddess's low-knot-
ted, close-to-the-head melon coiffure is of the
form worn by Arsinoe II and Berenike II of
Egypt in the first half of the third century. A
parallel for the pose and coiffure, dated in the
early third century by Becatti, is the Nereid
inside the lid of a pyxis from Canosa, now in
Taranto. Another, less ambitious version of
the Tomb of the Erotes intaglio, also ap-
parently of Hellenistic date, was found at
Amrit and was once in the De Clerq collec-
tion. The Boston ring is very different in
scale and feeling from the other, miniaturistic
jewelry found in the same tomb, a hint but
certainly no proof that it might have belonged
to another, perhaps later, member of the fam-
ily group.

Probably mid third century B.C.

A. Furtwaengler, *Die antiken Gemmen* I
(1900), pl. 66, 4; K. Kourouniotis, *AE* (1899),
col. 228; K. Vollmoeller, *AM* 26 (1901):
355–356; J. D. Beazley, *The Lewes House
Collection of Ancient Gems* (1920), no. 102;
Greek Gold, pp. 61ff.; G. M. A. Richter,
*Engraved Gems of the Greeks and the Etrus-
cans* (1968), no. 552. See also R. Higgins,
Greek Terracottas (1967), pl. 46A for the
large terra-cotta lady, wearing a ring, from
the Tomb of the Erotes; G. Becatti, *Orefi-
cerie greche* (1955), nos. 446–447 for the
Tarentine pyxis.

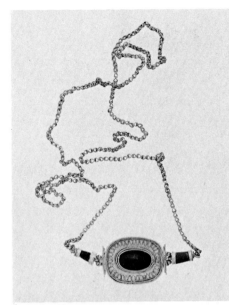

100 (*detail*)

100

GOLD NECKLACE WITH GARNETS

Length of necklace .67m. (26⅜ in.); center-
piece .03m. by .022m. (1⅛ in. by ⅞ in.)
Archaeological Museum of Thessalonike,
no. 2837
Found in a cist grave at Neapolis,
Thessalonike

The necklace consists of a loop-in-loop chain
with an oval centerpiece made of a dark red
garnet in a gold setting ornamented with fili-
gree and granulation. The stone has a repre-
sentation of Eros carved in intaglio. The
chain is attached to the centerpiece by two
truncated conical garnet beads set in gold.
Chain necklaces ornamented with semipre-
cious stones were popular throughout the Hel-
lenistic period.

Third century B.C.

TAM, no. 307, pl. 43.

101

PAIR OF GOLD BRACELETS

Greatest diameter .055m. (2⅛ in.)
Archaeological Museum of Thessalonike,
nos. 2831, 2832
Found in 1958 in a cist grave at Neapolis,
Thessalonike

Each bracelet is made of twisted wire ending
in gazelle heads.

Third century B.C.

BCH 83 (1959): 706, figs. 25–26; *TAM,* no.
310, pl. 44; Stella Miller, *Two Groups of
Thessalian Gold* (1979), p. 40, n. 251. See
also *Greek Gold,* pp. 160ff.

102

GOLD NECKLACE

Length .638m. (25⅛ in.)
Archaeological Museum of Thessalonike, no.
2835
Found in a cist grave at Neapolis,
Thessalonike

Gold necklace consisting of openwork cylin-
ders, "cages," made of wire and ornamented
with beads of granulation.

Third century B.C.

BCH 83 (1959): 706, fig. 26; *TAM,* no. 309,
pl. 43. See also *Greek Gold,* pp. 126–127,
no. 43 and pp. 147–151, no. 53.

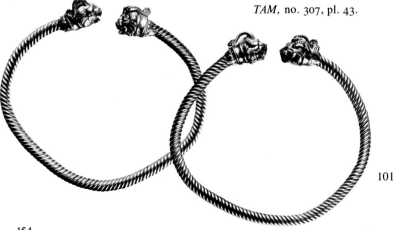

101

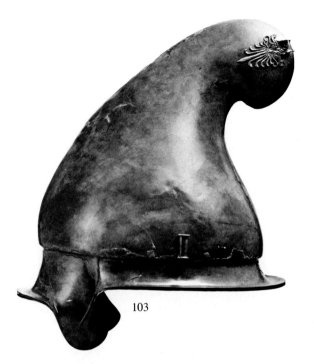

103

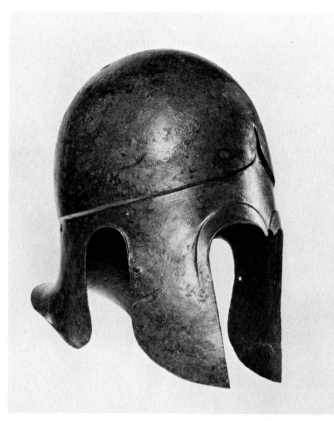

105

103 (*Color plate 16*)

BRONZE HELMET

Maximum height .315m. (12⅜ in.); diameter
.27m. (10⅝ in.)
Ioannina Museum, no. 6419
Found at Vitsa, Epiros

The helmet is of the so-called Phrygian or
Thracian type. The cheek-pieces are missing.
At the peak is an appliqué palmette ornament
of bronze. At the temples and at the peak
above the palmettes are small spools for at-
taching the crest. The glossy blue-green pa-
tina is extremely well preserved.

This is the type of helmet worn by the
Macedonian army — in particular by the in-
fantry — in the time of Alexander the Great
and the Successors, as is known from repre-
sentations on reliefs and vases. Compare, for
example, the figures on the Alexander Sar-
cophagus.

Fourth century B.C.

B. Schröder, ''Thrakische Helme,'' *Jahrbuch*
27 (1912): 317–344, Beilage 10; Com-
stock–Vermeule, *Greek . . . Bronzes*, p.
494, no. 589 A (dated ca. 450 B.C., but there
is no evidence for dating this helmet so
early); *Gold der Thraker*, Das Römisch-Ger-
manische Museum Köln, no. 244, p. 125.

104 (*Color plate 16*)

BRONZE ARROWHEAD

Length .07m. (2¾ in.); width .03m. (1⅛
in.); letter height .006m. (¼ in.)
Archaeological Museum of Thessalonike,
Olynthus collection
Found in House A 9, room 1, Olynthus

Bronze arrowhead, Type C, with inscription
in relief ΦΙΛΙΠΙΟ (of Philip). A fair
number of arrowheads inscribed with the
name of Philip II, king of Macedonia, have
been found at Olynthus, which was excavated
by the American archaeologist D. M. Robin-
son. Olynthus, at the head of the Chalkidian
League, was one of the states opposing the
Macedonians. Philip besieged and sacked the
town in 348 B.C. The weapons used by the
Macedonians were manufactured in work-
shops operated by the state and therefore this
arrowhead bears the name of King Philip,

vividly reminding us of the famous siege of
Olynthus which became so widely known
through the speeches of Demosthenes.

Olynthus X (1941), p. 383, pl. 120, no. 1907.

105 (*Color plate 16*)

BRONZE HELMET

Height .30m.(11⅞ in.)
Archaeological Museum of Komotini,
no. 1887
Found in the grave tumulus at Arzos, Hebros
district

Bronze helmet of the Chalkidian type. The
nose-guard is broken. The eyebrows and the
crown are clearly marked with offsets. There
is a strong curve outward at the base of the
neck. The perforations in the cheek-pieces
were for fastening the leather padding.

End of the fourth century B.C.

TAM, no. 458, pl. 60; *Deltion* 30 (1975):
Chronika (in press).

104

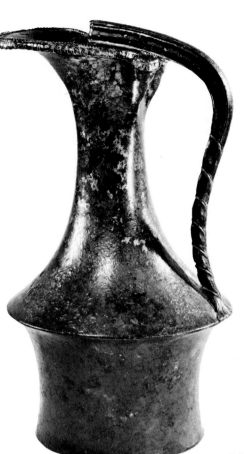

106

107

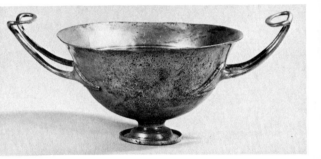

108

106

BRONZE WINE PITCHER (OINOCHOË)

Height .265m. (10½ in.); diameter at base
.11 m. (4⅜ in.)
Archaeological Museum of Komotini,
no. 1888
Found in the grave tumulus at Arzos, Hebros
district

The pitcher has a trefoil mouth, long neck,
and carination at the juncture of the cylindri-
cal body and the neck. The lower part of the
S-shaped handle takes the form of acanthus
stalk. There is a fine band of ovolo pattern
around the rim and incised concentric circles
on the base.

End of the fourth century B.C.

TAM, no. 460, pl. 61; *Deltion* 30 (1975):
Chronika (in press). For comparison see W.
Lamb, *Ancient Greek and Roman Bronzes*
(1969); *Bronzes in Yugoslavia,* no. 54.

107 *(Color plate 17)*

BRONZE SITULA

Height .21m. (8¼ in.); diameter at rim
.205m. (8 in.); diameter at base .095m.
(3¾ in.)
Archaeological Museum of Komotini,
no. 1894
Found in the grave tumulus at Arzos,
Hebros district

Two arched swinging handles with turned-up
ends hook into the handle attachments, which
consist of palmette ornaments flanked by half
rings. Below the rim a band of wreath pattern
is incised. Three concentric circles are incised
on the base, and there are three low supports
at the edge of the base.
 Situlas were used to carry wine in sym-
posia or at funeral ceremonies.

End of the fourth century B.C.

TAM, no. 459, pl. 61; *Deltion* 30 (1975):
Chronika (in press). See also bibliography for
catalogue no. 122.

108

SILVER KYLIX

Height .06 m. (2⅜ in.); diameter at rim
.12m. (4¾ in.)
Archaeological Museum of Komotini,
no. 1889
Found in the grave tumulus at Arzos,
Hebros district

The cup has large curving loop handles with
ivy leaves at the juncture of handles and
body, a low foot, and slightly flaring rim.
There are concentric ridges on the interior
below the rim and concentric circles incised
at the bottom.

End of the fourth century B.C.

TAM, no. 462, pl. 61; *Deltion* 30 (1975):
Chronika (in press). *Bronzes in Yugoslavia,*
no. 55.

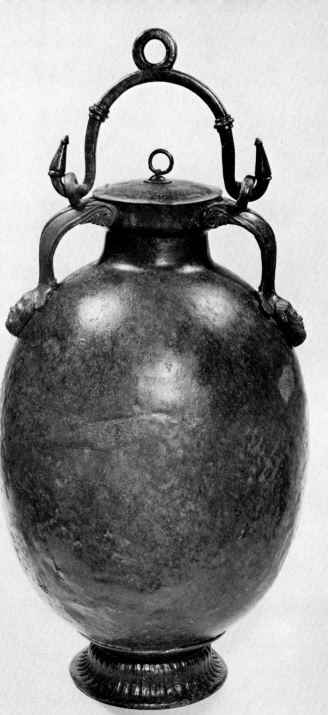

110

Because of the decoration and quality of the execution, this alabastron is considered to be one of the most interesting examples of its kind (container for perfumed oils) to have come down to us. Both the dating and the interpretation of its decoration have been the subject of much discussion.

Late Hellenistic, end of second century B.C.

TAM, no. 21, pl. 4; S. Miller, "The So-called Palaiokastro Treasure," *AJA* 83 (1979): 182, 191, n. 77.

111

SILVER SPRINKLER

Height .16m. (6½ in.)
Archaeological Museum of Thessalonike, no. 5146
Found in 1965 at Potidaia

Sprinkler of the type common in the fourth century B.C., with ring base, swelling body with greatest diameter below the center, and petal ribbing. The lid, made in one piece with the rim, is perforated for sprinkling liquids. These vessels were used for sprinkling during funeral ceremonies.

Fourth century B.C.

TAM, no. 347, pl. 49. See also W. Fröhner, *Collection H. Hoffmann* (1888), p. 115, no. 432, pl. 33.

109

109

BRONZE AMPHORA

Height .41m. (16¼ in.); diameter at base .135m. (5⅜ in.); diameter at rim .095m. (3¾ in.)
Larissa Museum, no. 76/1
Found at Karditsa, Thessaly

This bronze amphora, with a low base decorated with tongue pattern, has a lid and three handles, two at the sides with rings on top to secure the third, a swinging handle by which the pot could be suspended. The handles at the shoulders are made in the form of acanthus shoots, with attachments in the form of satyr masks. One head is a restoration. (Compare the amphora from Derveni, catalogue no. 134.)

TAM, no. 1, pl. 1

Fourth century B.C.

110 (Color plate 17)

SILVER ALABASTRON
 (PERFUME CONTAINER)

Height .183m. (7¼ in.); diameter .055m. (2⅛ in.)
National Museum, Athens, no. 13713
Found at Palaiokastro, Karditsa

A silver alabastron with rounded base, tapering to a short, narrow neck, the entire vase is covered with reliefs executed in repoussé and chasing. The base is decorated with a circle of leaves. The main representation, in fairly high relief, pictures a scene from Dionysos' childhood: the infant god handed over to the nymphs who will bring him up. Above it is a frieze with Erotes. The relief zones are set off by bands of wreath pattern. The vessel has been mended and restored.

112

113

112

BRONZE JUG (OINOCHOË)

Height .265m. (10⅜ in.); diameter at base
.085m. (3⅜ in.); diameter at mouth
.05 × .075m. (2 × 3 in.)
Kozani Museum, no. 73
Found at Tsotyli, western Macedonia

The oinochoë has a trefoil mouth and a high
handle shaped like a stalk which ends in a
separate acanthus leaf applied where it joins
the body. Restoration and conservation work
have been carried out.

Fourth century B.C.

AE (1948/49), p. 97, fig. 11; *TAM*, no. 42.
See also J. Sieveking, *Collection Loeb, Bron-
zen, Terrakotten, Vasen*, p. 7, pl. 8.

113 (*Color plate 17*)

BRONZE MIRROR AND CASE

Diameter .16m. (6¼ in.)
Larissa Museum, no. 77/134
Found at Larissa, Thessaly

The two discs of this bronze mirror case are
connected by a hinged double plate to which
the suspension handle is fastened. The out-
side of the cover carries a relief, badly dam-
aged by corrosion and repaired, showing
Aphrodite on a swan. Aphrodite Ourania
traveling on a swan, in distinction to Aphro-
dite Pandemos riding a goat, was a favorite
theme in the fourth century B.C.

Fourth century B.C.

(detail)

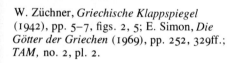

114

W. Züchner, *Griechische Klappspiegel* (1942), pp. 5–7, figs. 2, 5; E. Simon, *Die Götter der Griechen* (1969), pp. 252, 329ff.; *TAM*, no. 2, pl. 2.

114 *(Color plate 11)*

GOLD ORNAMENT

Length .18m. (7 in.); width .035m. (1⅜ in.)
Archaeological Museum of Thessalonike, no. 7418
Found in 1974 in a cist grave, Stavroupoli, Thessalonike

The piece consists of two bilaterally symmetrical floral compositions with spiraling tendrils springing from nests of acanthus and ending in palmettes. The gold ornament was attached to an ivory backing, a piece of which is preserved. The workmanship recalls that of the diadem found in the golden chest in the antechamber of Tomb II at Vergina (*TAM* no. 87). Found with no. 115.

Second half of the fourth century B.C.

TAM, no. 294, pl. 42.

115

SILVER LEKYTHOS

Height .12m. (4¾ in.); diameter at base .045m. (1¾ in.); diameter at lip .065m. (2½ in.)
Archaeological Museum of Thessalonike, no. 7432
Found in 1974 in a cist grave, Stavroupoli, Thessalonike

116

This squat lekythos with ring base has a wide mouth, incised circles around the rim and ridges around the spring of the neck. The handle has ridges down the middle and ends in leaf-shaped terminals. This shape, known from pottery as well as metal, appears around the end of the fifth century and lasts throughout the fourth century B.C. in both clay and metal.

TAM, no. 279, pl. 41.

116 *(Color plate 18)*

BRONZE KRATER-KADOS

Height with handle .365m. (14⅜ in.); without handle .235m. (9¼ in.)
Archaeological Museum of Thessalonike, no. 5124
Found at Stavroupoli, Thessalonike

The wide-bodied bronze vessel with golden luster has a short neck and large mouth, like that of a krater. The curving handle hooks into rings attached to the rim and has a ring at the top for suspension. Below the rings are archaizing Gorgon heads attached with studs. The rim and base are embossed with a leaf pattern, and the neck has an elaborate guilloche pattern engraved with the aid of compasses.

Fourth century B.C.

Deltion 20 (1965): B2 Chronika, p. 411, pl. 462 a–b.

117

BRONZE WINE JUG (OINOCHOË)

Height .18m. (7 in.); greatest diameter .14m.
(5½ in.)
Archaeological Museum of Thessalonike,
no. 5125
Found at Stavroupoli, Thessalonike

Bronze trefoil oinochoë with pear-shaped
body, circular ring base, and high plain
handle.

Second half of the fourth century B.C.

Deltion 20 (1965): B2 Chronika, p. 411, pl.
463b.

118

SILVER CUP (KALYX)

Height .057m. (2¼ in.); diameter .087m.
(3⅜ in.)
Kavalla Museum, no. A 870
Found in Grave *Delta*, Tumulus of Nikesiani

Kalyx cup with a central boss. On the inside
are traces of scale pattern done in the re-
poussé technique, a pattern which does not
occur frequently on vessels of this shape. On
the outside the surface is very worn, probably
because the cup was in use for a long time;
the only decoration that has been preserved is
the astragalos pattern below the neck. Inside
there is a gilded boss with a relief of a female
head framed by ovolo pattern, also in relief.

The following coins were found in Grave
Delta: Philip II, Alexander the Great, and a
bronze of Cassander which dates the grave to
the beginning of the third century B.C.

Late fourth century B.C.

D. Lazarides, *Praktika* (1959), p. 47; *TAM,*
no. 405, pl. 56.

119

SILVER CUP (KALYX)

Height .08m. (3⅛ in.); diameter at rim .095m.
(3¾ in.)
Archaeological Museum of Komotini,
no. 1896
Found in the grave tumulus at Arzos, Hebros
district

This example belongs to the class of kalyx
cups with central boss, hemispherical body,
cylindrical neck and flaring rim. Another
kalyx cup, slightly shallower, was found in
the same tomb.

End of the fourth century B.C.

TAM, no. 464, pl. 61; *Deltion* 30 (1975):
Chronika (in press).

120

SILVER CUP (KALYX)

Height .068m. (2¾ in.); diameter .10m.
(4 in.)
Kavalla Museum, no. A 869
Found in Tomb *Alpha,* Tumulus of Nikesiani

This kalyx cup has a central boss, a rounded
body well shaped to fit the palm of the hand,
and a wide neck with flaring rim. Repoussé
decoration as follows, from the bottom up:
elongated petals radiating from two concen-
tric circles around the base; a band of guil-
loche pattern between rows of fine astragalos
pattern; Lesbian leaf-and-dart in relief and a
cable pattern around the base of the neck. In-
side, a gilded central boss is framed by two
circles of astragalos pattern in relief.

This shape is most probably derived from
the Achaemenid deep bowl. Since it appears
in Attic pottery in the fifth and fourth century
B.C., the Achaemenid influence must have
been felt well before the conquests of Alex-
ander paved the way to direct contact be-
tween Greek art and the East.

Metal vases with the same shape and
scheme of decoration as the Nikesiani ex-
ample have been found throughout Mace-
donia, in Vergina, Derveni, Sedes,
Stavroupoli, and they occur with equal
frequency in Aegean Thrace (for example, in
Arzos, Mesemvria).

121 122 *(detail)*

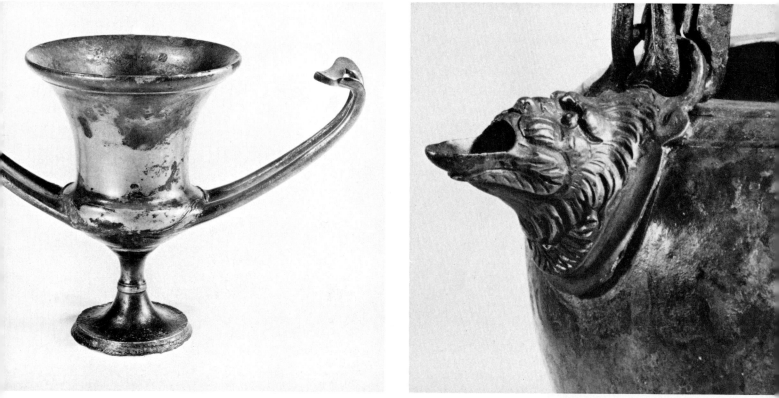

Certain of these, such as the one found in 1977 in the Royal Tomb II at Vergina (catalogue no. 164) or the one from Derveni, may easily be dated to the third quarter of the fourth century B.C.

D. Lazarides, *Praktika* (1959), p. 47; *TAM,* no. 401, pl. 56. For similar cups from Macedonia and Aegean Thrace, see *TAM,* no. 103 (Vergina), nos. 194, 261 (Derveni), nos. 280, 283, both pl. 41 (Stavroupoli), no. 317, pl. 45 (Sedes), no. 433 (Mesemvria), nos. 464 (pl. 61), 465 (Arzos). See also A. Oliver, *Silver for the Gods* (1977), no. 10, with bibliography. For Attic pots of the same shape, see *Agora* 12 (1970): nos. 691–695, p. 121; cf. K. Rhomiopoulou, *AE* (1964), p. 100, on Attic pottery from Amphipolis.

121

BRONZE KANTHAROS

Height .108m. (4¼ in.)
Kavalla Museum, no. A 872
Found in Grave *Epsilon,* Tumulus at Nikesiani

Bronze kantharos with high foot, kalyx-shaped bowl, and high slender loop handles which start at the shoulder of the bowl, swing

out and up and curve in on themselves; at the juncture with the shoulder are lanceolate leaves. The shape is well known, occurring frequently in Attic pottery of the end of the fourth century B.C.; silver vessels of this shape have been found in Macedonia.

End of the fourth century B.C.

D. Lazarides, *Praktika* (1959), p. 47; *TAM,* no. 409, pl. 57. For comparison see *TAM,* no. 246, pl. 33, from Grave *Delta,* Derveni; for similar silver vessels from Grave *Beta,* Derveni, see *TAM,* nos. 188 and 189, both pl. 28, and also no. 283, pl. 41, from a grave at Stavroupoli, all probably earlier. For Attic pottery of the same shape, see *Agora* 12 (1970): 284, no. 677, pl. 28, 325–310 B.C.; for a discussion of the type, see J. Mertens, "A Hellenistic Find in New York," *Metropolitan Museum Journal* 11 (1976), pp. 80–84.

122 *(Color plate 18)*

BRONZE SITULA

Height .215m. (8½ in.)
Kavalla Museum, no. A 1403
Found in Grave *Epsilon,* Tumulus at Nikesiani

Bronze situla with curving walls and disc-shaped base. The incurving rim is continuous with the narrow shoulder, which is emphasized by two slightly projecting rings. Two

swinging arched handles hook into the rings, which flank vertical palmettes attached to the rim; the ends of the handles turn up and end in tear-shaped finials. The spout below the base of the handle is a lion's head in relief. Spout, base, and handle attachments were all separately wrought and attached.

Coins of Alexander the Great were found in the tomb.

Second half of the fourth century B.C.

TAM, no. 406, pl. 56. B. Schröder, *Griechische Bronzeeimer im Berliner Antiquarium* BWPR (1914); G. Zahlhaus, *Hamburger Beiträge* I (1972), pp. 115ff.; W. Schiering, "Stellung und Herkunft der Bronzesitula von Waldgesheim," *Hamburger Beiträge,* Band V, Heft I, pp. 77–97; I. Venedikov, "Les situles de bronze en Thrace," *Thracia* 4 (1977): 59ff.

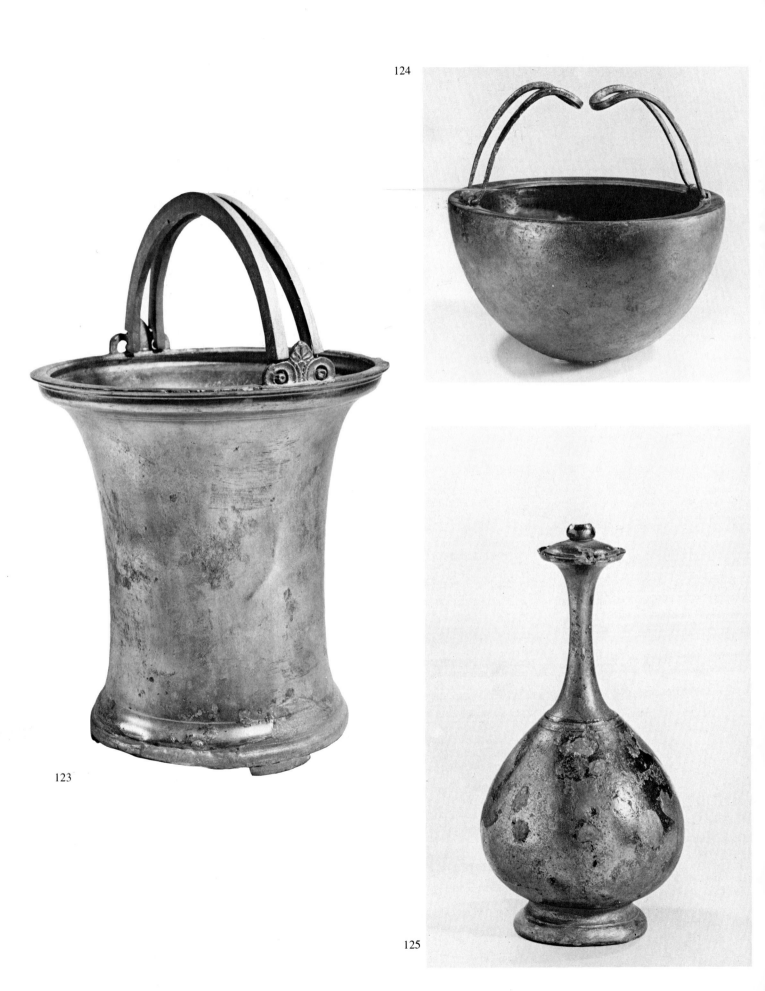

124

123

125

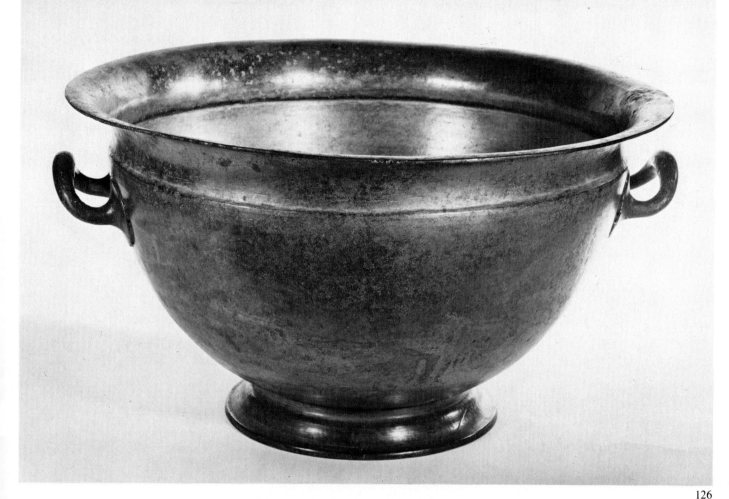

123

BRONZE SITULA

Height .215m. (8½ in.)
Archaeological Museum of Thessalonike,
Derveni A 48
Found in Grave *Alpha,* Derveni

Situla of cast bronze, with concave wall. The
base, made in one piece with the body, is
supported on three solid low feet which are
attached. There are moldings at base and rim.
The two curved swinging handles are hooked
into double palmette rings attached to the
rim. Acanthus leaves curl softly between the
rings, and from them five-petaled flame pal-
mettes rise; the whole palmette attachment is
fitted into a curved triangular form.

Second half of the fourth century B.C.

TAM, no. 171. For further bibliography, see
catalogue no. 135.

124

HEMISPHERICAL BRONZE BOWL

Height .14m. (5½ in.); diameter .27m.
(10⅝ in.)
Archaeological Museum of Thessalonike,
Derveni A9
Found in Grave *Alpha,* Derveni

Bronze bowl with golden luster. The hemi-
spherical form without a base is unusual; the
level rim slants inward, and two unusual

hinged loop handles are attached to the rim.
The interior has been coated with a greenish-
brown pigment.

Second half of the fourth century B.C.

Deltion 18 (1963): B2 Chronika, p. 194;
TAM, no. 165, pl. 24.

125

BRONZE SPRINKLER
(PERIRRHANTERION)

Height .145m. (5¾ in.)
Archaeological Museum of Thessalonike
Derveni A13
Found in Grave *Alpha,* Derveni

Bronze sprinkler with golden luster; the sur-
face is slightly corroded. The body is pear
shaped, with a ring base that has a scotia
molding at the juncture with the body. The
long, narrow, flaring neck terminates in a
disc to which the round sprinkler section is
attached. The vase is decorated only with del-
icate rings, one on the base, two at the base
of the neck, and one below the rim. (See also
catalogue no. 111.)

Second half of the fourth century B.C.

Deltion 18 (1963): B2 Chronika, p. 194, pl.
227; *TAM,* no. 169, pl. 33. See also
Comstock–Vermeule, *Greek . . . Bronzes,*
p. 322, no. 450; *BCH* 99 (1975): 569, 571,
no. 12, fig. 40.

126

BRONZE MIXING BOWL

Height .25m. (9⅞ in.); diameter at rim
.465m. (18¼ in.)
Archaeological Museum of Thessalonike,
Derveni A51
Found in Grave *Alpha,* Derveni

The mixing bowl, bronze with golden luster,
has a cup-skyphos shape. The open body is
hemispherical; it has a short, concave neck;
thin, flaring rim; low base; and small horizon-
tal handles, circular in section, terminating in
discs at juncture with body.

Second half of the fourth century B.C.

TAM, no. 174.

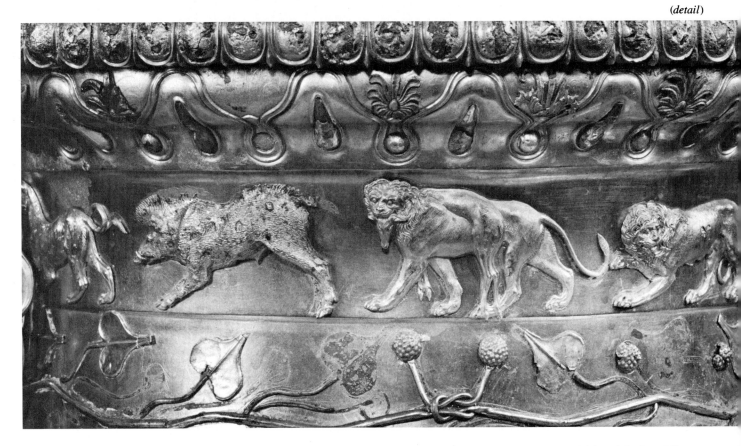

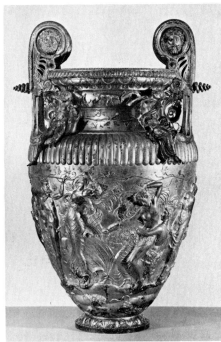

127

127 *(Color plate 20)*

BRONZE KRATER

Height .905m. (35⅝ in.); diameter at rim
.40m. (15¾ in.); diameter at base .23m.
(9 in.)
Archaeological Museum of Thessalonike,
Derveni B 1
Found in Grave *Beta,* Derveni

The krater was found in 1962 in the Derveni
area, eleven kilometers northwest of Thessa-
lonike. A gold olive wreath was found on top
of the strainer lid. The bones found in the
krater had been wrapped in a cloth and placed
there after cremation (the actual ritual of cre-
mation was performed outside the grave); a
gold ring, three gold pins, and a gold coin of
Philip II were found together with the re-
mains. After the upper part of the krater was
covered with cloth, the gold wreath was put
in place. The way in which the funeral cere-
mony was performed — placing the bones in
the krater, and so forth — recalls Homer's
account of the burial of Hector in *Iliad,* Book
24, lines 791–796.

Perhaps the bones buried in the krater were
those of a nobleman from Larissa. An in-
scription in silver lettering around the rim
reads: ΑΣΤΙΟΥΝΕΙΟΣ ΑΝΑΞΑΓΟΡΑΙΟΙ
ΕΣ ΛΑΡΙΣΑΣ ([I am the krater] belonging
to Astion the son of Anaxagoras from
Larissa).

The krater, which weighs forty kilograms,
is a masterpiece of ancient Greek metallurgy.
The handles, the base, and the figures on the
shoulder were separately cast. Stalks of ivy
and vine were applied in silver on the neck
and upper part of the body of the krater, and
Ariadne's necklace and sandals were also ap-
plied in silver.

The shape of the vessel recalls that of the
large Apulian clay kraters of the fourth cen-
tury B.C., and they do, in fact, derive from a
common prototype, the Attic krater, but have
differing lines of development. The body is
decorated with rich subsidiary reliefs of ani-
mals and plants, and a main relief represent-
ing scenes from the life of the god Dionysos,
the most important god, and the one with the
most popular, widespread cult, in the fourth
century B.C. On the front, the youthful Dio-
nysos is indolently seated on rocky ground
with his right leg draped over Ariadne's
thigh. Perhaps the marriage of Ariadne and
Dionysos is represented. The panther which
accompanies them is the sacred animal of the
god. Maenads and Silens, his attendants,
dancing frenziedly and tearing animals limb
from limb, complete a representation vibrat-
ing with ecstasy and pathos. One figure
stands out, the bearded man with a sandal on
one foot; he holds spears in his right hand and
his sword in its scabbard hangs from his
shoulder. Is he the legendary hero and Diony-
sos' opponent, Pentheus; or Lykourgos, king
of Thrace?

(detail)

There are four masks on the handles: in front, Herakles, the ancestral hero of the Macedonians, and a god with bull's horns and ears; in back, two masks of Hades. Four lovely figures of separately cast bronze adorn the shoulders of the krater. In front: Dionysos and a sleeping Maenad; in back, a tipsy Satyr who has fallen asleep holding on to a full wineskin and a Maenad who flings her beautiful head back in a transport of ecstasy.

This unique work is of paramount importance for a study of stylistic developments of the fourth century B.C. and is also especially important for the study of Dionysiac cult. Its dating has been the subject of much controversy.

Second half of the fourth century B.C.

E. Jiouri, *The Derveni Krater* (in Greek) (Athens, 1978) (Greek Archaeological Society publication no. 89); B. Barr-Sharrar, "Towards an Interpretation of the Dionysiac Frieze on the Derveni Krater," *Cahiers d'Archéologie Romande* no. 17 (1979): 55–59; K. Schefold, "Der Basler Pan und der Krater von Derveni," *AK* 22 (1979): 112–118; *TAM,* no. 184, pl. 27.

(detail)

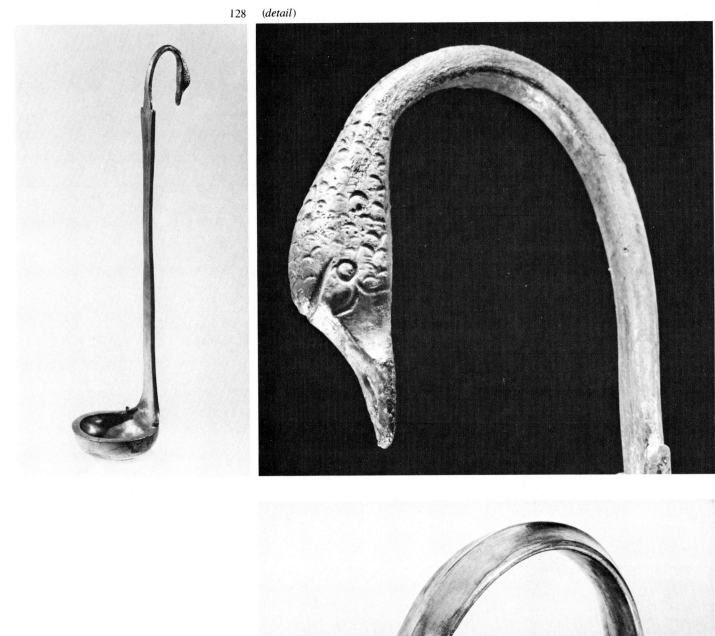

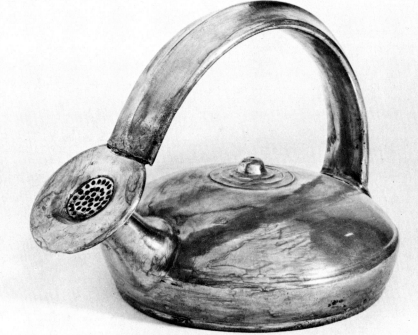

129

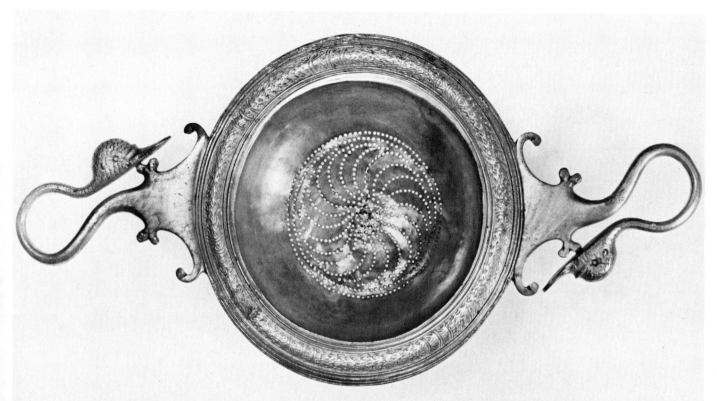

128

SILVER LADLE

Length .265m. (10⅜ in.); diameter of bowl .06m. (2⅜ in.)
Archaeological Museum of Thessalonike, Derveni B 2
Found in Grave *Beta*, Derveni

Intact silver ladle with handle, rectangular in section, ending in a goose head. The goose is a sacred fowl connected with the cult of Dionysos. The ladle was most probably used for dipping wine out of large vessels to fill drinking cups.

Fourth century B.C.

TAM, no. 185, pl. 28. See also D. E. Strong, *Greek and Roman Gold and Silver Plate* (1966), pp. 91–92, 115–116, 143; A. Oliver, *Silver for the Gods* (1977), p. 43, no. 13 and p. 46, no. 15.

129 *(Color plate 19)*

SILVER ASKOS

Height .105m. (4⅛ in.); diameter at base .105m. (4⅛ in.); diameter of spout .048m. (1⅝ in.)
Archaeological Museum of Thessalonike, Derveni B 3
Found in Grave *Beta*, Derveni

Low askos with flat base. In the center of the convex upper surface is a nipple-shaped projection imitating the handle of a lid. The narrow-necked, flaring spout has a strainer that is joined to an arching strap handle with a longitudinal ridge. The vessel was clearly made specifically as a grave offering, in facsimile of a real askos, because it is completely closed and could never have held any liquid.

Second half of the fourth century B.C.

Agora 12 (1970): 159 with n. 8; *TAM*, no. 186, pl. 29.

130 *(Color plate 19)*

SILVER STRAINER

Length .22m. (8⅝ in.); diameter .105m. (4⅛ in.); height .025m. (⅞ in.)
Archaeological Museum of Thessalonike, Derveni B 4
Found in Grave *Beta*, Derveni

The holes of the strainer are arranged in the form of a whirling rosette framed by concentric circles. Around the rim is a bound wreath engraved on the flange. The handles are in the form of ducks' or swans' heads with long necks springing from flat triangular plaques. This shape, widespread in Macedonia in the fourth century B.C., was used to strain wine.

Second half of the fourth century B.C.

TAM, no. 187, pl. 29. See also A. Oliver, *Silver for the Gods* (1977), p. 45, no. 14, where Kavalla in Thessaly is reported as the provenience for a similar strainer in the Walters Art Gallery, Baltimore. This is an error because Kavalla is in eastern Macedonia and was probably named as the place of finding as a matter of convention. In fact, Amphipolis is most likely as the findspot.

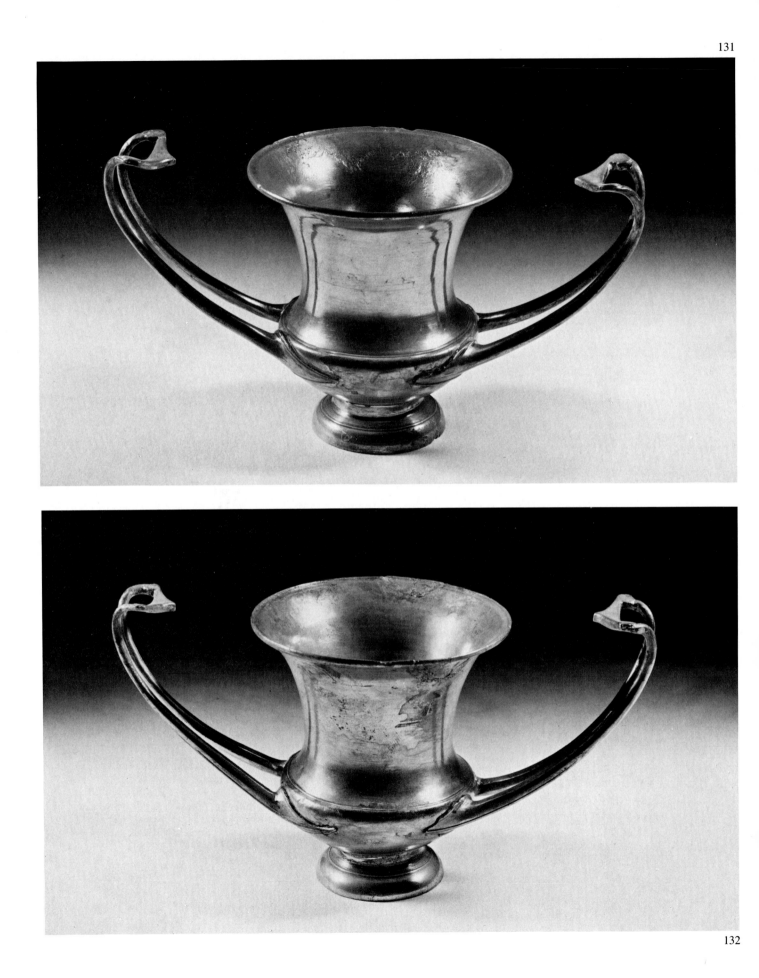

133

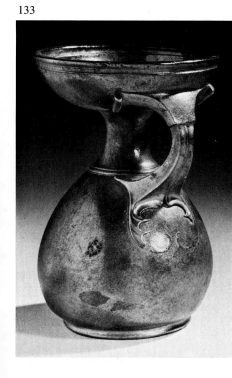

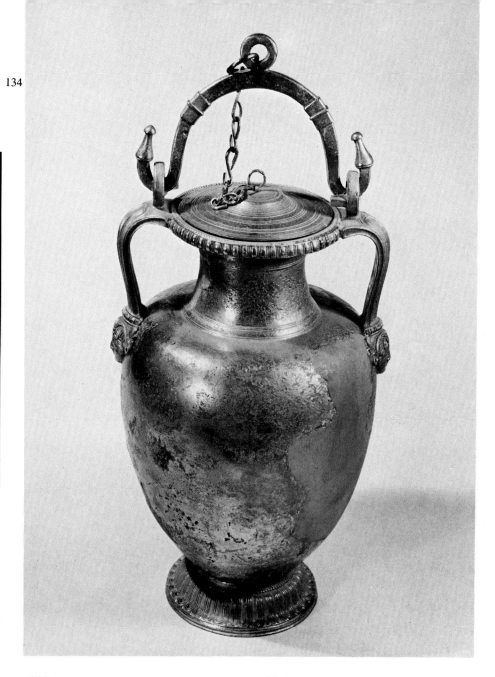

131

SILVER CUP-KANTHAROS

Height .09m. (3½ in.); diameter at rim
.085m. (3½ in.); diameter at base .046m.
(1⅞ in.)
Archaeological Museum of Thessalonike,
Derveni B 5
Found in Grave *Beta,* Derveni

Silver cup-kantharos with kalyx-shaped body
on a ring base. The handles have leaf-shaped
projections for attachment to the body.

For Bibliography, see catalogue no. 132.

132

SILVER CUP-KANTHAROS

Height .09m. (3½ in.); diameter at rim
.086m. (3½ in.); diameter at base .045m.
(1⅞ in.)
Archaeological Museum of Thessalonike,
Derveni B 6
Found in Grave *Beta,* Derveni

This and the preceding cup-kantharos are
identical twins; the only difference is in mea-
surements and that a very slight one.

Fourth century B.C.

TAM, nos. 188 (cat. no. 131) and 189, pl.
28. For the shape in general see *Agora* 12
(1970): 119–120, pl. 28; K. Rhomiopoulou,
AE (1964), p. 100, fig. 9; J. Mertens, "A
Hellenistic Find in New York," *Metropolitan
Museum Journal* 11 (1976): 80–84.

133 *(Color plate 19)*

BRONZE PERFUME VASE
(LEKYTHOS)

Height .107m. (4¼ in.); diameter .071m.
(2¾ in.)
Archaeological Museum of Thessalonike,
Derveni B 23
Found in Grave *Beta,* Derveni

This bronze perfume vase with golden luster
was found intact. It has a very wide, funnel-
shaped mouth. The handle terminates in
acanthus leaves, the tips of which are miss-
ing. It has a molded ring base, and fillets at
the lip and below the neck. There are per-
fume pots of the same shape in clay.

Second half of the fourth century B.C.

Deltion 18 (1963): B2 Chronika, p. 194, pl.
227a; *Agora* 12 (1970): 162, n. 2; *TAM,*
no. 206.

134 *(Color plate 18)*

BRONZE AMPHORA

Height with handle .375m. (14¾ in.); with-
out handle .27m. (10⅝ in.)
Archaeological Museum of Thessalonike,
Derveni B 22
Found in Grave *Beta,* Derveni

This bronze amphora with golden luster
shows restoration on the body. The swinging
handle has a ring on top for a chain to secure
the shield-shaped lid. The vessel has relief
decoration: Ionic kymation around the lip; an
elongated leaf on each strap handle; relief
heads on the lower handle attachments of de-
monic female beings, with volutes and pal-
mettes springing from their foreheads. The
base is decorated with moldings in relief in
leaf pattern and bead pattern.

Second half of the fourth century B.C.

Deltion 18 (1963): B2 Chronika, pl. 226a;
TAM, no. 205, pl. 35.

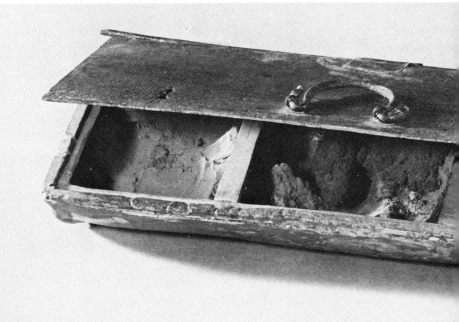

136

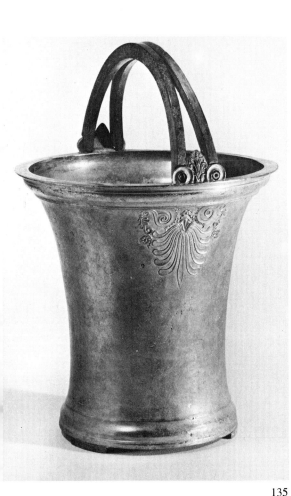

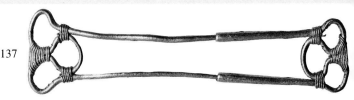

137

135

135 (Color plate 19)

BRONZE SITULA

Height .20m. (7⅞ in.)
Archaeological Museum of Thessalonike,
Derveni B 28
Found in Grave *Beta*, Derveni

This bronze situla with concave walls was
made in one piece with the base, which has
kymation and fillet moldings. Three low,
solid feet are attached. Moldings on the lip
are like those at the base. Two swinging han-
dles of the same diameter and width as the
rim hook into rings flanking upright palmettes
attached to the rim. On the sides of the vessel
below the handles are elaborate inverted pal-
mettes harmoniously combined with scrolls,
small palmettes, acanthus leaves, and tendrils
ending in eight-petaled rosettes.

Second half of the fourth century B.C.

TAM, no. 211. On this type, see B. Schröder,
*Griechische Bronzeeimer im Berliner An-
tiquarium* (1914); P. J. Riis, *ActaA* 30
(1959); G. Zahlhaus, *Hamburger Beiträge* I
(1972): 115ff.; I. Venedikov, "Les situles de
bronzes en Thrace," *Thracia* 4 (1977): 59ff.;
W. Schiering, "Stellung und Herkunft der
Bronzesitula von Waldgesheim," *Hamburger
Beiträge*, Band V, Heft 1, pp. 77–97.

136

BRONZE COSMETICS BOX

Length .13m. (5⅛ in.); width 0.04m.
(1½ in.)
Archaeological Museum of Thessalonike,
Derveni B 35
Found in Grave *Beta*, Derveni

Bronze box with golden luster. The surface is
slightly corroded and there has been some
restoration.

The box, oblong in plan and oval in sec-
tion, has a plain lid fitted with a curved
swinging handle and two keyholes. The inte-
rior of the box is partitioned into three com-
partments in one of which a hardened mass of
rose-red pigment is preserved.

Second half of the fourth century B.C.

Deltion 18 (1963): B2 Chronika, pp. 193ff.;
Bronzes in Yugoslavia, no. 277; *TAM*, no.
218, pl. 36.

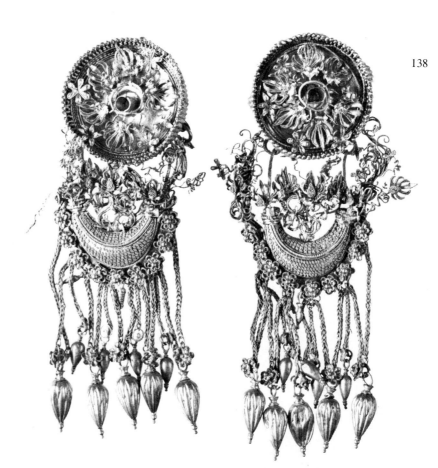

137

GOLD PIN WITH SHEATH

Length .06m. (2⅜ in.)
Archaeological Museum of Thessalonike,
Derveni *Delta* 3
Found in Grave *Delta,* Derveni

Two-shank pin complete with sheath, of a
type occurring throughout the northern Greek
area.

Fourth century B.C.

TAM, no. 241, pl. 33.

138 *(Color plate 11)*

PAIR OF GOLD EARRINGS

Height .095m. (3¾ in.)
Archaeological Museum of Thessalonike,
Derveni Z 8
Found at Derveni, Grave *Zeta*

The boat-shaped earrings are of the type
called Ionian, which was extremely popular
in the fourth century B.C. The ornamental
motifs are executed in filigree, granulation,
and appliqués, combined to produce striking
effects. At the top is a disc ornamented with a
rosette of palmettes and tiny flowers; on the
other side of the disc is the hook to go over
the ear. A crescent-shaped element with elab-
orate floral decoration is suspended from the
disc. There are nine pendant buds on chains
attached to nine rosettes on the lower curve of

the crescent; of these, five larger buds are on
double chains and four smaller, more delicate
ones are on single chains. The links are con-
cealed by rosettes inlaid with glass paste.

Second half of the fourth century B.C.

TAM, no. 257, pl. 34; Stella G. Miller, *Two
Groups of Thessalian Gold* (Univ. of Califor-
nia Classical Studies vol. 18, 1979), pp.
7–10 and n. 25. R. A. Higgins, *Greek and
Roman Jewellery* (1961), pl. 25G.

139 *(Color plate 13)*

GOLD PENDANT

Height .04m. (1⅝ in.)
Archaeological Museum of Thessalonike,
Derveni Z 4
Found in Grave *Zeta,* Derveni

Head of Herakles, done in repoussé and chas-
ing techniques. The hero wears his character-
istic lion-skin cap. The head must have been
attached to a piece of jewelry, as there are
holes, one in back and one on either side,
which are linked by copper wire inside. The
hook at the top of the head makes it probable
that the head was an earring pendant. Hera-
kles was a favorite subject for jewelry in the
Macedonian area, where he was considered to
be an ancestral hero.

Second half of the fourth century B.C.

TAM, no. 255, pl. 34.

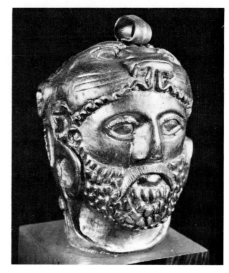

139

140

140

APHRODITE

Height .45m. (17¾ in.)
Terra-cotta
Veroia Museum, no. *Pi* 2360
Found in a grave, Veroia

Complete. Well-washed reddish yellow clay.

The goddess stands on a high round base. Her upper body is bare and she rests her left elbow on a pillar. In her raised right hand she holds the mask of a Silen, and in her left a bowl of fruit. A little Eros is perched on top of the pillar and a large kithara is propped against it below.

The pose — the fluid movement of the body with the pronounced curve of the hips and the sharply bent, relaxed left leg — dates this work to late Hellenistic times. On the other hand, the head with the melon hairstyle and the fine-featured face recalls prototypes of the end of the fourth century B.C.

Colors: rose for the strap below her breast, part of the himation border, and the palmette on the lower part of the kithara. The cross-straps in front are rendered in white.

Mid second century B.C.

141

142

141

APHRODITE

Height .46m. (18 in.)
Terra-cotta
Veroia Museum, no. *Pi* 2364
Found in a grave at Veroia

Complete. Yellow, well-washed clay. Generally similar to catalogue no. 140.

The goddess holds a Silen mask in her upraised right hand; along her left side is a cornucopia. A small Eros in fetal position rests in the crook of her left arm.

There are traces of white on the strap and on the bracelets worn high on the right arm.

Mid second century B.C.

142 *(Color plate 22)*

APHRODITE
 WITH EROS AND LITTLE GIRL

Height .36m. (14⅛ in.)
Terra-cotta
Veroia Museum, no. *Pi* 2361
Found in a grave at Veroia

Fine, dark yellow clay. Missing: Eros' left wing. The goddess stands holding Eros on her left shoulder; on her right, a little girl stands with a dove.

The goddess wears a chiton leaving her right shoulder free and a himation which veils her head and leaves the right side of the upper body uncovered. The child wears a peplos with a long overfold. The figurine is interest-

ing for its type, although the workmanship is sketchy. The letters *delta iota* are stamped on the upper surface of the unworked back, and on the lower mold the monogram *mu eta* and the sign ⴤ are written sidewise.

Mid second century B.C.

143 (*Color plate 22*)

APHRODITE

Height .39m. (15⅜ in.)
Terra-cotta
Veroia Museum, *Pi* 2359
Found in a grave at Veroia

Complete. Reddish clay, fairly free of impurities.

The goddess is shown seated on a solid throne without backrest, with her foot on a footstool. Her legs are crossed at the knee, with her right foot projecting forward.

Nursing the infant Eros, whom she holds tenderly, she wears a sleeved chiton leaving the left breast uncovered and a himation falling free in back.

An accomplished coroplast made this figurine, as evidenced by the way the himation, made out of a flat piece of clay, frames the body and by the sensitive gesture of the marvelously big hands.

The variety of colors is most interesting. To convey the effect of precious metal, a grayish substance has been applied to the sandal straps, bracelets, crown, and to the deco-

ration of throne and footstool. An intense violet is added on the himation; the flesh is white.

Mid second century B.C.

144

APHRODITE

Height .35m. (13¾ in.)
Terra-cotta
Veroia Museum, no. *Pi* 2376
Found in a grave at Veroia

Restored. Red clay well free of impurities. The general scheme is similar to that of catalogue no. 140.

Aphrodite rests her left arm on a pillar and holds a horn of plenty in the crook of her left arm. A boukranion is on the side of the horn. She holds an omphalos phiale in her outstretched right hand. To her right an infant Eros stands astride a column fluted only in the upper portion.

The goddess has insipid features. The hair, parted in the middle, falls over the shoulders in stylized tresses. An elaborate Herakles knot adorns the hairband.

In back, only the upper part of the figure is worked. The base is four-sided. The figurine is not well worked but is derived from a good archetype.

Second century B.C.

145

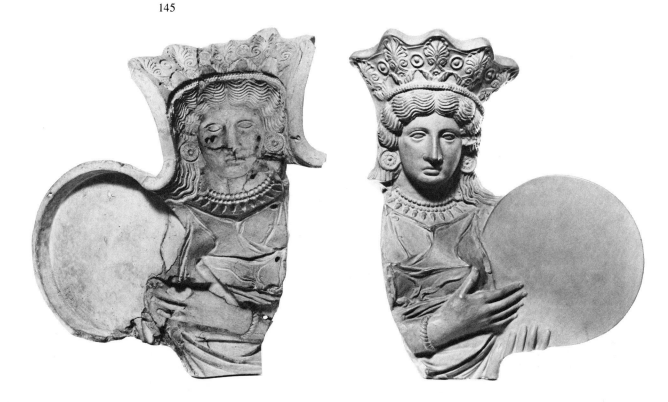

145

KYBELE

Mold, with cast shown at right, above
Preserved dimensions: height .45m. (17¾
in.); width .34m. (13⅜ in.); thickness .45m.
(17¾ in.)
Terra-cotta
Archaeological Museum of Thessalonike,
Olynthus no. 524
Found at Olynthus

Mold for a terra-cotta protome (bust) of Ky-
bele. Red clay with greenish surface. Reas-
sembled from many fragments. Right side
(as shown) and lower part missing. Fingers
damaged.

The mold is unusually large. The goddess
is clad in peplos and himation (visible below
her left hand). Her thick wavy hair is parted
in the middle and falls over her shoulders.
She wears a fillet and above it a crown with
palmettes and stylized rosettes in relief. There
are also rosettes on the heavy earrings. A rich
necklace adorns her throat and a bracelet
made to look like strands of twisted gold is
on her wrist. In her left hand she holds a
cymbal which she taps with the fingers of her
right.

Early fourth century B.C.

D. M. Robinson, *Excavations at Olynthus*,
Part IV, The Terracottas of Olynthus Found
in 1928 (1931), pp. 92ff., pls. 51–54.

146 (*Color plate 23*)

PYXIS

Height with lid .13m. (5⅛ in.); without lid
.09m. (3½ in.)
Clay
Pella Museum, no. 77/175
Found in a grave in the East Cemetery, Pella

Black-glaze pyxis with lid, of the so-called
West Slope type; complete, but reassembled
from fragments. The red clay is free of impu-
rities; the black glaze has a metallic luster.

The pyxis is on a low ring base. Its lid is
richly decorated with patterns added in clay
relief and left unglazed, and with a central
relief medallion with the head of Medusa
framed by a band of palmettes and other
floral motifs. The body is decorated with an
ivy garland added in clay and with bands of
purple.

Third–second century B.C.

146

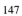147

148

149

150

147

APHRODITE

Height .43m. (17 in.)
Terra-cotta
Pella Museum, no. 1977/230
Found in Pella, Grave *Gamma,* Section
Omicron Upsilon Theta

The figure is intact; peeling surface. The red
clay is not well washed. The goddess leans
her bent left arm on a pier and holds a large
kithara in her left hand. She plucks the strings
with the plektron held in her right hand.

Her lovely features are blurry. Luxuriant
hair tumbles down her back in curls, and she
wears a heavy wreath of fruits and leaves
wound round with a fillet.

Hellenistic period

148

WOMAN WITH HIMATION

Height 0.275m. (10⅝ in.)
Terra-cotta
Pella Museum, no. 1976.271
Found in a Hellenistic grave at Pella

The figurine is complete but mended. Rela-
tively well-washed red clay. White slip over
all; traces of red on hair and lips; slight traces
of gold on the hair.

Figurine of a woman with no base; Tanagra
type. Most of her body is covered by the vol-
uminous drapery of a himation arranged in
diagonal folds. The white chiton is visible
below the himation and at the neck. Her right
arm is bent, with the hand at the waist.

The grace of her movement is heightened
by the slight turn of her head and the bent
right leg projecting forward. She has a lovely
face with delicate, pale features. Her lux-
uriant hair is arranged in the melon coiffure.

Third century B.C.

149

APHRODITE

Height .32m. (12⅝ in.)
Terra-cotta
Pella Museum, no. 1977/201
Found at Pella, Tomb *Gamma,* Section *Omi-
cron Upsilon Theta*

The figurine is complete but mended. The
surface is worn. The reddish clay is not well
washed.

Aphrodite, clad in chiton and himation,
holds a little Eros on her bent left arm and a
triangular fan in her right hand, hidden by the
himation. The hair style with three rows of
snail-shell curls occurs often in figurines from
Myrina.

Found together with catalogue no. 147.

Hellenistic period

150

ATHENA

Height .41m. (16⅛ in.)
Terra-cotta
Pella Museum, no. E 3795
Found in Pella excavations, Section I,
square 4

The goddess stands on a high round base. She
wears a peplos with long overfold, girt high
above the waist. A gorgoneion adorns the
front. She holds out her arms; the objects
which she once held in her hands are lost.

The figure wears a helmet with bull's horns
at the sides. It is perhaps a copy of the cult
statue of Athena Alkidemos worshipped at
Pella. For the type of helmet see catalogue
no. 103.

Late Hellenistic period

Deltion 19 (1964): Chronika, pp. 340ff., pl.
393 *alpha, beta, gamma.*

177

151

T 169

152

151

IONIC PILASTER CAPITAL

Height .24m. (9½ in.); depth .59m. (23¼ in.); width between outer edges of volutes .41m. (16⅛ in.)
Porous limestone
Pella Museum, no. T 169
Found on the Acropolis of Pella

Complete. Volute channels are in the form of triple spirals. Half palmettes decorate the echinus, which bulges out markedly. On the bolster are pointed leaves which spring from a nest of acanthus.

Hellenistic period

Deltion 16 (1960): 81, pl. 59b.

152 (*Color plate 24*)

HORSEMAN

Height .28m. (11 in.); length .385m. (15⅛ in.)
Marble
Pella Museum, no. *Gamma Lambda* 54
Found in Pella, stray find

Missing: the horse's legs, forepart of muzzle, and the tail; the youth's upraised right arm, lowered left hand, and lower legs and feet. Fine-grained white marble.

The youth is naked except for a chlamys, which is shown in conventional windblown manner; the ends of the garment lie on the horse's rump.

The work is well executed, but not particularly inspired.

Hellenistic period

M. Robertson, *Greek Painting,* The Great Centuries of Painting (1959), pp. 166, 169–170, 2 plates; M. B. Hatzopoulos, L. D. Loukopoulos (editors), *Philip of Macedon* (1980), pp. 156–157, plate.

153 (*Color plate 25*)

ALEXANDER-PAN

Height .375m. (14¾ in.)
Marble
Pella Museum, no. *Gamma Lambda* 43
Found in the Pella excavations

Missing: legs from the knees down, right arm, and most of the left forearm. The head has been glued on. Light grayish marble with dark gray veining, oxidized in places.

Alexander is represented nude, standing with his left leg drawn back a little and stretching his raised right arm forward.

In his hair are a band and two little horns like Pan's. The head is turned to the right and upward.

Hellenistic period

Deltion 18 (1963): Chronika, p. 205, pl. 242.

154 (*Color plate 25*)

POSEIDON

Height without base .46m. (18⅛ in.); with base .52m. (20½ in.)
Bronze
Pella Museum, no. M 383
Found in the Pella excavations

The figure is complete, except for the index finger of the left hand. The trident and the support that was under the right foot are missing. Shiny black patina.

The statuette was found with the base to which it was attached by dowels made of lead and iron. A raised base supports the relaxed, right leg; the body is slightly bent, forward and to the right. The left hand is raised to hold the missing trident, and the closed right hand rests on the right thigh. Wet, sleek, straight strands of hair allude to the god's watery domain. The plastic volumes are strongly brought out.

This statuette is of the well-known Lateran Poseidon type, whose original is attributed to Lysippos.

Late Hellenistic period

Deltion 16 (1960): 80, pl. 65a.

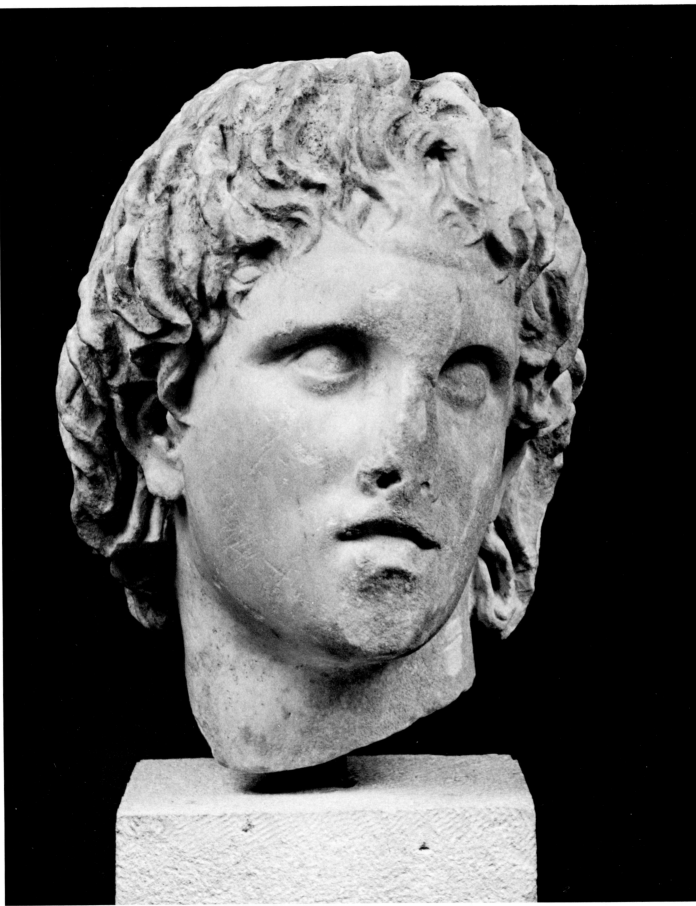

157

158

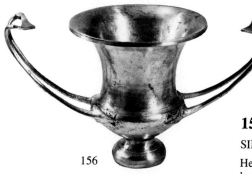

156

155 *(Color plate 25)*

ALEXANDER THE GREAT

Height .30m. (11¾ in.)
Marble
Pella Museum, no. *Gamma Lambda* 15
Stray find from the Yannitsa area

A break down the middle of the face has damaged the nose and part of the mouth and chin, and there are slight breaks in the hair. The hair is worked in fine wavy tresses falling lightly over the forehead. The back of the head is sketchily worked.

This is the well-known type of Alexander portrait, with slight turn of the head, eyes looking upward, and hair swept up at the center of the forehead.

Late Hellenistic period

Pella I (1971): 63 with n. 5, pl. 6 *delta*.

156 *(Color plate 26)*

SILVER DRINKING CUP (KANTHAROS)

Height without handles .086m. (3⅜ in.); with handles .097m. (3⅞ in.); diameter of rim .085m. (3⅜ in.)
Archaeological Museum of Thessalonike, no. 15
Found in Tomb III, Vergina

The very small bowl of this cup-kantharos is supported by an attached base. The lip is very high and the rim is downturned. The handles start at the top of the bowl and rise just above the level of the rim.

350–325 B.C.

157 *(Color plate 26)*

SITULA (WATER OR WINE VESSEL)

Height .325m. (12¾ in.); diameter of rim .216m. (8½ in.)
Silver
Archaeological Museum of Thessalonike, no. 13
Found in Tomb III, Vergina

This bell-shaped vessel, used to carry water or wine, is made in one piece with the base and has a broad, level rim. The two swinging loop handles are hooked into the volute-like attachments placed on opposite sides of the

rim. There is a gilded floral design engraved under each attachment. The color combination of the two metals, silver and gold, matches the classical simplicity of the shape and the decoration perfectly.

350–325 B.C.

158 *(Color plate 26)*

SILVER WINE JUG (OINOCHOË)

Height .257m. (10⅛ in.); greatest diameter .157m. (6⅛ in.)
Archaeological Museum of Thessalonike, no. 14
Found in the chamber of Tomb III, Vergina

A strongly accentuated acute angle well below the center gives this shape its individuality. The long neck terminates in a U-shaped spout. The handle has an incised twisted-rope pattern, and its attachment is shaped like an ivy leaf.

350–325 B.C.

159

159 (*Color plate 27*)

PAIR OF GILDED BRONZE GREAVES

Right: height .415m. (16¼ in.); greatest width .097m. (3¾ in.)
Left: height .38m. (15 in.); greatest width .09m. (3½ in.)
Archaeological Museum of Thessalonike, no. 2
Found in the antechamber of Tomb II, Vergina

On the inside of the greaves are remains of the leather padding which protected the legs from the metal. The thread on the upper edge by which the padding was sewn to the metal is preserved in very good condition. The great difference in size is the striking feature of the greaves: the left one is distinctly shorter and slightly narrower, suggesting that it was worn by a man whose left leg was shorter and weaker than his right.

350–325 B.C.

M. Andronikos, *AAA* 10 (1977): 66, fig. 26; *TAM,* no. 88.

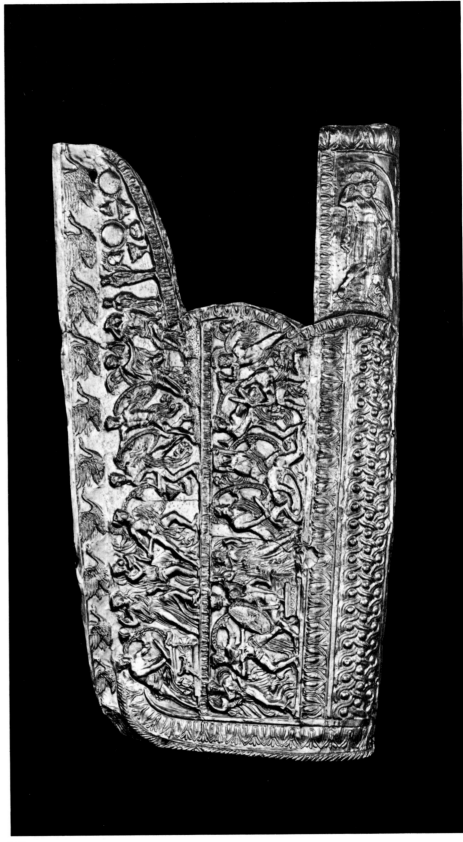

160

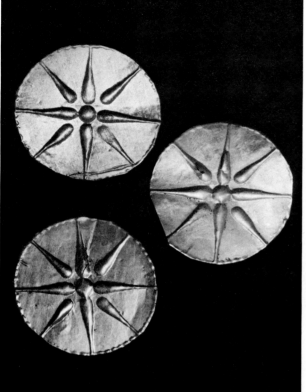

162

160 *(Color plate 28)*

GILDED SILVER GORYTUS
(BOW-AND-ARROW CASE)

Greatest height .465m. (18¼ in.); greatest
width .255m. (10 in.)
Archaeological Museum of Thessalonike,
no. 3
Found in the antechamber of Tomb II,
Vergina

This elaborately embossed sheathing for a
portable case for bow and arrows was fas-
tened to the quiver, which was probably
made of leather, by means of small nails
which are still preserved along the edges. The
whole surface is covered with relief decora-
tion; the two major zones show a great many
figures in a battle taking place in a sanctuary.
A third zone is adorned with a triple-braid
pattern; it is a relief of a fully armed warrior.

A separate sheet of silver sheathed the bot-
tom of the quiver; its shape permits us to
reconstruct the exact shape of the entire
quiver.

On a Scythian gorytus apparently made
from the same mold, see page 36.

350–325 B.C.

M. Andronikos, *AAA* 10 (1977): 64–66, figs.
26–27; *TAM*, no. 89, pl. 22.

161 *(Color plate 29)*

THREE GOLD DISCS

Diameter .032–.033m. (1¼ in.)
Archaeological Museum of Thessalonike,
no. 4
Found in the antechamber of Tomb II,
Vergina

These round sheets were found together
with many others of the same kind in among
the disintegrated organic material in the an-
techamber; it is not yet known how they were
used. They are embossed with the same star
emblem of the Macedonian dynasty that
adorns the lid of the golden chest (catalogue
no. 172).

350–325 B.C.

M. Andronikos, *AAA* 10 (1977): 66; *TAM*,
no. 94.

162 *(Color plate 30)*

GILDED SILVER DIADEM

Inside diameter .21m. (8¼ in.); diameter of
the rod .024–.027m. (1 in.)
Archaeological Museum of Thessalonike,
no. 10
Found in the main chamber of Tomb II,
Vergina

This circular diadem, symbol of royal power,
is a hollow cylindrical rod with a lozenge pat-
tern engraved on the outer surface. It is vir-
tually entirely gilded except for the central
row of lozenges, where the gold has been me-
ticulously removed. The ends of the rod fit
into a separate ring, making it possible to ad-
just the size of the diadem. This ring is
adorned with a knot of tresses in relief,
clearly indicating the back of the diadem.

350–325 B.C.

M. Andronikos, *AAA* 10 (1977): 57, figs. 9,
11; *TAM*, no. 151, pl. 18.

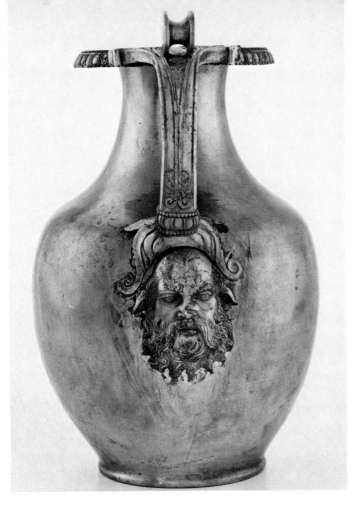

163

164

163 *(Color plate 31)*

SILVER WINE JUG (OINOCHOË)

Height .223m. (8¾ in.); greatest diameter
.151m. (6 in.)
Archaeological Museum of Thessalonike,
no. 6
Found in the main chamber of Tomb II,
Vergina

This type of wine jug has a swelling body
made in one piece with the base. In this ex-
ample the rim is decorated with a relief pat-
tern (Ionic kymation) that calls to mind lace
borders. The handle is richly decorated with
an attachment in the form of a floral or-
nament, below which is the head of a Silen in
relief. Although the animal traits of the crea-
ture are clearly discernible, this depiction of
the bald attendant of Dionysos is idealized,
conveying a suggestion of a human nature.

350–325 B.C.

M. Andronikos, *AAA* 10 (1977): 58–59, figs.
14, 15a; *TAM*, no. 110, pl. 23.

164 *(Color plate 33)*

SILVER CUP (KALYX)

Height .061m. (2⅜ in.); greatest diameter
.10m. (4 in.)
Archaeological Museum of Thessalonike,
no. 5
Found in the chamber of Tomb II, Vergina

In contrast to the plain neck, the deep hemi-
spherical body is richly decorated with floral
reliefs. A medallion attached to the center of
the interior carries the relief of a Silen's head
with gilded beard, hair, and wreath. This
head of Dionysos' attendant has very expres-
sive features, with the right eye half-closed
and a merry smile. The workmanship is mar-
velous down to the smallest detail; it is a
miniature sculpture of high quality.

350–325 B.C.

M. Andronikos, *AAA* 10 (1977): 59, fig. 14;
TAM, no. 105.

165 *(Color plate 32)*

SILVER JAR (ALABASTRON)
WITH LID AND HANDLES

Height .364m. (14⅜ in.); greatest diameter
.129m. (5 in.)
Archaeological Museum of Thessalonike,
no. 7
Found in the main chamber of Tomb II,
Vergina

This jar, probably used for aromatic oil, is

equipped with a lid fastened to one of two
handles by a chain. The handles, rare in ves-
sels of this shape, are richly decorated. A
separately wrought Herakles head is attached
below each handle. The beardless face of the
young hero is completely framed by the lion
head, and the lion's paws are tied in a knot
below his chin. The Macedonians believed
Herakles was the ancestor of their royal line.

350–325 B.C.

M. Andronikos, *AAA* 10 (1977): 59, figs. 14,
15a, 15b; *TAM*, no. 113.

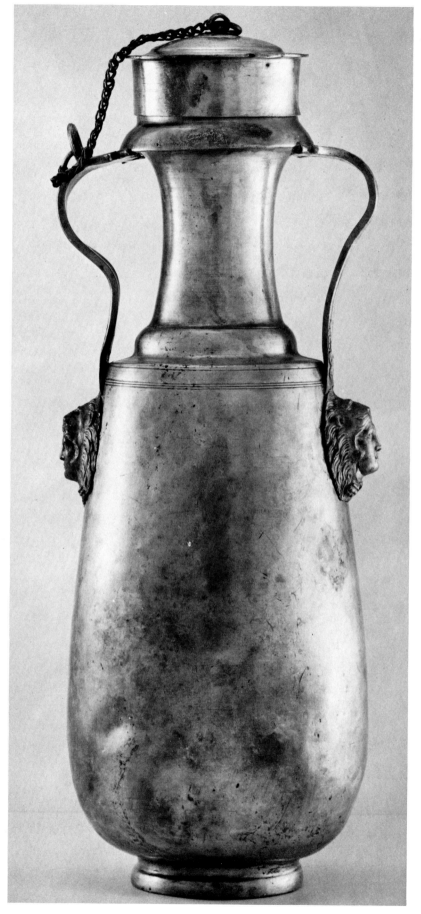

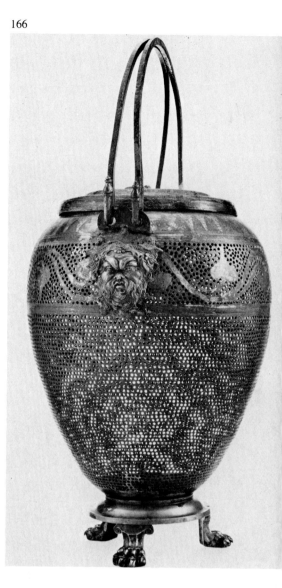

166 *(Color plate 33)*

BRONZE LANTERN WITH LID
AND MOVABLE HANDLES

Height .305m. (12 in.); greatest diameter
.205m. (8 in.)
Archaeological Museum of Thessalonike,
no. 9
Found in the main chamber of Tomb II,
Vergina

The clay lamp attached inside this vessel
shows that it was a lantern; the lamplight
would have shone through the perforated
walls. The upper part is decorated with espe-
cially elaborate silvered-over floral and geo-
metric patterns. It is attached to a separate
base with three lion paws. The lid is attached
to one of the handles by a chain. A head of
Pan, separately wrought, is preserved below
one of the handle attachments; presumably
there was a matching head below the other
handle. The relief work is exquisite, and it is
clear that the artist intended to emphasize the
animal side of the goat- god.

350–325 B.C.

M. Andronikos, *AAA* 10 (1977): 57, fig. 8;
TAM, no. 148.

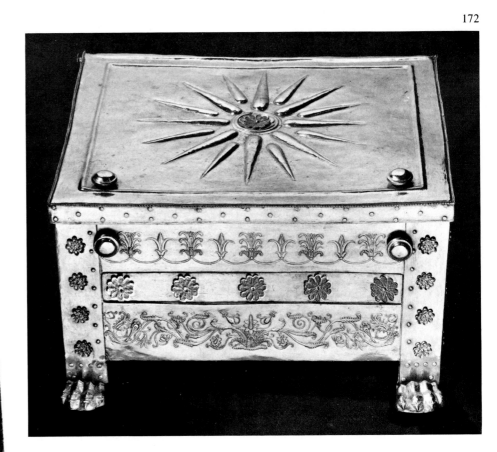

167, 168, 169 (*Color plate 27*)

THREE IRON SPEAR HEADS

Archaeological Museum of Thessalonike, no. 16
Found in the main chamber of Tomb II, Vergina

167 Length .45m. (17¾ in.); greatest width .054m. (2⅛ in.) The long round socket, into which the wooden shaft fitted, tapers to a rib coming to a point just above the tip of the wide, leaf-shaped blade. After removal of the rust, part of the original surface was revealed, and it could be seen that the metal was forged with special care to make it as resistant as possible.

168 Length .333m. (13⅛ in.); greatest width .028m. (1⅛ in.) The very short socket tapers into a very pronounced rib which takes up most of the width of the long, narrow blade.

169 Sarissa head. Length .553m. (21¾ in.); greatest width .033m. (1¼ in.) The extremely long blade could belong to a sarissa, a type of spear introduced by Philip II for the Macedonian army. The socket is especially well made. The angled rib extends the whole length of the blade, which is especially elegant and meticulously worked, the point in particular.

350–325 B.C.

M. Andronikos, *AAA* 10 (1977): 58; *TAM*, nos. 141, 143, 146. On sarissas, see M. Andronikos, "Sarissa," in *BCH* 94 (1970): 91–107.

170 (*Color plate 34*)

PHILIP II

Height .032m. (1¼ in.); greatest width .021m. (⅞ in.); thickness .017m. (⅝ in.)
Ivory
Archaeological Museum of Thessalonike, no. 11
Found in the main chamber of Tomb II, Vergina

This miniature head of a middle-aged, bearded man, which is carved almost in the round, formed part of the relief decoration of a wooden couch, the bier, whose remains were found in the main chamber. The back of the head, which would have been in contact with the bearing surface, is flat, and the head is incomplete at the top, ending in an oblique plane which would have supported hair made out of some other material and gilded. The broad features, the aquiline nose with the prominent bridge, and the austere expression make it obvious that it is a portrait, and comparison to known images of Philip II indicates that it is most probably of him. The differentiation in the treatment of the eyes is striking: the right eye appears to be sightless and the right eyebrow is marked by a scar which cuts across it. The artist excelled both in the conception and in the execution of this work on an extraordinarily small scale. Despite its small physical size, this work has a monumental character.

350–325 B.C.

M. Andronikos, *AAA* 10 (1977): 59–60, figs. 16, 20; *TAM*, no. 152, pl. 20.

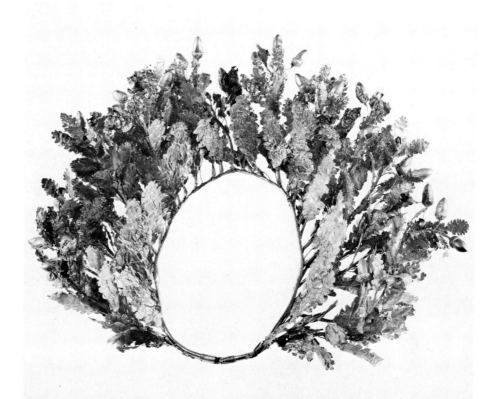

170

171

171 *(Color plate 34)*

ALEXANDER THE GREAT

Height .034m. (1⅜ in.); width .018m. (⅝ in.); thickness .012m. (½ in.)
Ivory
Archaeological Museum of Thessalonike, no. 12
Found in the main chamber of Tomb II, Vergina

Found with the head of Philip II (catalogue no. 170), this head is evidently also from the bier and is similar to the preceding in technical details.

In spite of the damage, the physical characteristics, especially the compact rounded cheeks of a young man, are clear. The emphasis on the neck, the relatively low, deeply creased forehead, the markedly aquiline nose, the deep-set eyes, the fleshy lips, and the strongly projecting chin are all individual characteristics known from most of the portraits of Alexander.

350–325 B.C.

M. Andronikos, *AAA* 10 (1977): 59–60, figs. 17a, 17b, 20; *TAM*, no. 153, pl. 21.

172 *(Color plate 35)*

GOLD CHEST (LARNAX)

Length .41m. (16⅛ in.); width .35m. (13¾ in.); height .20m. (7⅞ in.)
Archaeological Museum of Thessalonike, no. 8
Found in the main chamber of Tomb II, Vergina

The golden oak leaf wreath (catalogue no. 173) and the cremated bones of a man were found in this chest, which is unique in regard to both material and size. The chest stands on four legs terminating in lion paws. The decoration is fairly simple: three bands with floral decoration on three sides of the chest; on the fourth, the front, the central band carries attached rosettes with petals of blue glass paste. A similar rosette on the lid forms the center of a large starburst, the emblem of the Macedonian royal line, in relief.

350–325 B.C.

M. Andronikos, *AAA* 10 (1977): 60–61, fig. 21; *TAM*, no. 120, pl. 18.

173 *(Color plate 36)*

GOLD WREATH
WITH OAK LEAVES AND ACORNS

Inside diameter .185m. (7¼ in.)
Archaeological Museum of Thessalonike, no. 17
Found in Tomb II, Vergina

This striking wreath was found inside the gold chest (catalogue no. 172) together with the cremated bones. Thirty-two branches grow out of the main stem that constitutes the frame of the wreath. Each branch bears eleven to fifteen leaves and four acorns. The quality of the composition, the marvelous technique, and the naturalistic rendering of oak leaves and acorns (the oak was the sacred tree of Zeus) demonstrate not only the virtuosity of the goldsmith but also the high level of artistic accomplishment required by the owner of the wreath.

Second half of the fourth century B.C.

AAA 10 (1977): 28; *TAM*, no. 121.

PHOTOGRAPH CREDITS

Note: At the time this catalogue goes to press, it is understood that the following objects will be shown only in Washington and Boston: 46, 78, 83; only in Washington and Chicago: 56; only in Washington: 1, 3, 6, 13, 41, 63, 66, 73, 80, 84, 85, 86, 87.

Photographs were supplied by the lenders. The following photographers are represented (numbers are those of catalogue entries): A.C.L., Brussels: 42; Kristin Anderson, Boston: 16, 17, 18, 20, 22, 23, 24, 26, 27, 28, 29, 31, 32, 36, 37; Imantz Ansbergs, Boston: 5 (color); Atelier de Photographie, University of Geneva: 9; Chuzeville, Paris: 41; Harry J. Connolly, Jr., Baltimore: 10, 11, 33 (all also in color); Si Drabkin Studio, New York: 61, 62, 65 (all also in color); Wayne Lemmon, Boston: 92 (color); Studio Koppermann, Munich: 80; Isolde Luckert, Berlin: 54, 64, 81; Günter Meyer, Pforzheim: 66 (color); Allen Mewbourn, Bellaire, Texas: 71 (also in color), 72, 76; Ph. SAAS, Geneva: 9 (color); Erik Schmidt: Fig. 2; M. Skiadaressis, Greece: 155; Ken Strothman, Bloomington: 4; Time Inc.: Fig. 6; S. Tsavdaroglou, Athens: all loans from Greece in black and white and color, except 155 (black and white) and 79A; D. Widmer, Basel: 43, 53 (both also in color), and 75, 77.

SELECTED BIBLIOGRAPHY

HISTORICAL BACKGROUND

GENERAL MACEDONIAN BACKGROUND

N. G. L. Hammond, *A History of Macedonia*, vol. 1 (*Historical geography and prehistory*) (Oxford, 1972); vol. 2, with G. T. Griffith (*550–336 B.C.*) (Oxford, 1979); vol. 3, in preparation.

PHILIP II

G. C. Cawkwell, *Philip of Macedon* (London and Boston, 1978)

J. R. Ellis, *Philip II and Macedonian Imperialism* (London, 1976)

M. B. Hatzopoulos and L. D. Loukopoulos, editors. *Philip of Macedon* (Athens, 1980). (Chapters by leading scholars of Philip; also good on general Macedonian background.)

ALEXANDER THE GREAT

"Alexander the Great," *Greece and Rome*, vol. 12, 2 (October, 1965)

E. Badian, editor, *Alexandre le Grand*, Fondation Hardt, Entretiens XXII (Vandoeuvres-Geneva, 1975)

D. W. Engels, *Alexander the Great and the Logistics of the Macedonian Army* (Berkeley, Los Angeles, and London, 1978)

Peter Green, *Alexander of Macedon* (Pelican Biographies, Penguin Harmondsworth, 1974)

G. T. Griffith, editor, *Alexander the Great: The Main Problems* (Cambridge and New York, 1966)

R. Lane Fox, *Alexander the Great* (London, 1973)

————, *The Search for Alexander* (Boston, 1980)

C. Mercer–Cornelius C. Vermeule, Alexander the Great (New York, 1962)

M. Wheeler, *Flames over Persepolis* (London, 1968)

U. Wilcken, *Alexander the Great* (revised edition by E. N. Borza, New York, 1967)

PELLA AND VERGINA

M. Andronikos, *Pella Museum* (Athens, 1975)

————, "Vergina, the Royal Graves in the Great Tumulus," *Athens Annals of Archaeology* 10 (1977): 1–39

————, "Seeking the Tomb of Philip of Macedon," *National Geographic* 154 (1978): 54–77

————, *The Royal Graves at Vergina* (Athens, 1978)

S. Drougou & D. Touratsozoulou, *Hellenistic Rock-Cut Chamber Tombs at Veroia* (in Greek) (Athens, 1980)

N. G. L. Hammond, " 'Philip's tomb' in historical context," *Greek, Roman and Byzantine Studies*, Duke University, XIX (1978), p. 331 ff.

Phyllis Williams Lehmann, 'The So-Called Tomb of Philip II: A Different Interpretation," *American Journal of Archaeology* 84, part 4 (1980)

D. Papakonstantinou-Diamantourou, *Pella*, vol. 1 (Athens, 1971)

P. Petsas, "Pella, Literary Tradition and Archaeological Research," *Balkan Studies* 1 (1960)

————, "Pella," in *Enciclopedia dell'arte antica*, vol. 6 (Rome, 1965), pp. 16–20

————, *Pella, Alexander the Great's Capital* (Thessalonike, 1978)

Cornelius C. Vermeule, "Philip II, Alexander the Great, and Philip III," *Archaeology* 33, no. 6 (Nov.–Dec. 1980)

HELLENISTIC ART

GENERAL

M. Bieber, *The Sculpture of the Hellenistic Age*, revised edition (New York, 1961)

J. Charbonneaux, R. Martin, & F. Villard, *Hellenistic Art*, English edition (London and New York, 1973)

C. M. Havelock, *Hellenistic Art* (Greenwich, 1970)

J. Onians, *Art and Thought in the Hellenistic Age* (London, 1979)

Cornelius C. Vermeule, *Greek Art: Socrates to Sulla* (Boston, 1980)

GOLD AND SILVER WORK

P. Amandry, *Collection Hélène Stathatos*, vol. 1 (Strasbourg, 1953), vol. 3 (Strasbourg, 1963)

M. I. Artamanov, *Treasures from the Scythian Tombs* (London, 1969)

G. Becatti, *Oreficerie antiche dalle minoiche alle barbariche* (Rome, 1955)

P. Davidson & H. Hoffmann, *Greek Gold: Jewelry from the Age of Alexander* (Mainz, 1965)

R. A. Higgins, *Greek and Roman Jewellery* (London, 1961)

S. Miller, *Two Groups of Thessalian Gold*, University of California Classical Studies, vol. 18 (1979)

A. Oliver, "Greek, Roman and Etruscan Jewelry," *The Metropolitan Museum of Art Bulletin* (1966), pp. 269–284

————, *Silver for the Gods* (Toledo, 1977)

B. Segall, *Museum Benaki: Katalog der Goldschmiede-Arbeiten* (Athens, 1938)

D. E. Strong, *Greek and Roman Gold and Silver Plate* (London, 1966)

Treasures of Ancient Macedonia, published by the Greek Ministry of Culture and Science (catalogue of the exhibition which opened at the Archaeological Museum of Thessalonike in August, 1978) (Athens, 1979)

I. Venedikov & T. Gerassimov, *Thracian Art Treasures* (Sofia-London, 1975)

ALEXANDER PORTRAITS

B. Andreae, *Das Alexandermosaik aus Pompeii* (Recklinghausen, 1977)

M. Bieber, *Alexander the Great in Greek and Roman Art* (Chicago, 1964)

V. von Graeve, *Der Alexandersarcophag und seine Werkstatt* (Berlin, 1970)

H. Hoffmann, "Helios," *Journal of the American Research Center in Egypt* 2 (1963): 117ff.

F. P. Johnson, *Lysippos* (Durham, N.C., 1927)

H. P. L'Orange, *Apotheosis in Ancient Portraiture* (Oslo, 1947)

G. M. A. Richter, *The Portraits of the Greeks*, vol. III (London, 1965)

E. Schwarzenberg, "From the *Alessandro morente* to the Alexandre Richelieu," *Journal of the Warburg and Courtauld Institutes* 32 (1969): 398–405

————, "The portraiture of Alexander," *Alexandre le Grand*, Fondation Hardt, Entretiens XXII (Vandoeuvres-Geneva 1975), pp. 223–278.

E. Sjöqvist, *Lysippus*, Lectures in Memory of Louise Taft Semple (Cincinnati, 1966)

ALEXANDER: RELATED WORKS OF LATER PERIODS LENT FROM GREECE

A

A

Wooden bow of a pack-saddle decorated with the carving of a mermaid

Mytilene, 1921
Height .46m. (18 in.); greatest width,
.45m. (18 in.)
Collection of Phroso Euthemiadis, Athens

Saddle-makers often decorated the wooden framework of pack-saddles with ornamental representations of plants and animals. The decorative subject in this example is rather unusual: a mermaid is shown holding a fish — a sign of her marine origin — in one hand and a cross in the other. The sea below is indicated schematically. The background is filled with two wheel designs and inscriptions recording the owner's initials (K. I. Π.) and the date. The representation clearly combines elements of more than one tradition associated with the myth of the mermaid (see page 20).

This piece has come from Mytilene, one of the three places in Greece where pack-saddles were produced and supplied to the whole country in older days. The other two were Melies in Thessaly and Metsovo in Epiros.

A. Hadjimichali, *La sculpture sur bois* (1950), p. 55, fig. 62; P. Zora, Ἡ Γορλόνα εἰς τήν Ἑλληνιμν Λαϊμήν Τέχνην, *Parnassus* II(1960), p. 34, fig. 24.

B

Honoré Daumier, *Alexander and Diogenes*

Lithograph, no. 20 in the series *Histoire Ancienne,* with a tetrastich by Eugene Sue.

First published in the Paris newspaper *Charivari,* August 14, 1842.
Whole leaf, height .327m. (12⅞ in.); width .256m. (10 in.)
Printed part, height .261m. (10¼ in.); width .214m. (8⅜ in.)
Athens, National Gallery, engraving no. 3527

Reclining under a tree, Diogenes continues his smoking, annoyed by the voluminous presence of his important visitor, whose shadow deprives him of the sunlight. Standing beside Diogenes, Alexander, fat and aged, strikes an arrogant but unsteady pose and looks at the cynic with astonishment. A city is faintly sketched in the background. The artist's initials, H. D., and the number 403 are visible in the lower lefthand corner.

L. Delteil, *Le Peintre-graveur illustré* vol. 22 (XIXᵉ et XXᵉ siècles) (1926), no. 944.

C

Relief plaque showing the Ascent of Alexander

Marble, fourteenth century.
Height .32m. (12⅝ in.); width 1.05m. (41⅜ in.)
Formerly incorporated in the floor of the Church of the Peribleptos at Mistra
Mistra Museum, no. 1081.

The surface of the plaque is divided into two unequal parts, with a symmetrically composed representation of the Ascent on the left and floral ornament on the right. Both sections are carved in the low relief. The roughly worked background was originally covered with a layer of colored mastic-wax.

The theme of the Ascent was popular in the Middle Ages. This example depicts Alexander's voyage in heaven, as described in *The Romance of Alexander* by the Pseudo-Kallisthenes (third century A.D.) and in its medieval versions.

The technique of the relief and the type of the ornament assign this provincial work to the fourteenth century.

A. Orlandos, Epistimoniki Epetiristis Philosophikes Scholis-Panepistimiou Athenon, 1954–55, pp. 281–289.

D

Theophilos Hadjimichael, *Alexander the Great on Horseback.* 1900–1920
Detached fragment of a wall painting
Height 58m. (22⅜ in.); width .54m. (21¼ in.)
Athens, Museum of Greek Popular Art, no. 3095

Alexander, wearing a helmet and riding his galloping horse, moves to the right. In the background four foot soldiers march in the same direction. In the foreground, below, a rivulet with two ducks swimming to the left adds a picturesque note.

Unlike the traditional representation of the hero as a beardless youth, this painting and other works by Theophilos show Alexander as a mature man with a moustache, a figure reminiscent of Greek fighters in later times. It is known that Alexander was one of the favorite heroes of the painter, who often dressed himself as Alexander the Great and the children of his neighbourhood as Macedonian soldiers.

Unpublished.